SEEKING LIGHT

Portraits of Humanitarian Action in War

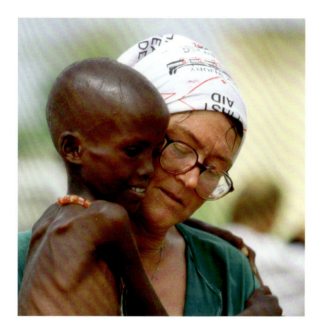

Paul Grabhorn

VIKING

VIKING

Published by the Penguin Group

Penguin Group (USA) LLC

375 Hudson Street

New York, New York 10014

USA | Canada | UK | Ireland | Australia | New Zealand | India | South Africa | China

penguin.com

A Penguin Random House Company

First published by Viking Penguin, a member of Penguin Group (USA) LLC, 2015

Some of the photographs in this book have been previously published, including the image on page 53,
which appeared in *An Inconvenient Truth* by Al Gore (Emmaus, PA: Rodale Press, 2006) and several images
in the chapter "Musicians Go to War," which appeared in *Woza Africa! Music Goes to War*
by Kole Omotoso (Johannesburg: Jonathan Ball Publishers, 1997).

ISBN 978-0-670-01685-3

Printed in China

1 3 5 7 9 10 8 6 4 2

Set in Helvetica Neue
Designed by Paul Grabhorn

CONTENTS

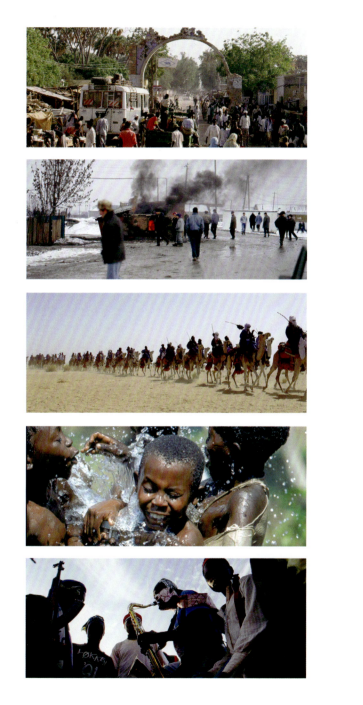

This book is dedicated to my father,

Edgar A. Grabhorn, who showed me how to seek light.

And to the humanitarian spirit that resides in us all.

INTRODUCTION

Bone-chilling cold seeped into the Land Cruiser as we drove fast down a road lined with high snowbanks. The snow had a purple twilight glow as night descended. In the headlights a policeman stood in the road, waving us down. It was impossible not to notice that we were riding in a Red Cross vehicle with the flag flying behind us and the insignia painted on all sides. Three delegates, an interpreter and I had been driving to villages and refugee camps in eastern Croatia all day. The policeman said there was an old woman alone in a house nearby and he was concerned she was very sick, or even worse, dying. Dianne Paul, one of the delegates, immediately asked to be taken to the woman's house.

We followed the policeman and on entering the house found the woman in bed, buried under layers of blankets. The fire had gone out and with no heat, the house was the same temperature as outside, below 0°F. She had not left the bed in days and was lying in excrement. Dianne gave the orders and soon the woman was on a stretcher and loaded into the Land Cruiser. We all squeezed in and drove her to the closest hospital. The admitting nurses were not happy to see the woman; they recognized her and said that they do not take in the indigent. Dianne explained in a heartfelt way how it was their duty to take her in, clean her up and give her a warm place for the night, which they did.

Dianne's instinctive response showed me that when you are faced with someone in need and have the capacity to respond, then you must. This detour had nothing to do with our mission and everything to do with responding. Days before Dianne had said goodbye to her husband and two young boys back in the United States, whom she was leaving behind for three months. She had come to Croatia to help refugee children who'd fled the fighting and ethnic cleansing in Vukovar, Bosnia, and were dealing with the trauma of having their lives destroyed.

Every day people leave the comfort of their lives and homes to help others. When fighting erupts, humanitarian workers enter the conflict zones to make a difference in the lives of those in need. This book shows some of the humanitarian responses to armed conflict. It also tells the story of my personal journey traveling and photographing in intense places with subjects that became embedded in my soul.

Much of this book focuses on the time I spent documenting the work of the International Committee of the Red Cross (ICRC). I have tremendous respect and admiration for their work, their delegates and their staff. This respect has grown over the years as I have experienced life more deeply and broadly. The ICRC is the only organization with the mission of preserving the dignity of people affected by war and standing up for basic principles and rules of humanitarian law. These rules protect the needs of those who are wounded, hungry, without a home, without clean water, cut off from contact with family members, or those who laid down their weapons or were captured as prisoners of war. As long as humanity turns to armed conflict it must also respect the need for basic humanitarian responses to the suffering that is caused by that choice. War is not dignified, but there is dignity to be found and maintained within the hardship of war.

It is my hope that the images in these pages speak to you at a level of feeling beyond the mind's reach. I also hope that you are called to act, in whatever way you are able, on behalf of others in need wherever you see them: at home, at work, on the street or out in a distant country somewhere. We all become humanitarians when we answer the call and act.

"The International Committee of the Red Cross (ICRC) is present in some eighty countries with around 12,000 staff worldwide. Its extensive network of missions and delegations allows it to act close to people affected by armed conflict and other situations of violence and to provide them with a meaningful response to their plight. The ten largest operations worldwide today are the Syrian Arab Republic, Afghanistan, the Democratic Republic of the Congo, Somalia, South Sudan, Iraq, Mali, Israel and the Occupied Territories, Sudan, and Colombia." ICRC.org

The photographs in this book are from:

Abkhazia • Azerbaijan • Angola • Armenia • Bosnia • Burundi • Croatia • Caucuses • Chechnya • Colombia • Cambodia • Democratic Republic of the Congo • Georgia • Guatemala • Kenya • Liberia • Mali • Nepal • Nagorno-Karabakh • Philippines • Rwanda • Senegal • Somalia • South Africa

Working in Conflict

Beledweyne, Somalia. September 1992

> *"It is one of the most beautiful compensations of this life that no man can sincerely try to help another without helping himself. . . . Serve and thou shall be served."*
>
> —Ralph Waldo Emerson

The Calling

You never know when your life is going to change forever.

It was mid-August 1992, in Washington, D.C. Sunlight pounded in through the skylights and the glass wall of my second-story studio set in the back of a bricked courtyard in Georgetown. Looking west I could see the golden domed bank on the corner of M Street and Wisconsin Avenue. The thick summer air and its dripping heat were held at bay by the air conditioner that was working full bore. I sat down to read the *Washington Post* at the wooden dining table that doubled as a conference table in my small office.

I had stayed up most of the night before working on the layout of a report for the National Space Council and was almost late for a meeting to review the latest draft at the Old Executive Office Building. Yet I could not pull myself away from studying an article describing the situation in Somalia and a new effort to get relief supplies to the starving people there. Sitting freshly showered in a business suit with the AC cranking, it was impossible for me to picture the situation and the suffering in that distant desert land. Even so, my heart was pounding hard and I felt an indescribable sense of urgency; it was a feeling that was both exciting and frightening at the same time. I knew then that I must get to Somalia quickly and document the situation. This was something I'd never done before.

Two weeks later I found myself boarding a military cargo plane at Dover Air Force Base in Maryland bound for Mombasa, Kenya, via Ramstein, Germany, and Cairo, Egypt.

In my knapsack I carried one camera body, two lenses, seventy rolls of film and a pocket journal. I also lugged a duffel bag full of stuff I would mostly never touch.

In retrospect I can see that moment in August was a "calling." I felt a mantle settle on my shoulders and the resulting effect was an amazing

flow of events. In the next ten days I acquired a Kenya work visa, got the multiple vaccines recommended by the World Health Organization and convinced the public affairs office of CENTCOM (U.S. Central Command) that I was a qualified journalist so that I was given space with the press pool on military transport. I also handed off a rapid brochure project I had been working on for the White House Council on Environmental Quality to my studio team, purchased a new camera lens and shot several test rolls (this was back in the predigital days of film and processing). Sheer naïveté and the energy of being thirty-five years old propelled me down this path after following the impulse that struck me reading the morning paper all those years ago.

Before I left Washington, I spent many hours learning about the Red Cross from Ann Stingle, the American Red Cross public affairs officer. She patiently explained the difference between the International Red Cross and the American Red Cross and described the situation on the ground in Somalia. She also explained why this was such a unique and important intervention.

There are three branches of the International Red Cross and Red Crescent Movement. The International Committee of the Red Cross works in situations of armed conflict and violence. The International Federation of Red Cross and Red Crescent Societies (IFRC) works before, during and after disasters and health emergencies. The National Red Cross and Red Crescent Societies, like the American Red Cross, act as auxiliaries to the public authorities of their own countries and occasionally work under the direction and coordination of the ICRC in conflict zones, such as in Somalia in 1992.

The ICRC is based in Geneva, Switzerland, and its mandate comes from the Geneva Conventions. The ICRC operates exclusively in places of conflict and violence around the world, providing relief from suffering to those who are affected. In Somalia, where there were hundreds of thousands of starving people due to the ongoing civil conflict, the ICRC was one of a handful of organizations that had the ability to move about the country. The usual method of providing food relief to such a large and disparate starving population was to bring in shiploads of food aid to an ocean port and then send convoys of trucks into the countryside. But now, convoys were being hijacked en route by armed bandits and warlords. Very little food was actually reaching the starving.

The solution was Operation Provide Relief, part of a UN-endorsed initiative to provide aid during the Somali civil war. This was an arrangement worked out between the U.S. military and the ICRC whereby convoys of C-130 cargo planes, uniquely marked with a red cross, would fly food aid to remote towns and villages around Somalia. But the ICRC does not allow a vehicle of any kind marked with a red cross to carry weapons, and the military does not send personnel into war zones unarmed. The two organizations came up with a short-term program: in the camps of displaced persons, drums of water would be heated throughout the night. Next, twelve C-130 cargo planes with nine metric tons of food aid each would fly in early-morning convoys from Mombasa and land on remote dirt runways in Somalia. The food aid was then rushed to the boiling drums of water and immediately cooked and served to lines of hungry people. It was also stored in small amounts in many locations around key areas of famine. This was a temporary (and expensive) emergency relief program that made a drastic difference to many people.

Ultimately, this strategy changed dramatically in December 1992, with the launch of Operation Restore Hope, a major coalition operation to provide more aid. By 1993 there were twenty-eight thousand U.S. troops occupying Somalia as part of the UN-sanctioned operation.

Covering relief missions during Operation Provide Relief in September of 1992 followed a familiar pattern.

It was zero dark hundred. Around 3:30 a.m. local time.

The night air was filled with the smells of airplane fuel and warm tarmac and the rumble of planes starting their engines. I waited in the hot Mombasa humidity to walk up the rear ramp of a C-130 cargo plane. Nine planes had started their engines. Each plane had four engines and I felt the sound in my body as a vibration; the whir of feathering props became deafening. I joined a four-man unarmed combat control team (CCT) in civilian dress carrying small knapsacks as they boarded the lead plane. We buckled into bench seats that lined a wall of the cargo bay. In front of us were four large pallets of food aid (sacks of wheat and sorghum) strapped in and ready to go. The load master closed the cargo bay tail ramp and gave the thumbs-up for takeoff.

After the plane leveled off, the combat control team members huddled around maps spread out on top of a food pallet and went over their plan of action on landing. Afterward they stretched out to sleep for the three-hour flight. I made some notes in my journal and fell asleep to the drone of the engines.

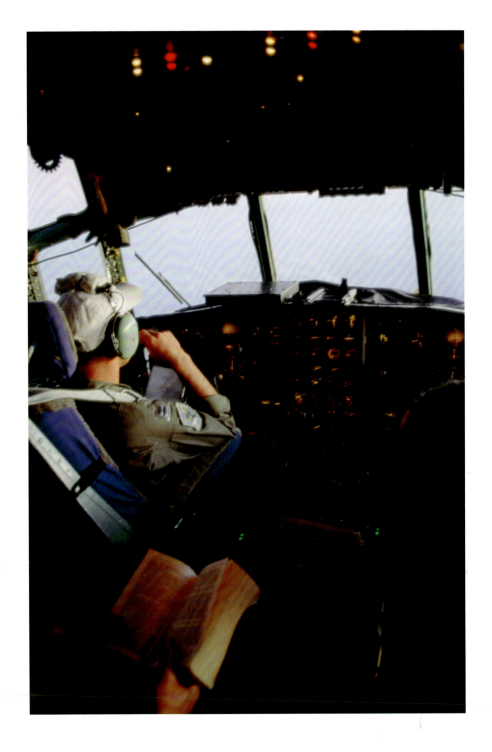

Combat control team members asleep on food aid pallets in the cargo bay of a C-130 en route to Beledweyne, Somalia, from Mombasa, Kenya.

I awoke with the cold and the changes of air pressure during our descent.

As I prepared my camera the combat control team was getting ready to go. They put on and adjusted their knapsacks, collected their gear and assembled in the back of the plane. It had become cold in the cargo bay and as the plane approached to land the rear ramp opened to a brown landscape with a blast of dry heat. The camera lens instantly fogged over. I would later learn to put my camera and lens in a large plastic bag so the moisture would condense outside the bag rather than on them.

The plane landed on the short dirt strip of Beledweyne, Somalia. With all four engines in full reverse it rapidly slowed, and just as it came to a stop the tail ramp touched ground. The CCT guys were down the ramp and out in four directions before I had even wiped my camera lens dry.

The photographs I made that day, and in the days that followed, altered the course of my life. At the time I had no sense that in a short three months American and Canadian troops would land on this same dirt strip. First, a wave of ten Blackhawk helicopters carrying two hundred troops arrived just after dawn, followed by C-130 cargo planes that transported soldiers rather than food. What began as a humanitarian airlift shifted rapidly to an armed relief mission that ended in disaster for the U.S. military, the United Nations and the people of Somalia.

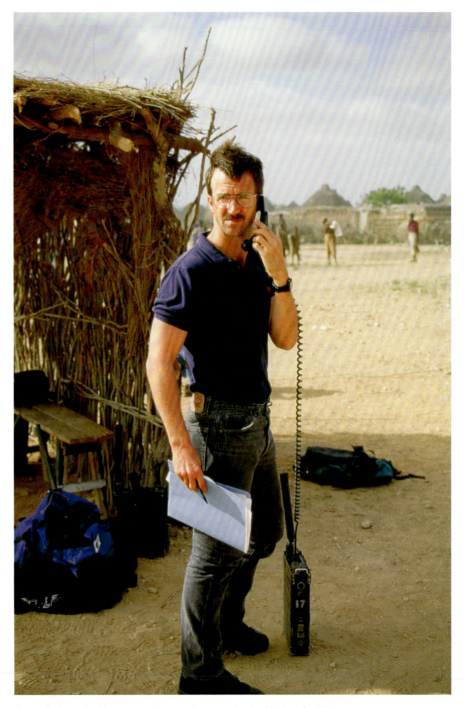

A combat control team member makes contact with the C-130 convoy.

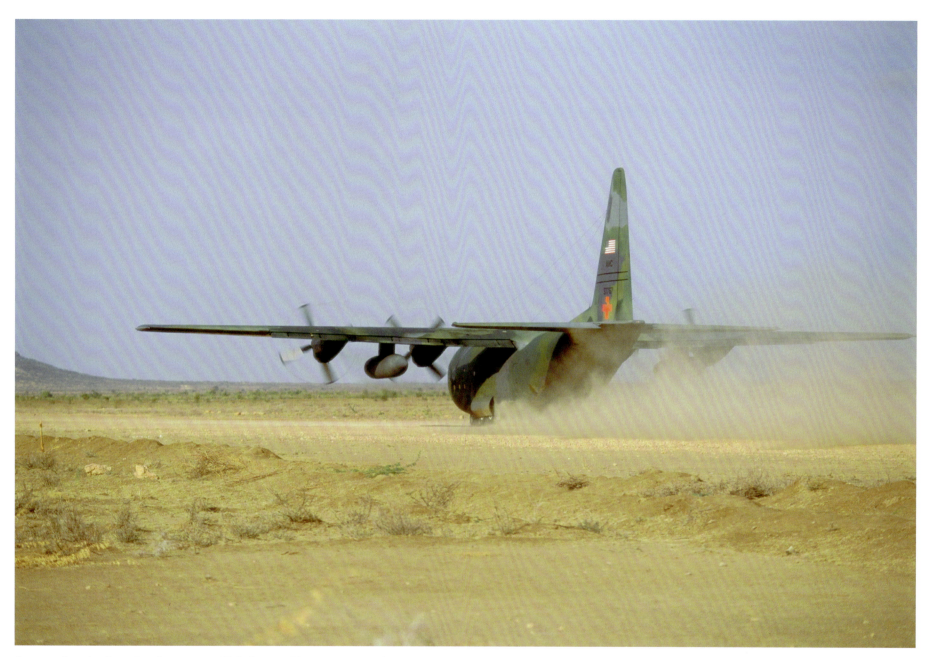

A cargo plane lands on the dirt runway at Beledweyne. The temporary red cross on the tail designates that the plane contains no weapons, only humanitarian aid.

A truck backed up to our plane's cargo ramp and men rapidly unloaded the plane's contents into the truck. The plane left its engines running, creating a wash of dust and a deafening roar. Eight planes were following us and would land one at a time to deliver their loads, each with its tons of food aid. Within twenty minutes the planes had been unloaded onto waiting trucks. The planes roared to the end of the dirt strip, turned and took off for the return flight to Mombasa.

While the plane I rode in was being unloaded the combat control team had set up communication links and began to coordinate the oncoming convoy of planes, in effect becoming the local air traffic control. They also communicated with a secret plane that was not marked with a red cross and contained a fully armed Special Forces team. It circled high above and out of sight in case anything went wrong on the ground. Special Forces medics often accompanied these airlift missions; they assessed the areas and detailed the conditions of runways. In the coming months Special Forces units were expanded with CIA paramilitary officers who made preparations for forces that would follow them. The first casualty of the conflict was a CIA officer, Larry Freedman.

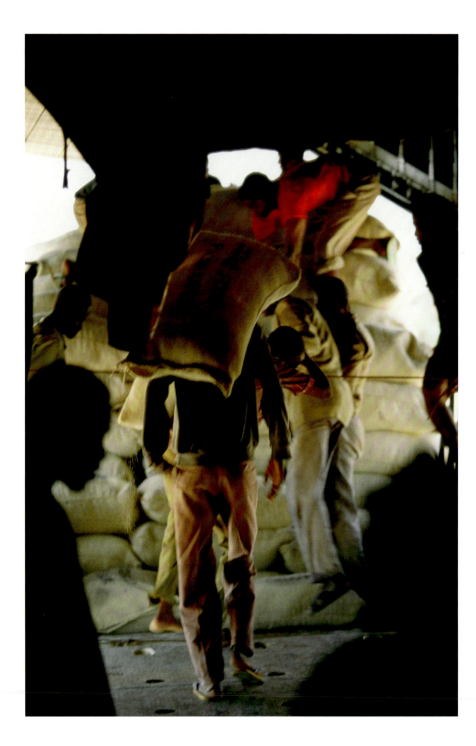

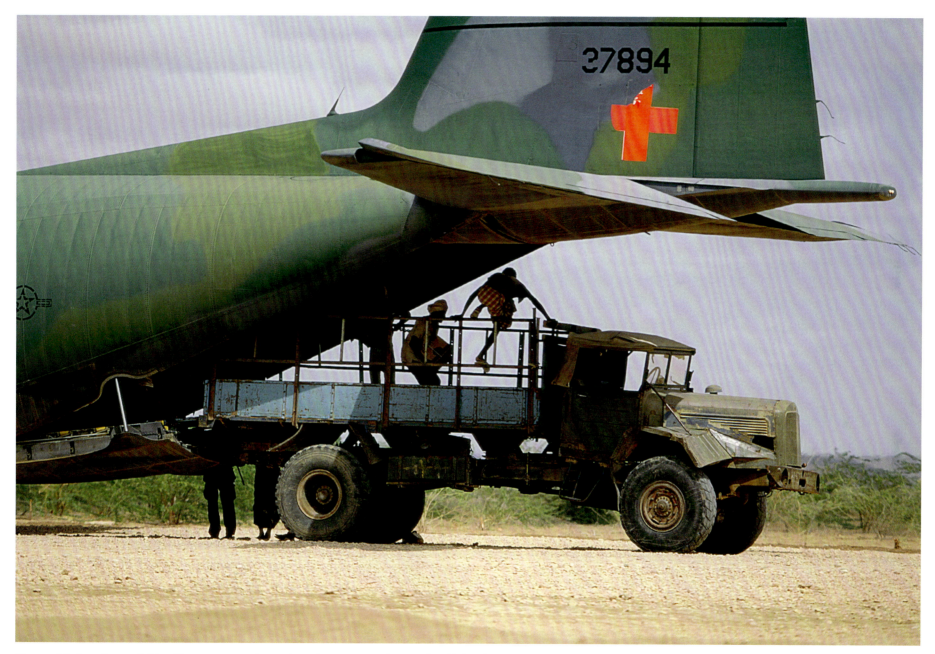

Men rapidly transfer a relief load from a cargo plane whose temporary red cross decal is beginning to peel away and will be removed within months.

I had come in on the first cargo plane of the convoy and would leave on the last. This gave me about five hours to document the situation in town and in the camps of hungry people that had grown around the perimeter. I caught a ride on the back of one of the trucks delivering food aid. The Somali drivers seemed fearless. They roared and honked through the crowded streets, leaving small amounts of relief at various locations. Drivers would be the first targets when trucks were hijacked by bandits.

The sudden influx of food aid that was arriving on the air convoys brought large migrations of starving people to the towns where it was delivered. Encampments of hungry displaced people surrounded the towns. The concentration of food also drew armed gangs from the countryside; when the food ran out the gangs left to prey on other victims. There was a daily pattern to the violence. In the morning men began chewing khat, a stimulant akin to amphetamines. By midafternoon tension rose and random gunfire was heard. In the evening, firefights and looting occurred. There were far more guns and ammunition than food or work.

Large, easily raided warehouses that had been used by aid agencies were now empty as relief workers decentralized storage and rapidly moved food aid directly from air convoys to kitchens and small storage areas around the towns.

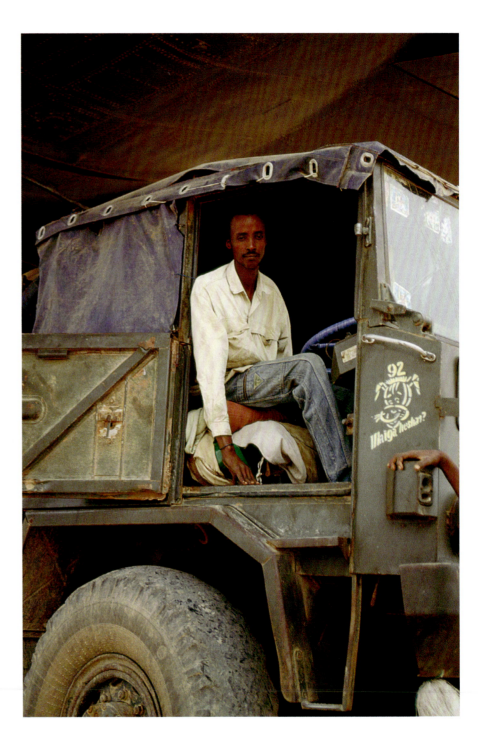

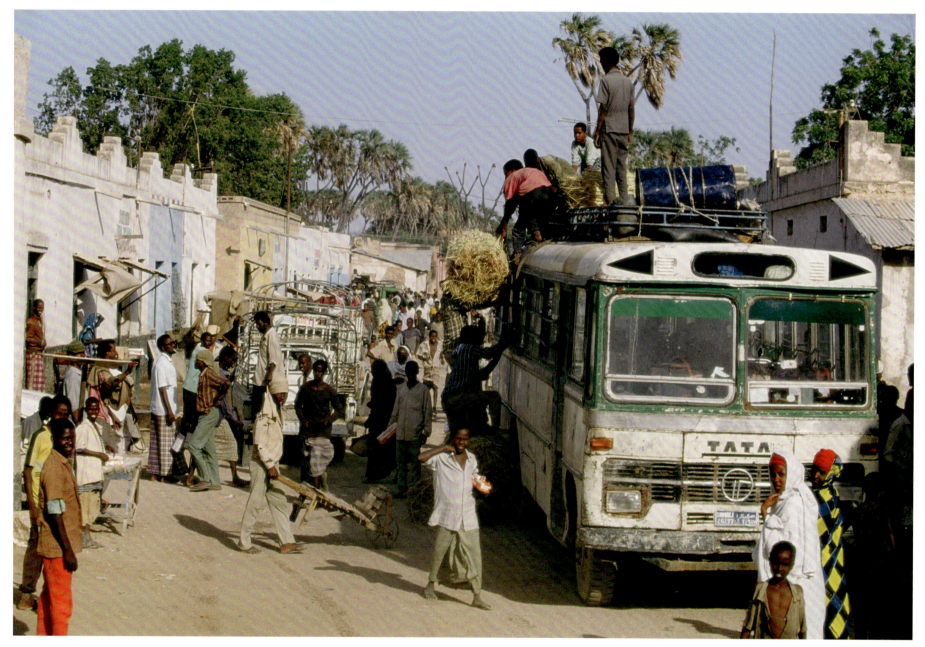

A main street in Beledweyne, Somalia's fourth largest city. September, 1992.

A female truck driver shuttles food aid from planes to distribution points around Beledweyne.

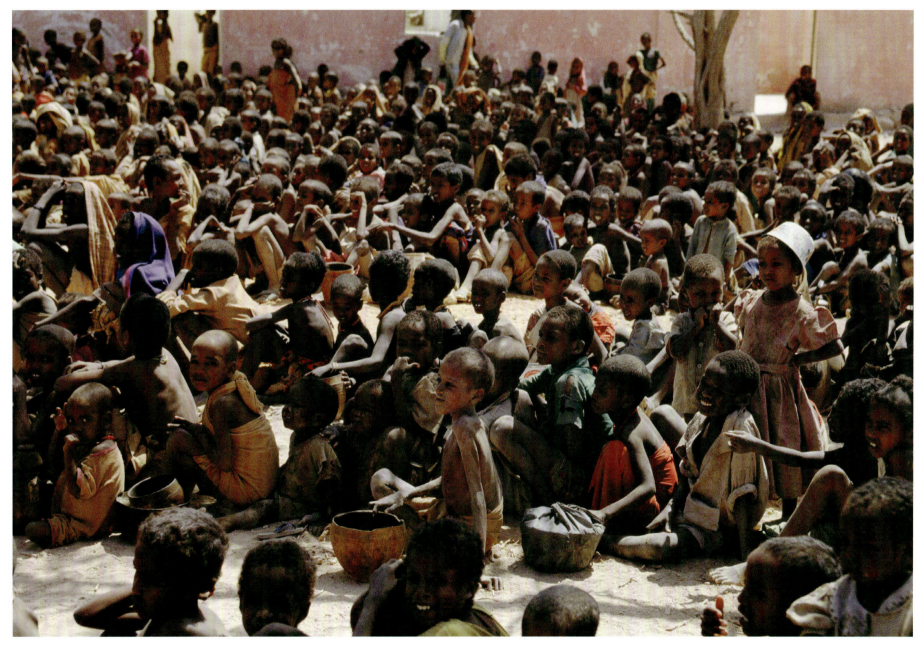

Hungry children wait in the blazing sun for food aid to finish cooking in Beledweyne.

Nothing in my life prepared me for what I witnessed and photographed in Somalia. The depths of privation and acute suffering of children was heart-wrenching. The pall of despair and pain permeated the air, mixed with the heavy smells of unwashed humanity. The constant tension of armed men roving the streets kept the population on edge.

And yet life went on in its myriad ways. Food was boiled in drums. Women and children waited patiently in the blazing hot sun. Waited to eat. Not to satisfy their hunger the way we do multiple times a day, but just to gain enough energy to make it through the day. Many of the children did not have the strength left to sit in line and wait. Some were falling asleep. Others died.

A boy had scratched his stomach raw clawing at hunger pains.

A child looked out of sunken eyes with a glazed look, as if from the beyond, yet he wore a green armband showing his selection in an ICRC intensive feeding program. He was one of the fortunate.

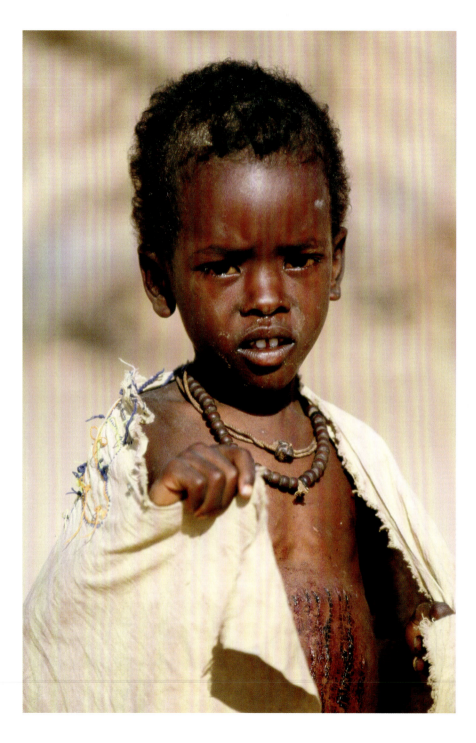

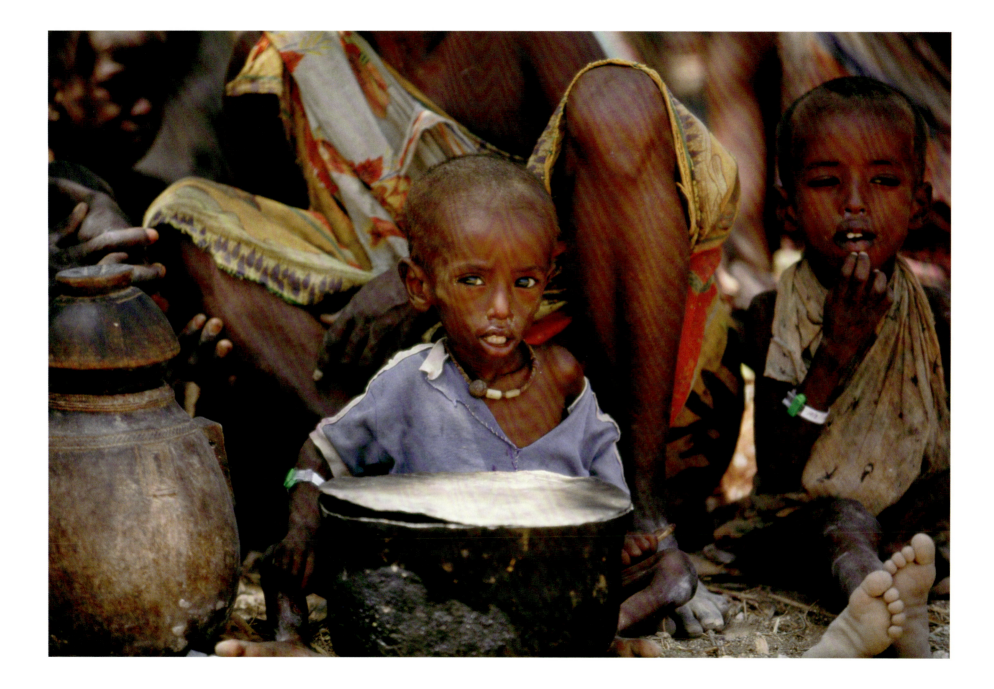

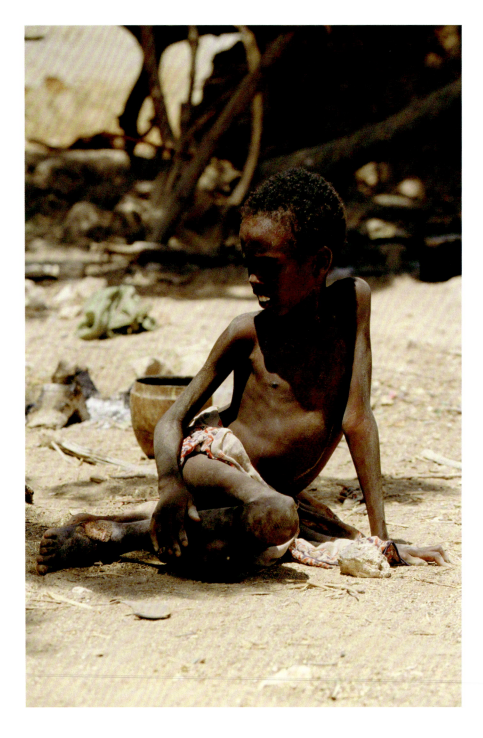

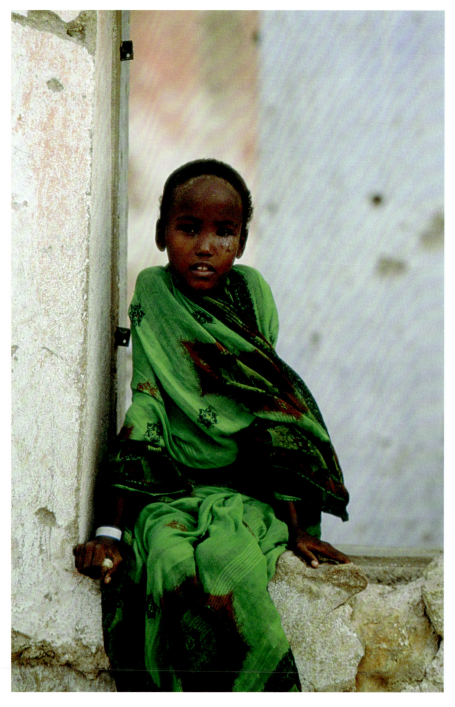

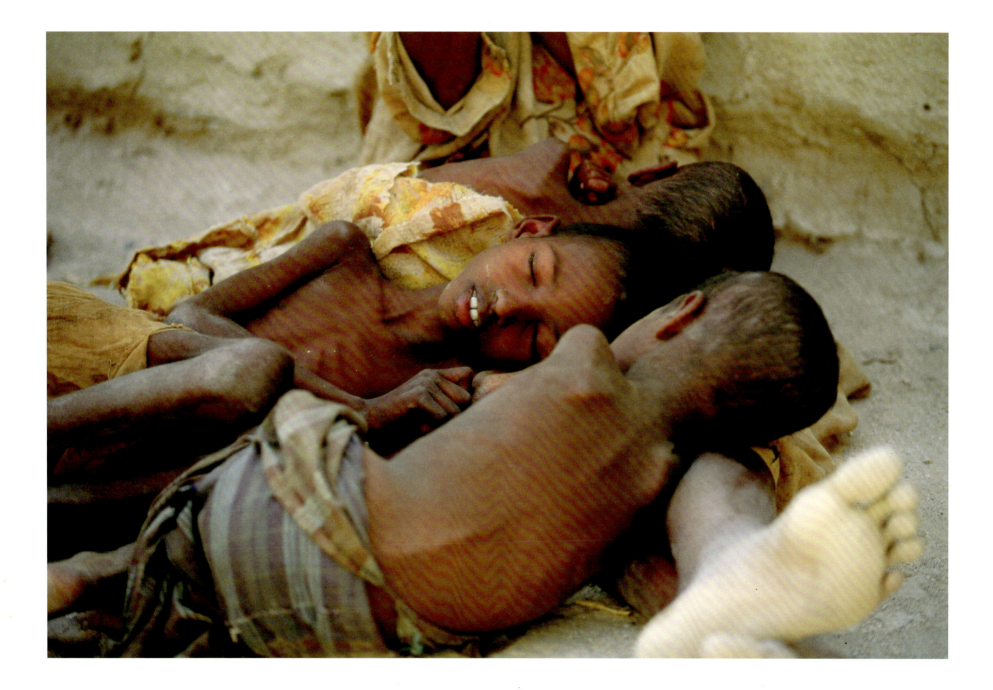

Each day brought a surreal range of highs and lows. I was on a flight in the early morning hours and descending into places of abject poverty, suffering and conflict, then flew back to a four-star hotel on the beach in Mombasa for the night. It became hard to eat the sumptuous food available in Kenya after a day of photographing starvation.

One day I missed the last flight out. Foolishly, I was carrying only enough water to last me until noon. I walked the dusty and searing hot roads and paths around Baidoa. As I began to feel parched my body stopped sweating. When I became dizzy I knew I had to find a drink. I passed a small local well where women were pulling up rust-colored water in an animal skin bucket and made my way to the nearest nongovernmental organization (NGO). I found Irish Concern's small compound and the staff invited me in. They were out of clean water. I sat down in the shade and drank a warm bottle of orange Fanta. I passed out for a while with the immediate hit of sugar. That evening a lone Canadian cargo plane with a load of aid landed. I hitched a ride back on it to Nairobi. Shortly after takeoff the load master came back and with a big grin on his face handed me a quart bottle of water that was frosted with ice. Cold water on a parched throat is the most basic bliss of life.

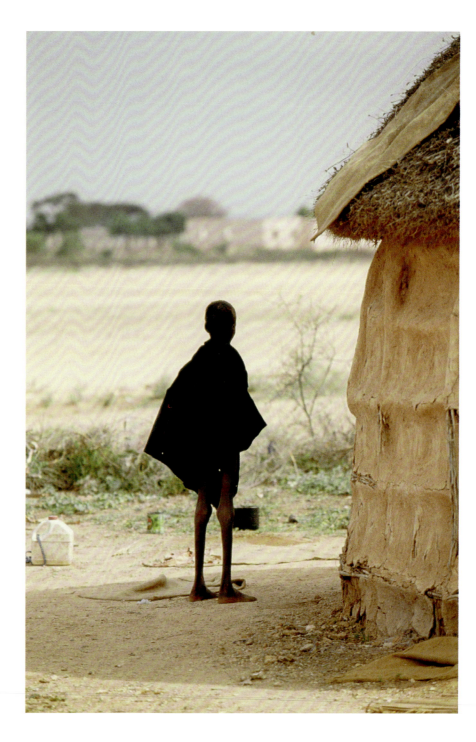

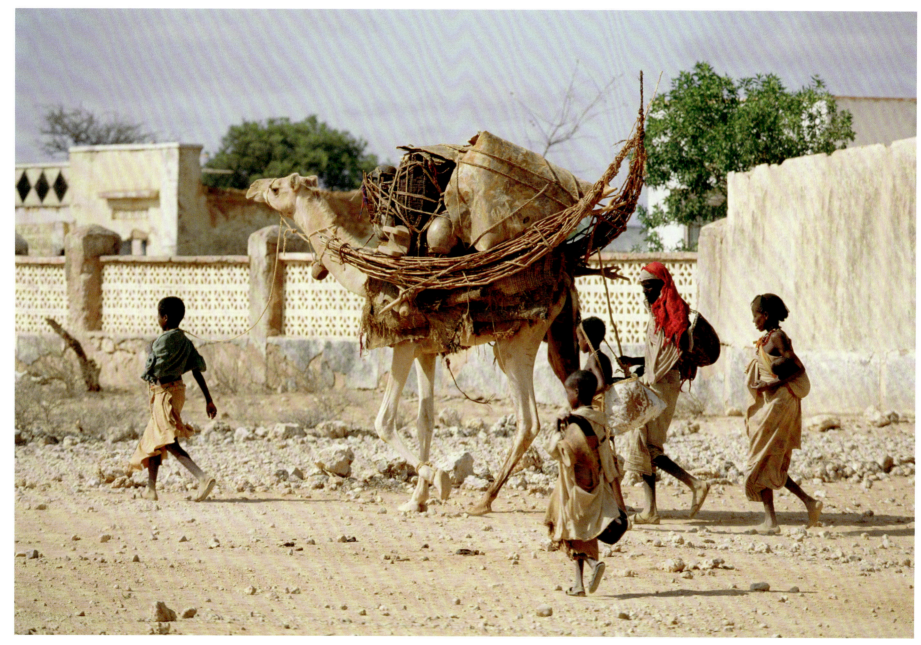

A Somali family walks out of the desert and into the town of Huddur looking for food.

During Operation Provide Relief I met Fred Cuny. He was an exciting and energized humanitarian with a grand vision of how the military and nongovernmental aid agencies could best work together. Fred's combination of experience, engineering perspective, strategic vision and tactical know-how made for a unique humanitarian. I learned more from him in a short time than in all my background research and reading to date.

Fred had prepared a preliminary technical paper for the U.S. National Security Council that outlined an operational concept mirroring what was initially unfolding on the ground in Somalia. He proposed that the United States lead an international force to enter specific areas of the famine zone and establish safe havens in which relief agencies could safely operate. He also proposed a larger exclusion zone that would prohibit armed vehicles. In his plan the duration of the operation in Somalia was to be short term, with turnover to a UN force at the beginning of the rainy season in March 1993. He strongly recommended that United States and allied forces stay out of the city of Mogadishu due to the potential for sniping offered by areas of easy concealment and because of the many escape possibilities.

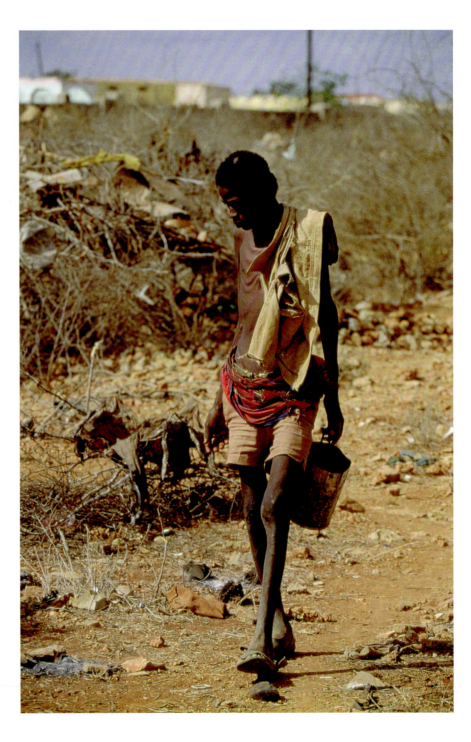

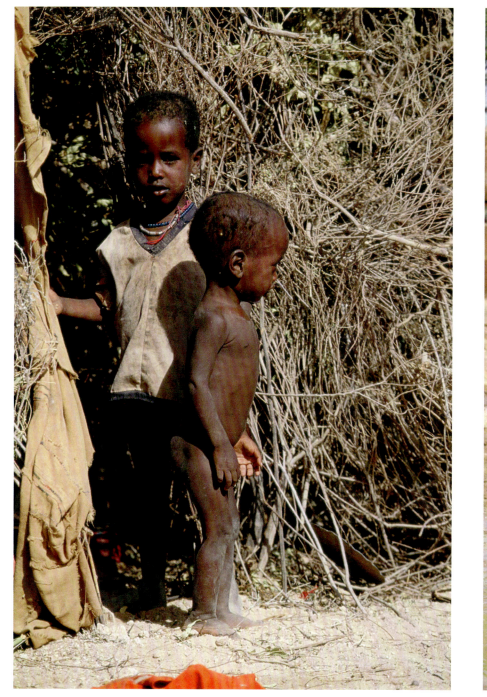

There were moments in Somalia that took my breath away and made my spirit cry out. It is shocking to see a father walk his starving teenage son by the arm, looking for some shade where they can sit on a piece of skin and wait for death or food to come. I was witness to a mother who was unable to feed her skeletal daughter whose only comfort was an empty bag to sit on.

A strange mixture of horror and beauty repeatedly washed over me. I was filled with a deep ache of compassion and existed in a constant state of hyperalertness. Only after putting down my camera for the day and after the adrenaline had worn off did the feelings and memories come rushing in and the tears fell.

While witnessing and photographing what life had brought these people and those helping them, the flame of an unknown duty to respond began burning inside of me. I saw what preserved the dignity of humanity in conflict through the action of those who had come to serve. I could feel and understand the difference humanitarian workers made to the bodies, hearts and souls of those suffering in the midst of abject starvation and the brutality of conflict.

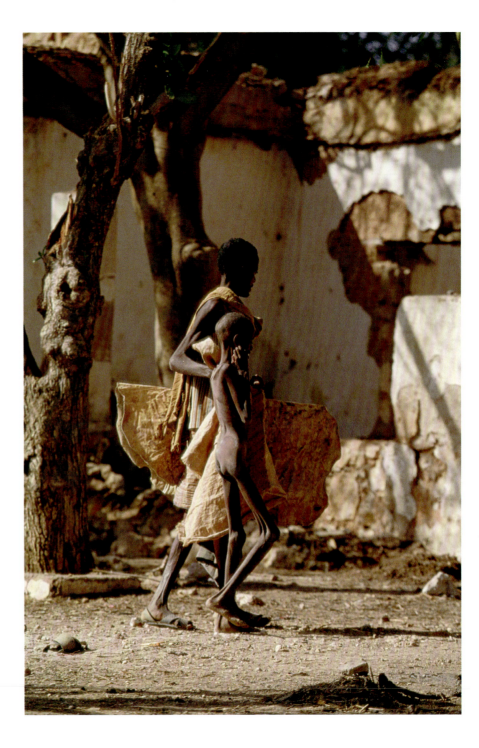

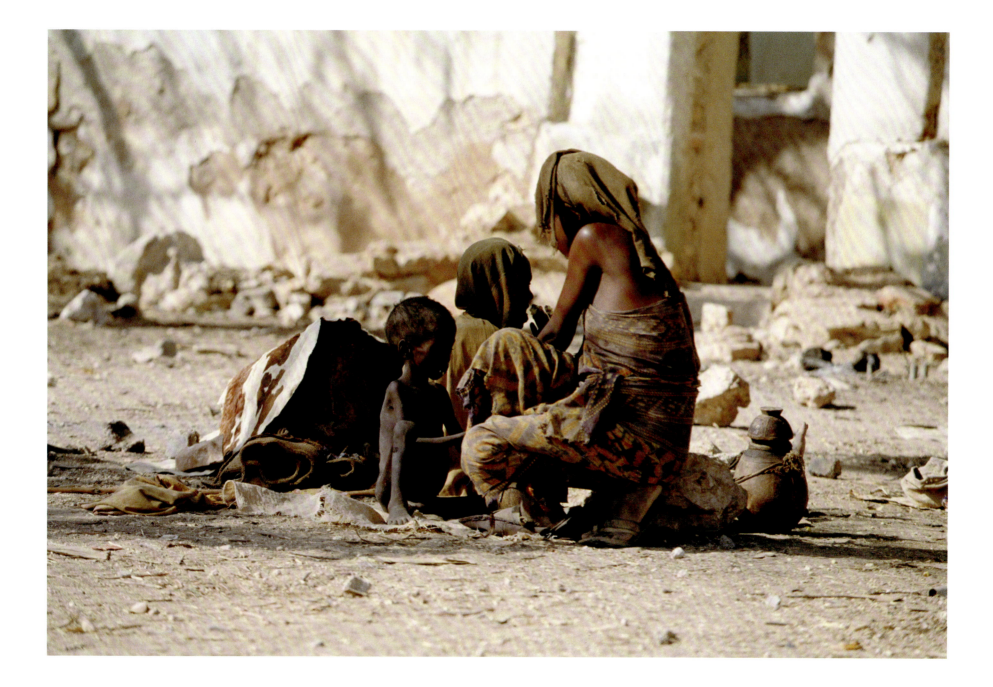

One day I joined a German flight that was headed to Mogadishu West, a small airstrip outside of the city. After a three-hour flight the plane landed, shut off the engines, dropped the tail ramp and began unloading the relief supplies. The runway was ringed with local "technicals," trucks with large caliber machine guns mounted in the bed. Each truck had twenty serious looking guys bristling with weapons. I wandered the runway taking pictures of fighters on their trucks believing they were acting macho, until I heard gunshots ring out nearby. Two overloaded small planes had wobbled in on rough landings minutes before. The planes flew in from Ethiopia carrying cargoes of khat, which was in wild demand by the men in Mogadishu.

Suddenly I was caught in the crossfire of a fight that broke out on the runway over both the khat and the food aid. I quickly moved to the plane and photographed out the windows until takeoff. When I returned to Mombasa airfield I was greeted by a U.S. military intelligence officer. He asked what it was like at Mogadishu West. When I described the situation he grew increasingly interested and asked if he could process my film for me, saying that he would make dupes and return my originals soon. I gave him about six rolls of film and never saw them again. After this experience I never wandered into a potential firefight to photograph men with guns again, or gave my film over to anyone except the lab on returning from the field. I've always wondered what was on those rolls of film, yet find myself more grateful for the lessons learned than for any photographs.

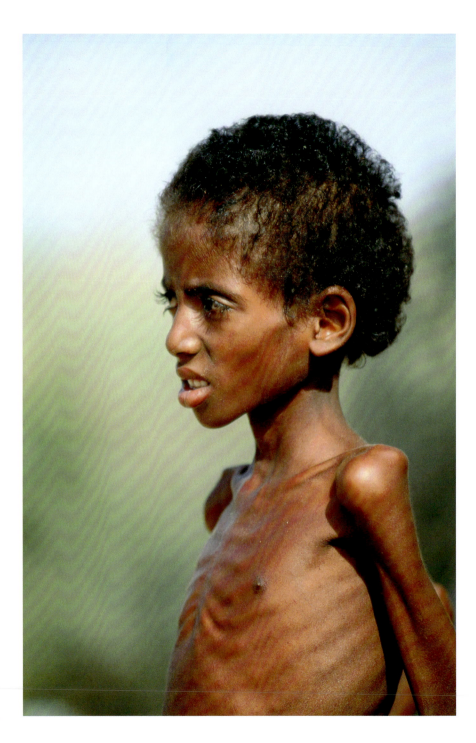

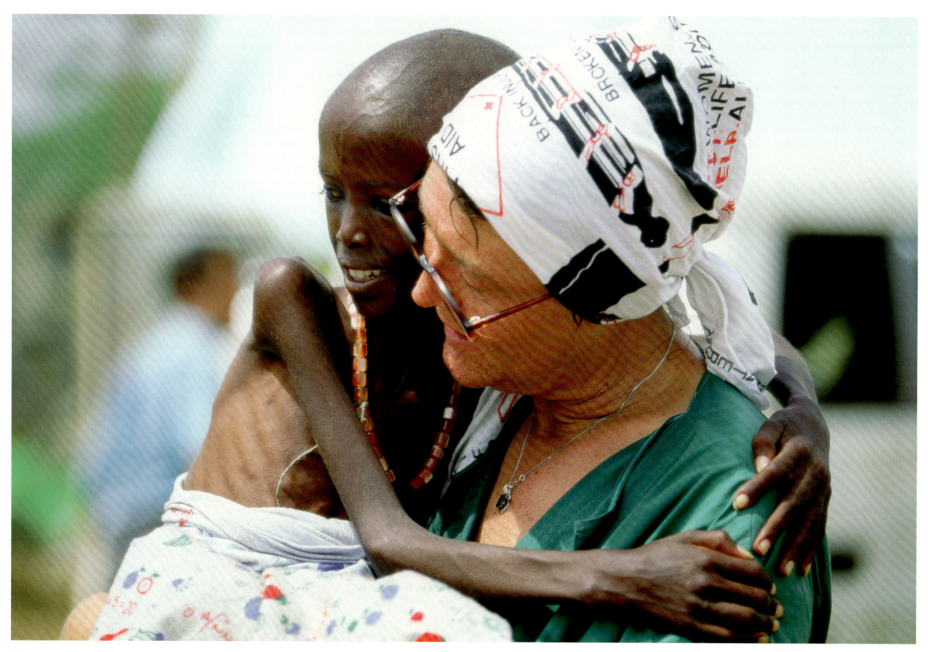

Human touch crosses the boundaries of suffering as an ICRC nurse comforts a child. She had been up all night in the surgery ward helping save the wounded.

On a second trip to Somalia in December of 1992 I spent a few days traveling with Mrs. Elizabeth Dole, then president of the American Red Cross. We flew one morning from Mogadishu to Bardera in a small Red Cross plane and landed on a muddy strip. The pilot told us we had only a couple of hours, concerned that the plane would become stuck in the mud as the day warmed up. We drove a few miles down a wet road to the ICRC camp outside of town; only days before the first American casualty of the war had occurred on this stretch of road. The driver was nervous, which made us nervous. Larry Freedman was killed when the vehicle he was driving in Bardera, Somalia, struck an antitank mine. Three State Department security personnel who were with him were injured and helicoptered, with Freedman's body, to the USS *Tripoli*.

I cringed each time we skirted a pool of water in the road, imagining the flash and bang of a land mine exploding. Especially after someone casually mentioned how some mines, being made of plastic, wash out of the ground and float around during heavy rains. In the years to come I spent many days photographing the work of de-miners and land mine victims in Cambodia, Bosnia and Angola. I've been lucky to have teachers early on who retrained my instinct to walk away from the road for a better photograph. And I no longer walked where there were no footprints or recent tire marks.

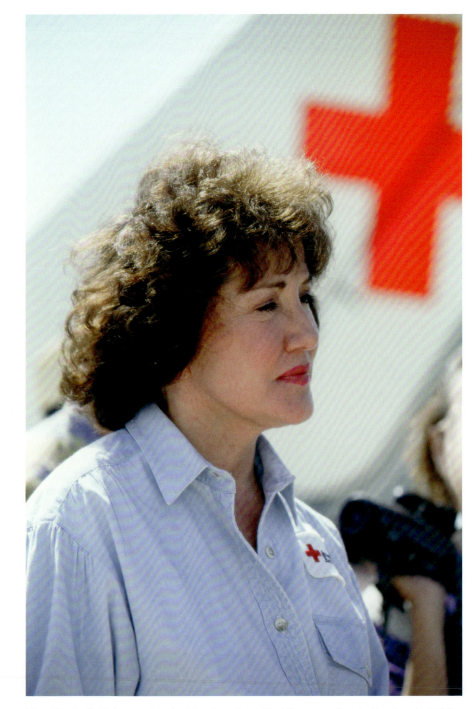

Mrs. Elizabeth Dole, president of the American Red Cross, arrives in Bardera in 1992.

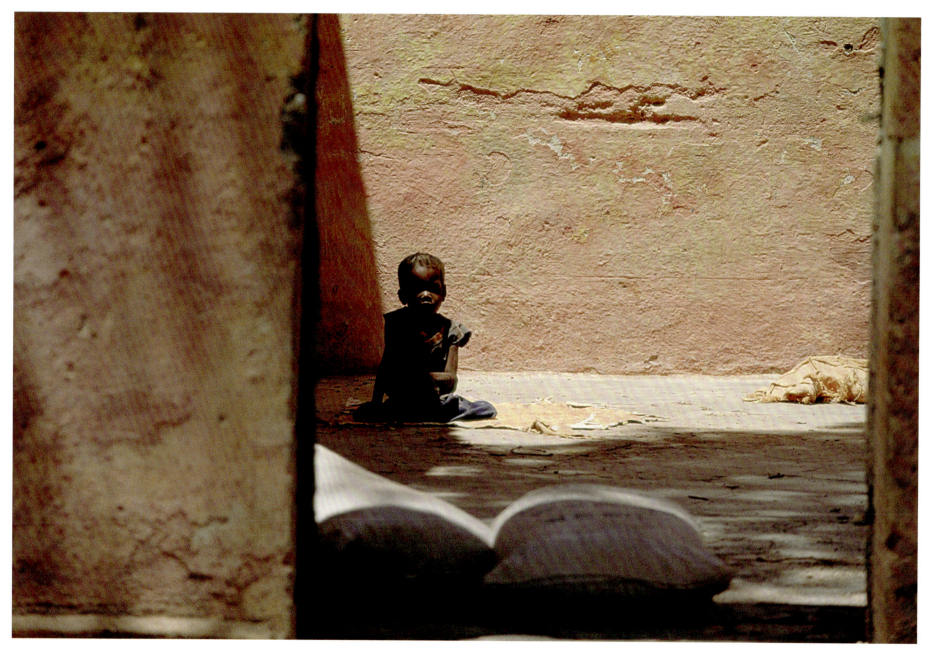

A young girl sitting on an animal skin waits in the shade for food to be prepared at a displaced persons camp in Huddur.

On arrival at the ICRC field hospital we were greeted by an exhausted team of doctors and nurses. They had worked all night tending to the wounds of a number of people who were shot the evening before. A gang of roving armed bandits had entered the camp and demanded relief supplies. When they found out there were no relief supplies stockpiled they began shooting people randomly and left with bravado. One person died immediately. Eight others were wounded and were operated on and treated throughout the night.

I could see that Mrs. Dole was deeply moved by the degree of suffering in Bardera. She wanted to know the facts of the situation and the challenges being faced by the delegates. While she inquired about the overall needs and what might be done to satisfy them, most of her time was spent making contact with individual Somali people, one at a time. Despite the painful situation, her energy and enthusiasm were unwavering. After these hours in Bardera I traveled with her to meetings with the military commanders of the United States and the UN, met with the Somali Red Crescent officials and visited hospitals, clinics and camps of displaced people. All the while, Mrs. Dole read reports and was constantly briefed by her staff on the details of the situation on the ground. I was privileged to photograph this dedicated woman with a big heart and great compassion for the individual Somalis she went out of her way to connect with.

It is a natural tendency, when exposed to the suffering of so many, to want to make a difference for one individual. During my first week in Somalia I learned how singling out someone with special treatment can have unintended consequences.

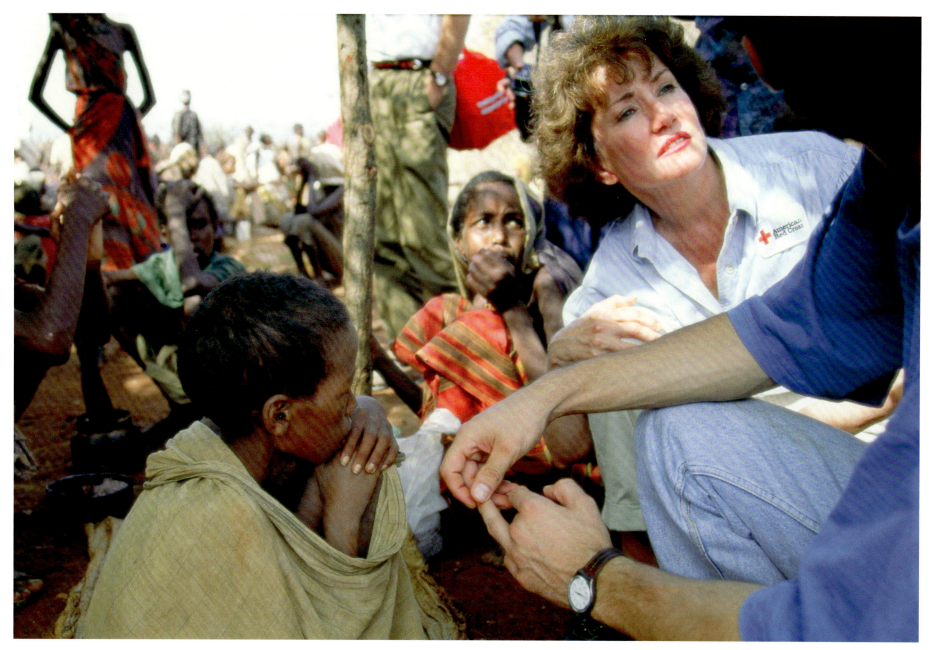

Mrs. Elizabeth Dole discusses how to help a starving boy in a displaced persons camp outside Baidoa.

One afternoon, as I was about to get on the last plane back to Mombasa, a boy who had been following me around all day tugged on my shirt and looked at me with such pleading eyes that I opened my knapsack and gave him a ready-to-eat meal pouch. I watched as he ran off with the pouch and then looked on in horror as he was swarmed by a group of boys. They kicked and punched him, took away the pouch, tore it open and fought like sharks over the contents. In less than a minute they had run off, leaving the boy to limp away. I learned that helping one person leads to more suffering, not less, when done inappropriately.

Even now looking at these images I remember the smells, the feelings, the textures of the moment. There is no returning to the way I saw and felt the world before going to Somalia. I was under the spell of humanitarian action. The work of the ICRC delegates and the insights they imparted in brief interactions inspired me. The narcotic mix of inspiration and intense clarity that comes through working in a heightened state of awareness—being on constant high alert—was addictive.

Because I had to buffer myself to prevent becoming overwhelmed, it's only in the remembering that the real depth of feeling from these experiences has come to me. I have found that there are few people I can talk to about my experiences. Only people who have had similar experience understand. The full range of feelings and the need to discuss the experiences had to be repressed in order to interact with others.

On returning to Washington, D.C., I sent a selection of photographs to the ICRC headquarters in Geneva with a letter of thanks for the work that they do. A few months later I got a call from Pierre Gassman at ICRC headquarters asking if I would like to photograph for them in Nagorno-Karabakh. I accepted on the spot, then asked where in the world that was! He explained that Nagorno-Karabakh is a landlocked mountainous region between Azerbaijan and Armenia, where heavy fighting was winding down.

One mission led to another. One region of conflict also led to another, and in January of 1995 I found myself in Chechnya with the war heating up. The ICRC put together an initial team to respond. They surveyed the situation on the ground, delivered emergency relief and prepared for the larger wave of support that followed. Shortly after my return to Washington, D.C., I met with Fred Cuny, who was about to begin a project there. We talked about the situation in Chechnya and I warned him to be very careful. I never saw him again. Fred's family called off the search five months after he disappeared in Chechnya. They publicly accused Chechens of having murdered him and also blamed Russians for having circulated propaganda about him. He was a great soul who is dearly missed by many.

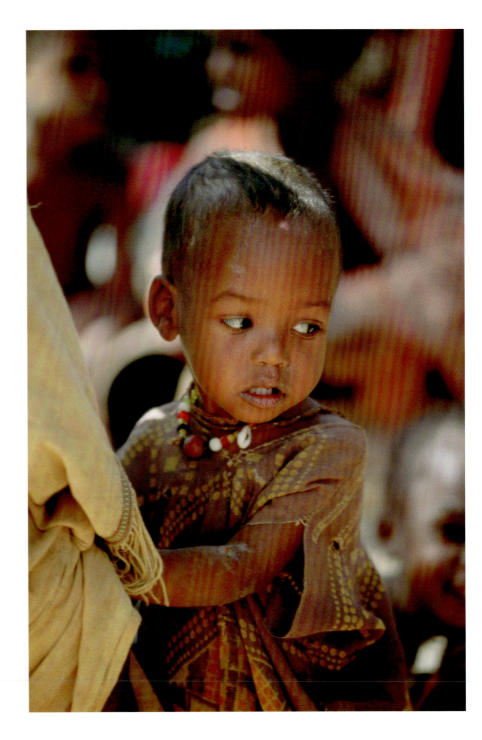

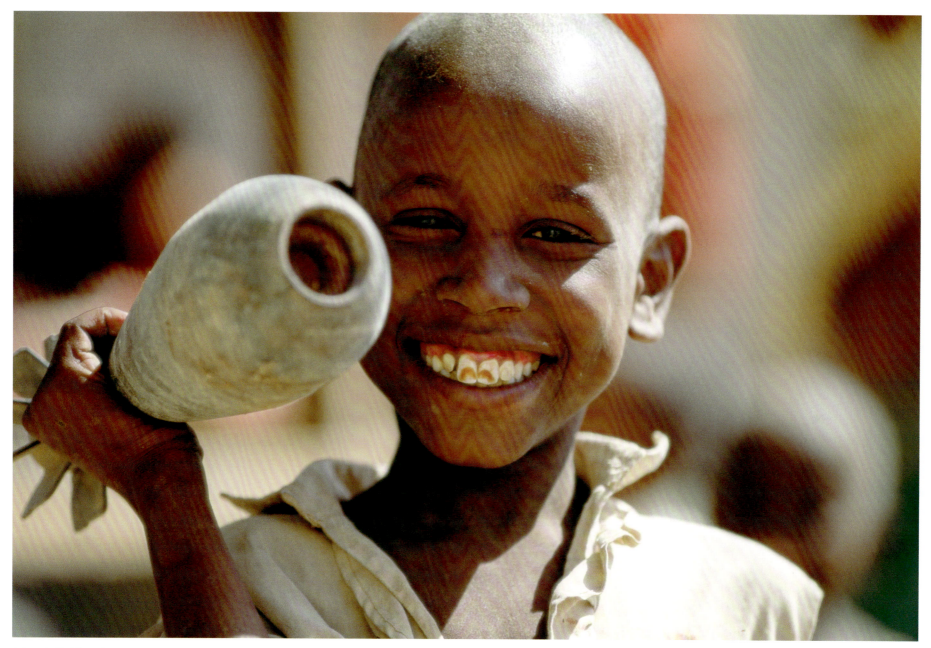

A boy in Baidoa plays with a rocket-propelled grenade that has had the detonator removed.

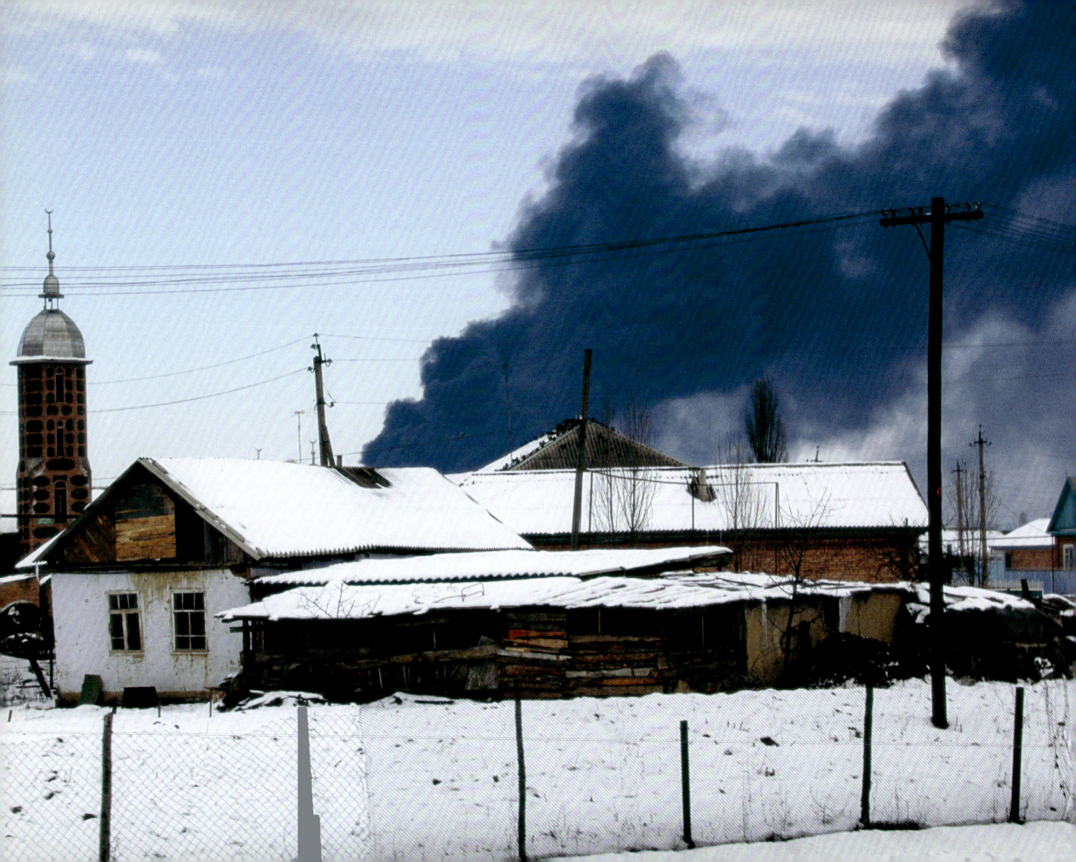

Rapid Response

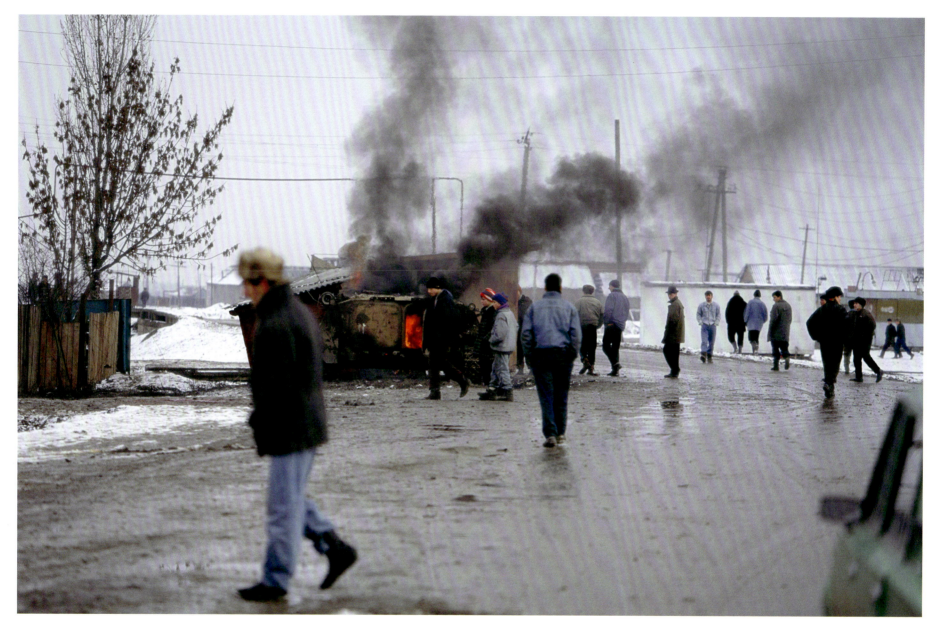

A Russian armored personnel carrier burns on the outskirts of Samashki, Chechnya, in January 1995.
Left: A fuel refinery outside Grozny has been bombed and is burning with a thick black cloud of smoke.

Artillery shells thumped in the distance. The explosions were felt in the body as well as heard by the ears. Blasts came in a regular and continual pattern. Grozny was being pounded by Russian artillery shells lobbed from the hills and by fighter jets dropping bombs. It was early January of 1995 and the ICRC was rapidly assessing the situation on the ground. On this day we began at a hospital in Stari Atagi about ten miles south of Grozny, the capital of Chechnya. A busload of wounded civilians and fighters from Grozny arrived while we were there. There were all kinds of war wounds; the worst were from bombs that contained nails. It took the surgeons hours to carefully remove these nails and bits of shrapnel.

The hospital was sorely understaffed and in great need of medical supplies. The ICRC delegates talked with the doctors about their needs, observed the surgical techniques being used, the kinds of wounds, and supervised the unloading of a truckload of medical supplies brought with us.

Russian fighter jets circled low over the hospital on bombing runs into Grozny. Everything shook as they roared overhead. I wondered how long it would be before this hospital was bombed. A fierce battle was raging in the area around the presidential palace and caused many casualties. Thousands of civilians were huddled in basements as the shelling and fighting continued day and night. They only went outside during brief lulls in the fighting to look for water and food in their destroyed landscape.

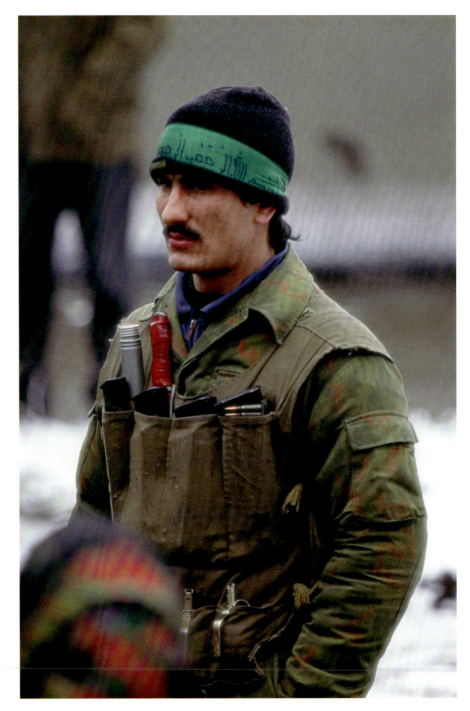

The green headband identifies this mujahideen fighter near Grozny.

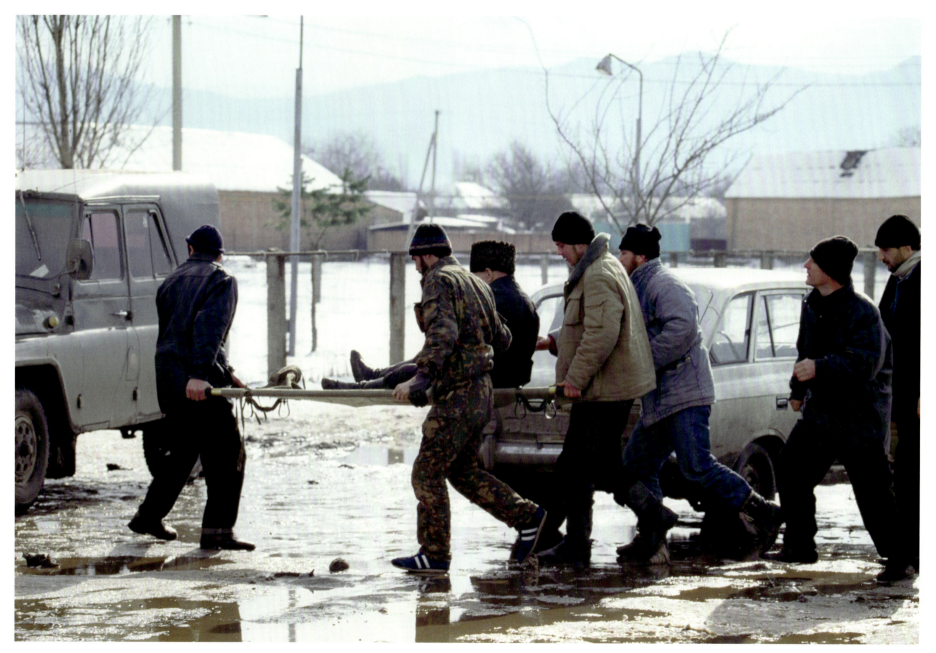

Men rush a wounded elder on a stretcher into the hospital in Stari Atagi.

The situation on the ground was chaotic. Bridges blown up overnight caused us to alter our normal routes between towns and villages. The small team of ICRC delegates working in Chechnya communicated and coordinated with military field commanders on both sides of the conflict before acting. It required a continual process of tracking a tumultuous and unstable situation to remain safe and to get to the places where people were in need.

We worked out of a temporary headquarters in Nazran, Ingushetia, about ten miles west of the border with Chechnya. Early each morning, after a team meeting, the delegates headed out with their interpreters in groups of two Land Cruisers; for safety no one went into the field alone. Some delegates worked on the Russian side, some inside Chechnya, assessing needs, building contacts and relationships and coordinating initial relief distributions of medical supplies and food.

Every day we crossed the front line outside the town of Samashki. Russian troops had closed the main road and were using it as a staging ground for helicopters, tanks, antipersonnel carriers and other military equipment. We drove over the open plains on a narrow road that paralleled the closed main thoroughfare. Attack helicopters, like giant insects, flew back and forth above us as we drove down the road. I felt safer with the large red cross painted on the vehicle roof and the flag flying behind us. As we passed through the Russian checkpoint the delegates inquired about the situation on the ground. Their constant inquiry, of soldiers and citizens alike, continued throughout the day. The only way to know the changing situation was to talk with people. This is how we stayed safe in a war zone.

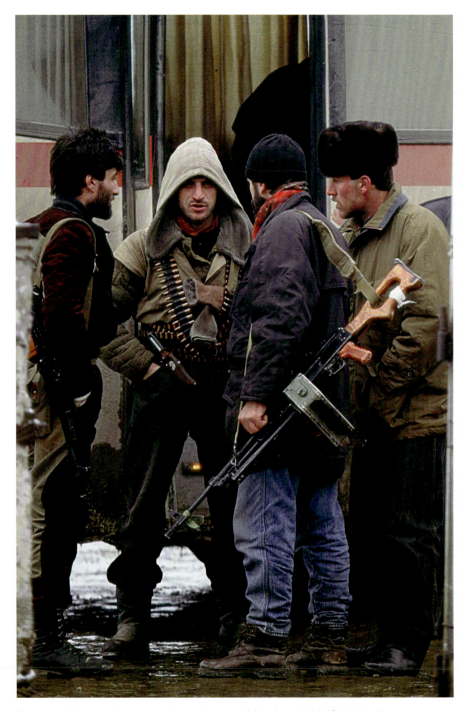

Chechen fighters talk among themselves outside a hospital in Stari Atagi.

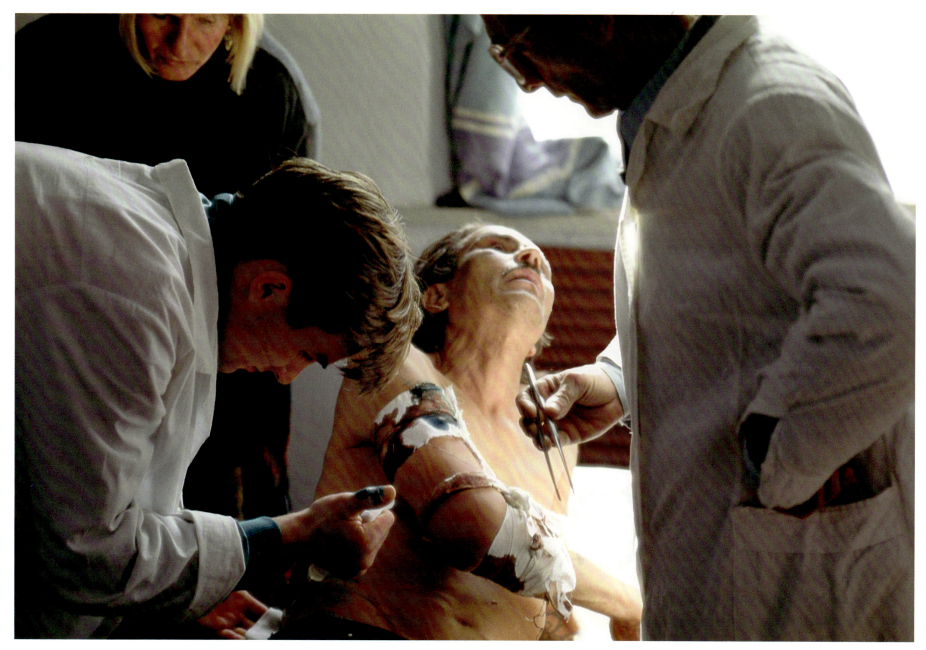

A wounded civilian has pieces of shrapnel removed from his body while an ICRC nurse observes the doctor's technique.

Located on the front line, just inside Chechnya, the town of Samashki was a tense place, and the delegates discussed locations in town they might retreat to if caught there in the fighting.

The needs of people around Chechnya were immense. Roads were closed. It was dangerous to move about. Food was getting scarce. The few hospitals that were operating were overwhelmed. It took many days of travel and meetings, discussions and assessments in the villages and towns to set up local contacts and to understand the scope of need. The delegates and their interpreters worked with little rest as they were energized by a sense of urgency. There was no time clock in the war zone and real sleep was rare. In the evenings, back at the delegation in Ingushetia, there was a short respite before the nonstop activities and an adrenaline-filled next day.

Relief convoys were sent from around Europe to meet the needs that had been determined by this team. All the delegates working here were seasoned professionals and had been in conflict before. They knew that security was of utmost importance and each day required careful calculation. The decisions and judgment calls made by the delegates were all based on a combination of gut instincts from their previous experience in conflict and the observance of strict rules that created a shared code of conduct.

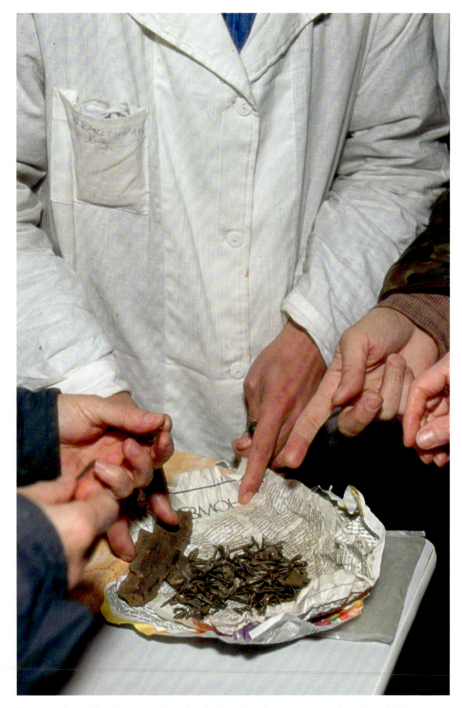

Doctors show bits of shrapnel and nails that they have removed from bomb blast victims to an ICRC nurse in the hospital of Stari Atagi.

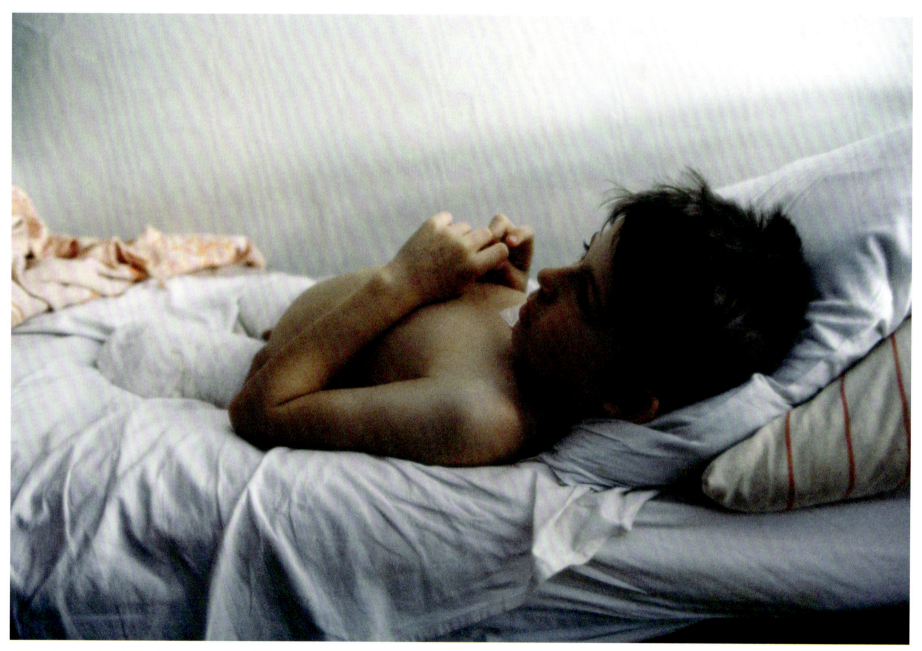

A young boy who has lost both his legs to a bomb blast lies in a hospital bed in Urus-Martin.

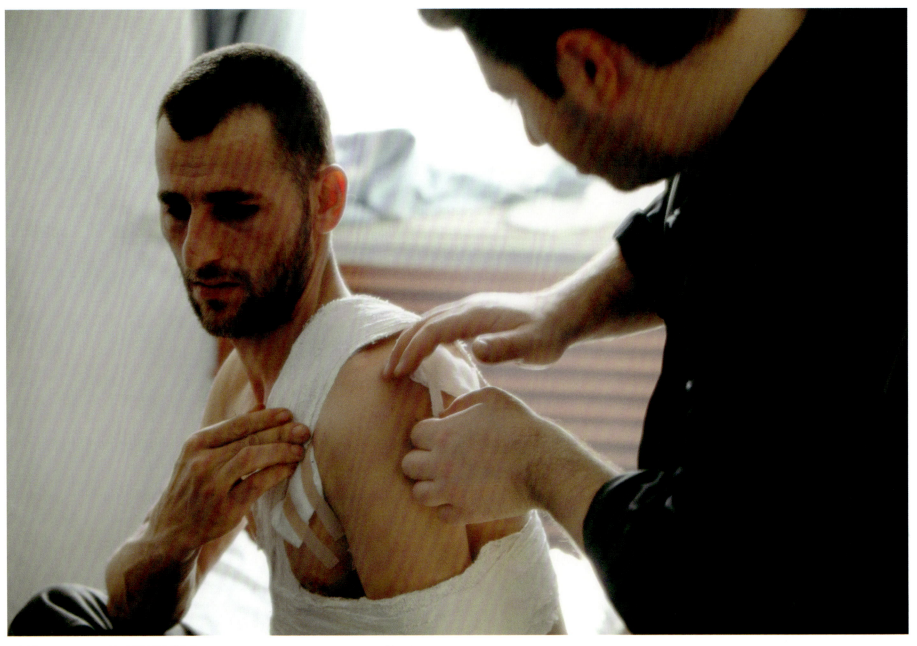

A local doctor dresses a wound after removing shrapnel at a small clinic in Chechnya.

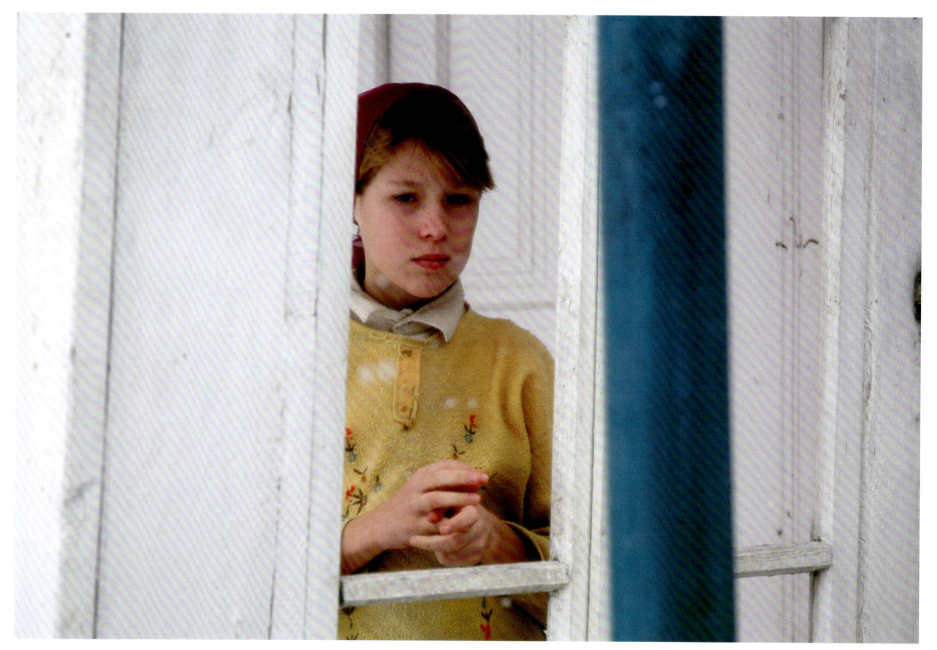

A girl nervously watches her mother read a Red Cross message from a family member in Chechnya.

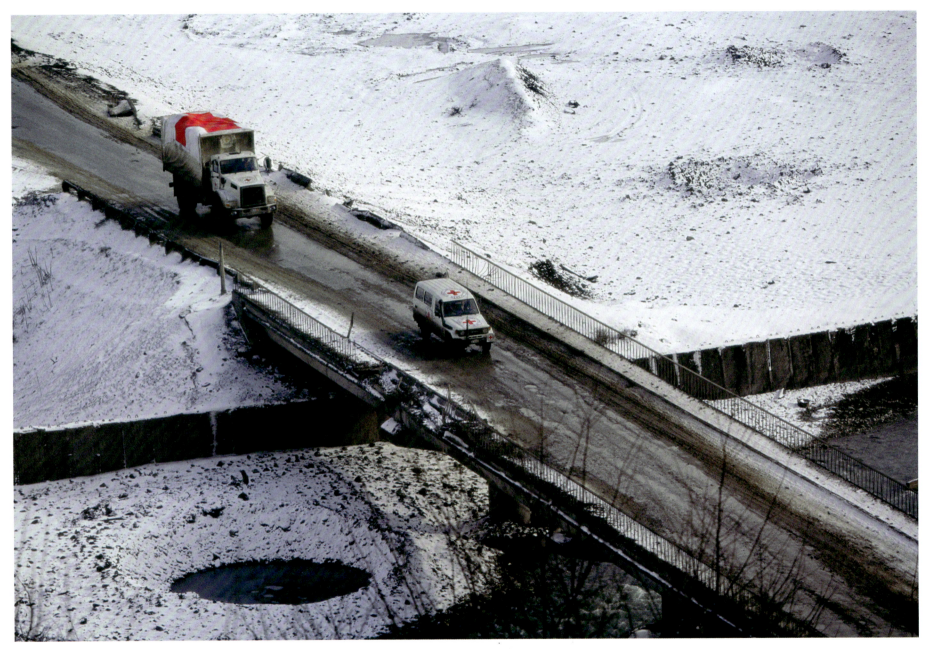

An ICRC Land Cruiser and truck of medical supplies cross a bridge that was recently damaged by an aerial bombardment.

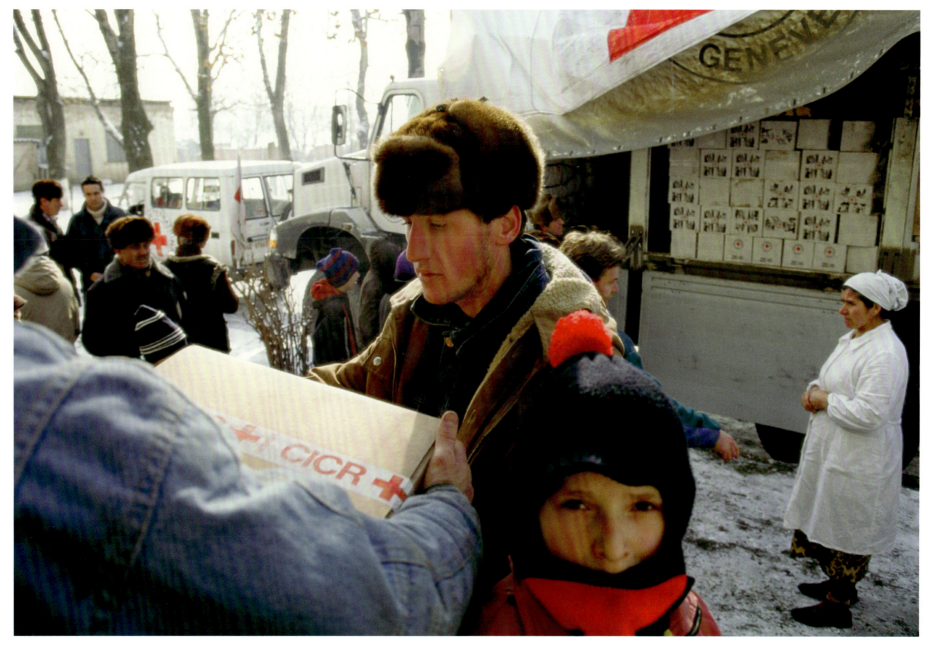

An ICRC convoy of medical supplies and food aid is unloaded at the hospital in Shatoy.

In the initial stages of the conflict many people did not understand the role of the ICRC. Quickly communicating why they were involved was important to explain to the locals. Establishing rules and having these rules clearly understood by the combatants makes the work of the ICRC possible. Communities in a conflict needed to learn that: the ICRC never takes or makes bribes, they deliver relief aid to all who need it, they don't take sides in a conflict, weapons are forbidden in ICRC vehicles and there are international laws and mandates that dictate their work. People could then see and experience the ICRC upholding these basic principles and rules, and with this confirmation came their support and mutual protection.

Bags of bandages have printed illustrations with the ICRC mandate and basic first aid instructions were handed out to fighters at checkpoints. Graphic pamphlets printed in the local language were given out to village elders as well as the general population as an overview of the ICRC mandate and activities. Each box of food aid that was distributed had pictures of the rules of war and the role of the ICRC printed on the outside. Each conversation became an opportunity to explain their mission.

Despite the difficulties, there was a method to the way that ICRC did its work. Once people understood the ICRC activities and processes, they began to feel some relief from these desperate conditions.

A village elder with an ICRC pamphlet in Shatoy.

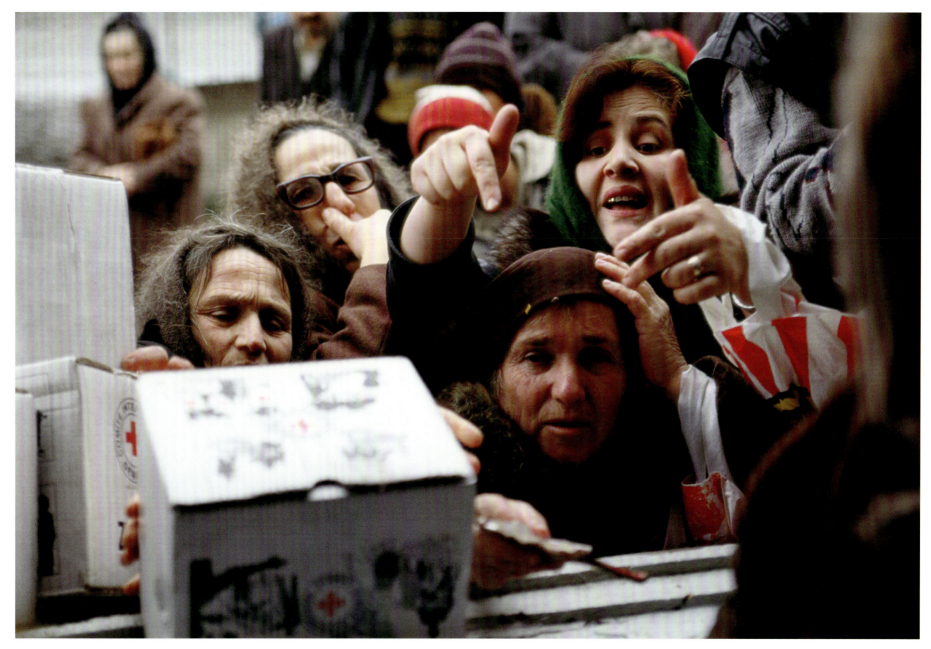

Women receive ICRC food parcels that have the rules of war illustrated on the sides at an aid distribution center in Stari Atagi.

Hospitality and generosity seemed a basic way of Chechen life. Many times I was invited into homes where meager supplies were graciously offered to me as a guest. There was no time for much deep interaction, but each conversation was an open-hearted exchange. At the roadside stands where we stopped for shashlik (the delicious Chechen barbecue that became our daily fare) we were often not allowed to pay.

Inside Chechnya at a food distribution center one morning, we got an urgent call on the radio about a meeting we were asked to attend. The location could not be given out over the radio, so we were instructed to drive to a village and meet with the official who was coordinating the gathering. The location changed a couple of times and eventually we found ourselves far out on an open plain in an old barn that was large enough for multiple vehicles to drive into. It turned out that the meeting was with President Dzhokar Dudayev. I was not allowed to take any photographs and vehicles and people were carefully checked to make sure phones and radios were off. The Russian military was hunting President Dudayev and if they had known who was at the meeting it would have been easy to send a helicopter to rocket the barn.

Another afternoon during a medical relief distribution at a hospital, a group of Chechen fighters dressed in white snow camouflage arrived. The field commander, Shamil Basayev, had come to coordinate with the ICRC. Confidential meetings with authorities and military commanders on all sides were crucial for the ICRC to carry out its work in the conflict zone. No judgments were made, no sides were taken, and it was clear we all sided with those who were suffering and in need of help.

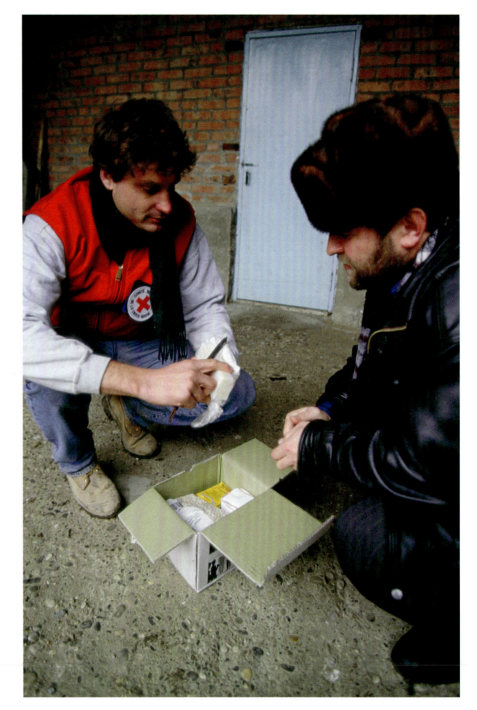

A delegate shows the contents of an ICRC food parcel in Shali.

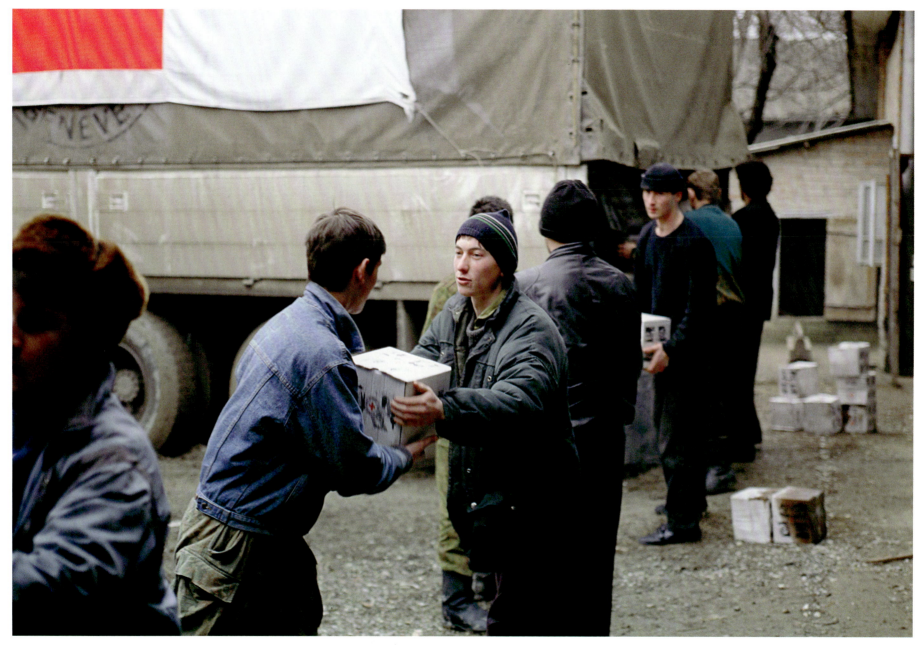

Young men help empty an ICRC relief truck by forming a human chain in Shali.

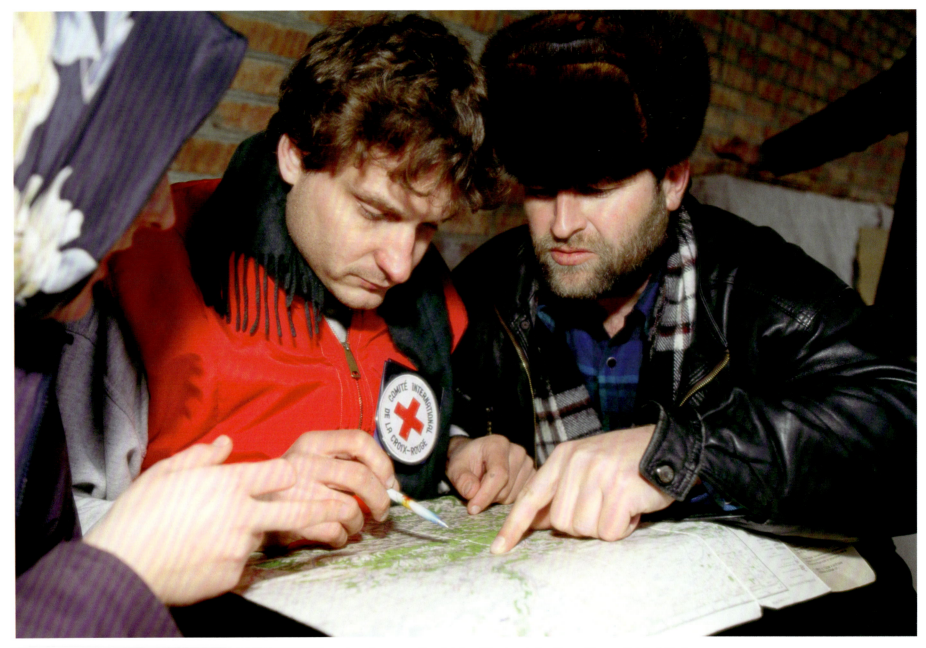

An ICRC delegate reviews a map and, with the help of his interpreter, discusses the details of the local situation with an official of Shali.

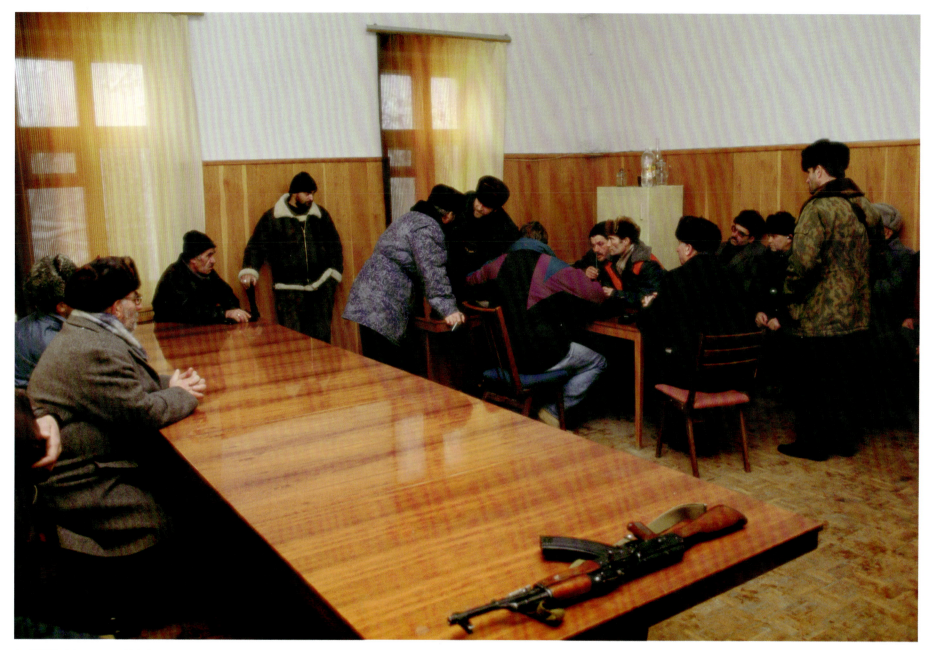

An ICRC delegate and his interpreter speak with a group of local leaders about current conditions on the ground in Shali.

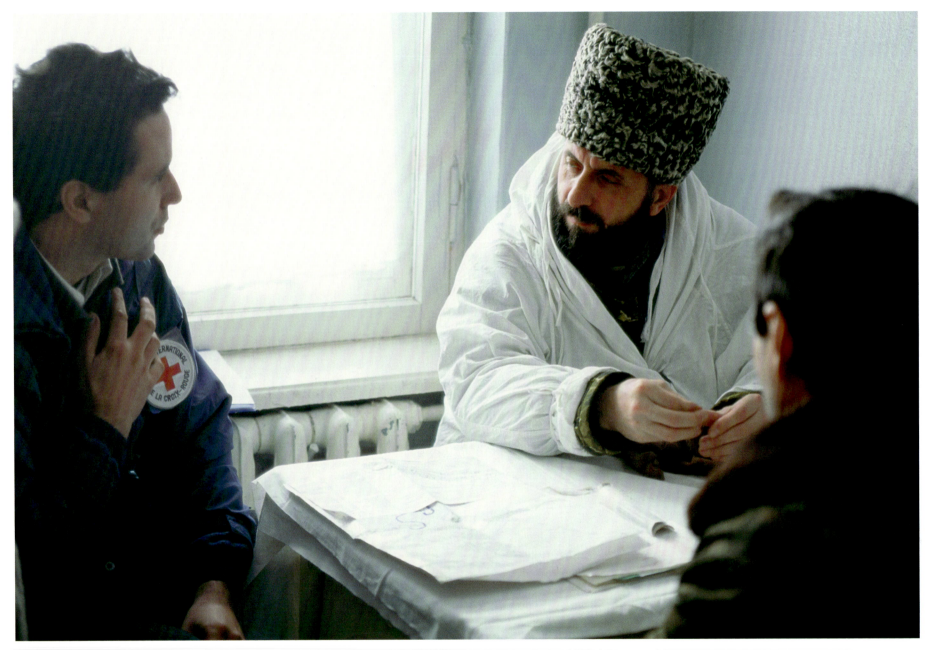

A delegate talks with Chechen front-line commander Shamil Basayev about the unfolding situation in January 1995.

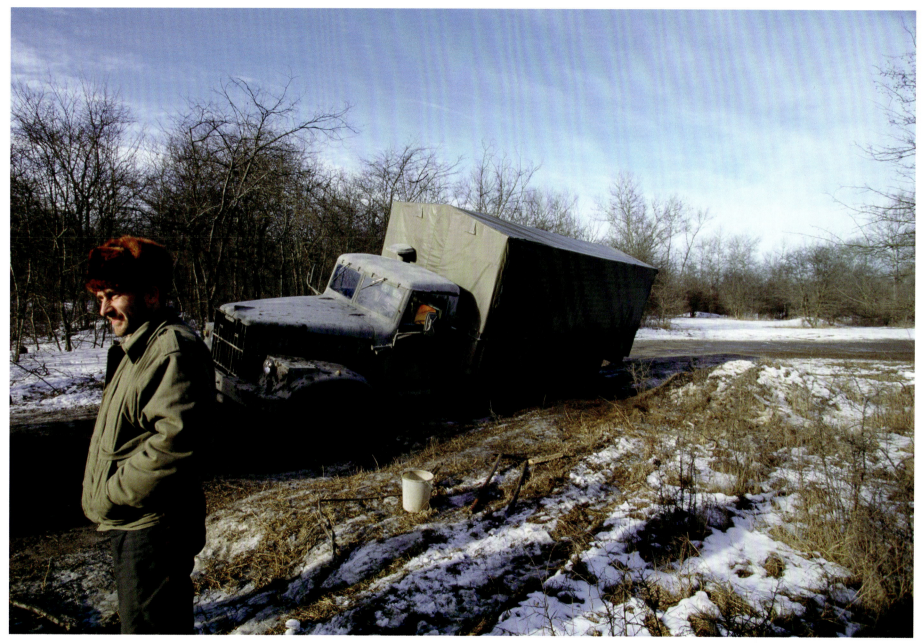

A civilian truck gets stuck in the mud trying to go around a blown-up bridge.

Fighting in the city of Grozny was intense. There were thousands of refugees. Some of them had fled the constant shelling and left for nearby Ingushetia. A train parked on a side rail in Nazran became home to many families escaping the conflict. In early January there was an air of a campout, an adventure, especially among the children and teenagers. But by late January it had transformed into boredom, anger and depression as the end of the conflict and the eventual return home seemed further away.

One frigid morning I joined an ICRC team visiting a temporary prison in Shali. One of the fundamental activities of the ICRC, mandated by the Geneva Conventions, is visiting and registering of prisoners of war in their places of detention. We would visit about fifty Russian paratroopers who were captured behind the lines in Chechnya.

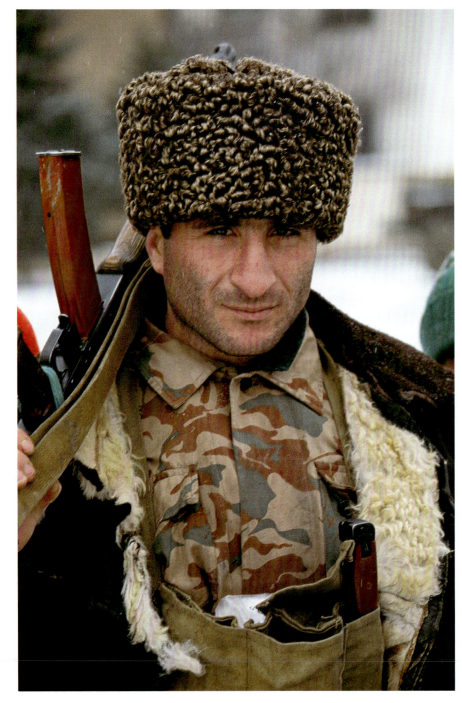

A Chechen fighter about to get on a truck and join the battle.

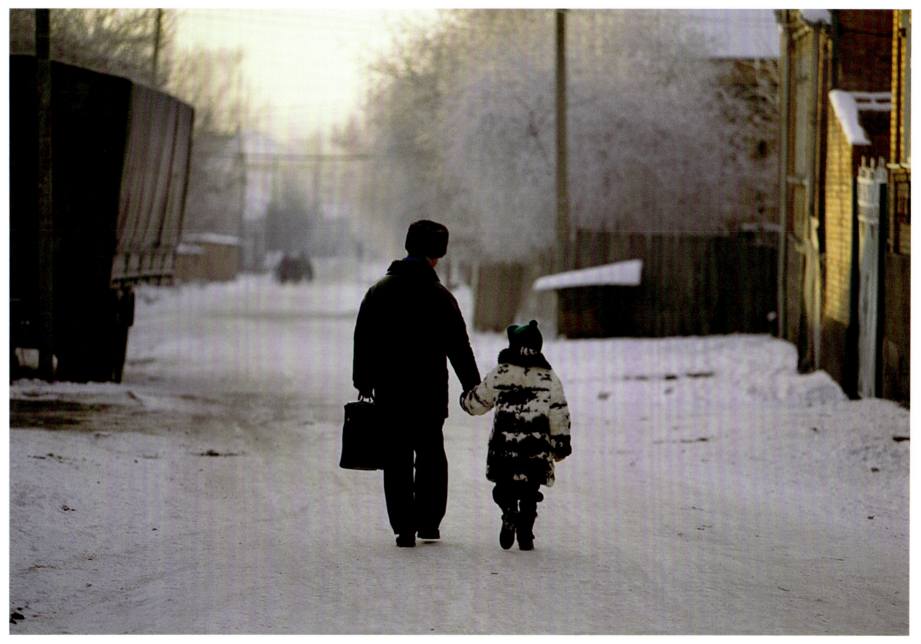

A father walks his daughter to school in Nazran. The war in nearby Chechnya seems distant on this frosty morning.

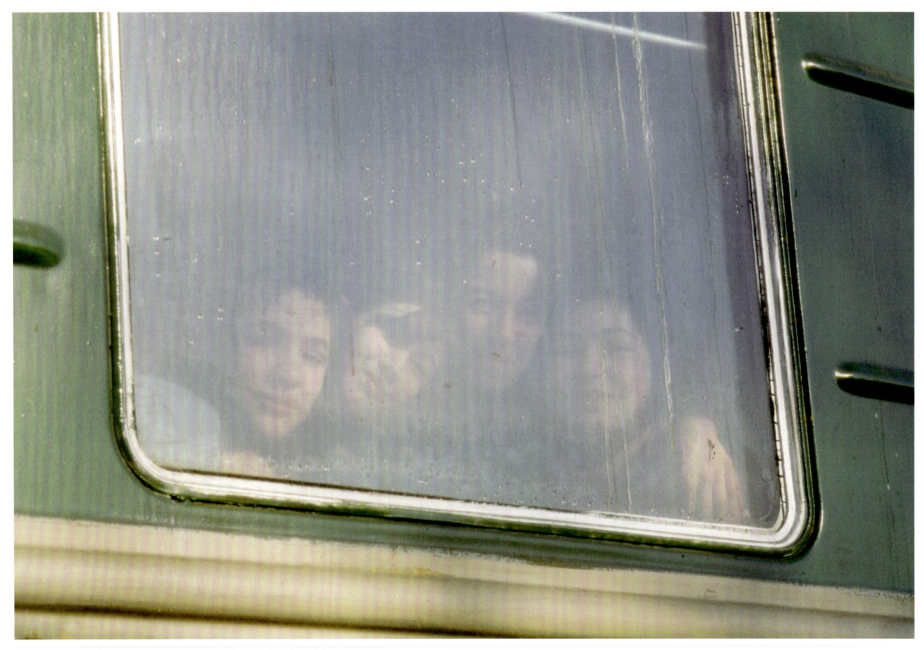

Refugee girls from Chechnya live temporarily on this train in Nazran.

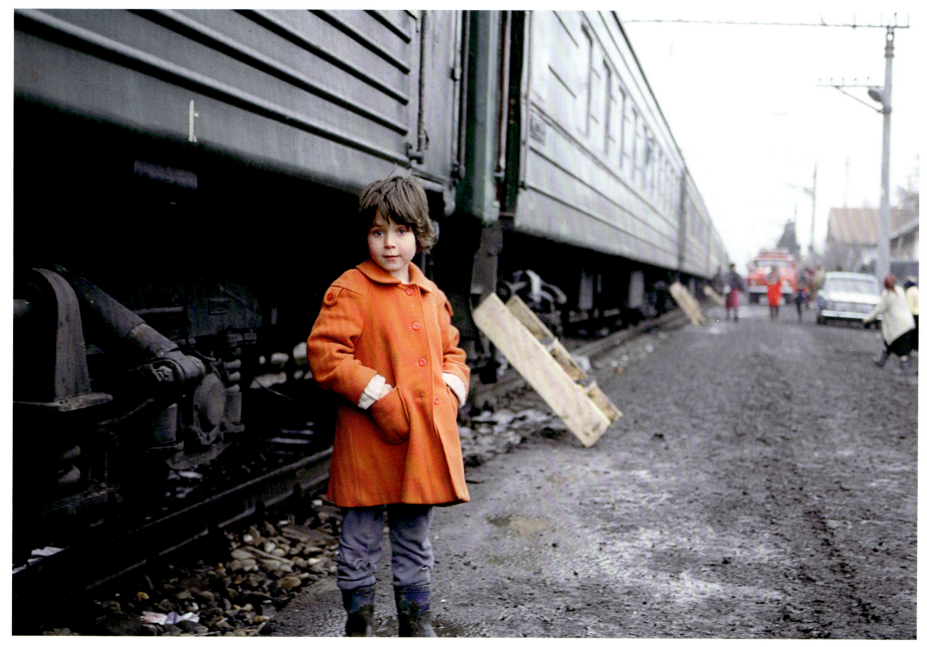

A refugee girl outside the train that has become her home in Nazran.

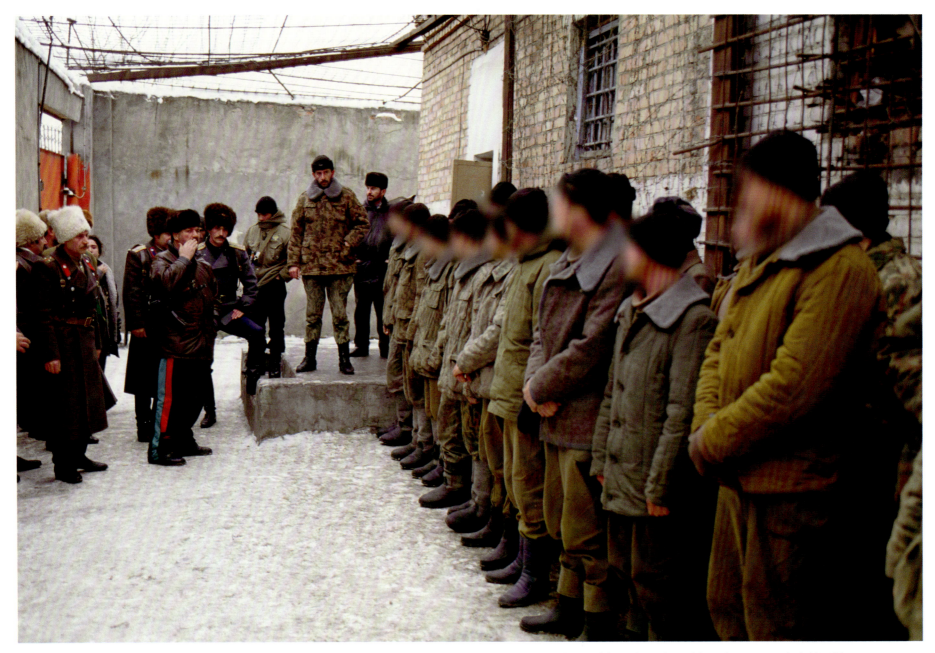

Russian soldiers detained in Chechnya line up and are introduced to ICRC delegates by their captors. The prisoners' faces have been blurred to protect their identities.

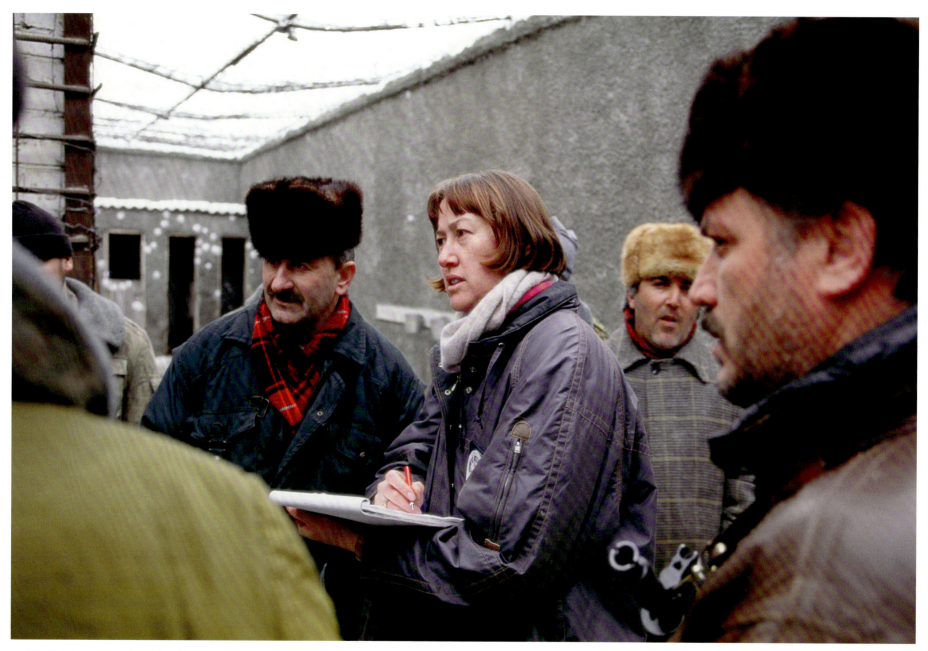

An ICRC delegate speaks with a Russian prisoner, through her interpreter, in a Chechen prison.

Prisoners of war have special meaning for me. Two weeks earlier while visiting my family home in Concord, Massachusetts, for Christmas, my father said he wanted to show me something. He took me down to the basement, opened an old trunk and pulled out a sheaf of papers. He had been a prisoner of war in Germany during World War II when the bomber he was navigating was shot down over the Baltic Sea. He was the only crew member who survived. Captured soon after being rescued by fishermen, he remained in German prison camps until the end of the war. My father opened the papers delicately and showed me the Red Cross messages that he had written to his family in Indiana from prison camp and his mother's return replies. He had many. He looked at me and said, "I know the work of the ICRC well and I am very proud of the work you are doing with them." I could not help but see my father reflected in every prisoner from that day forward.

Years later, while on a business trip to Geneva, my father visited with Pierre Gassman at ICRC headquarters. Pierre took him to the archives and they looked up his registration cards created at various prison camps. He had been registered and tracked by ICRC delegates the entire time of his imprisonment. He was liberated from prison camp into the custody of the ICRC on April 8, 1945. This is a fundamental and unique activity of the ICRC. The registering and visiting of prisoners of war in their places of detention, on all sides of a conflict, maintains the observance of a basic rule of war. To be a member of civil society, combatants must observe the Geneva Conventions and allow ICRC access to prisoners of war.

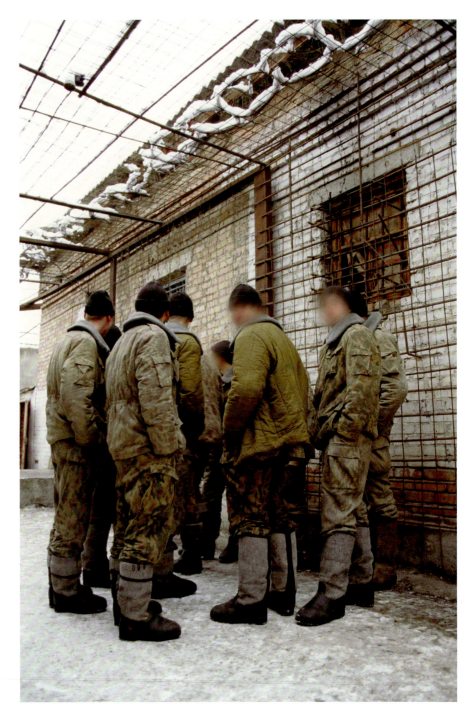

Russian pisoners waiting to be registered by the ICRC.

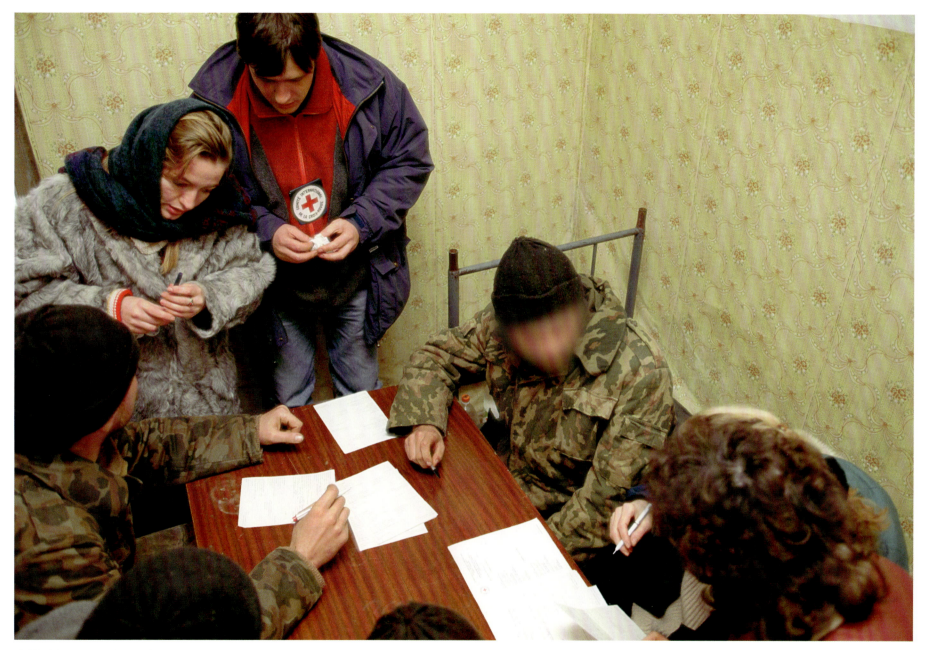

ICRC delegates and their interpreters register captured Russian soldiers and help them fill out Red Cross messages to their family members.

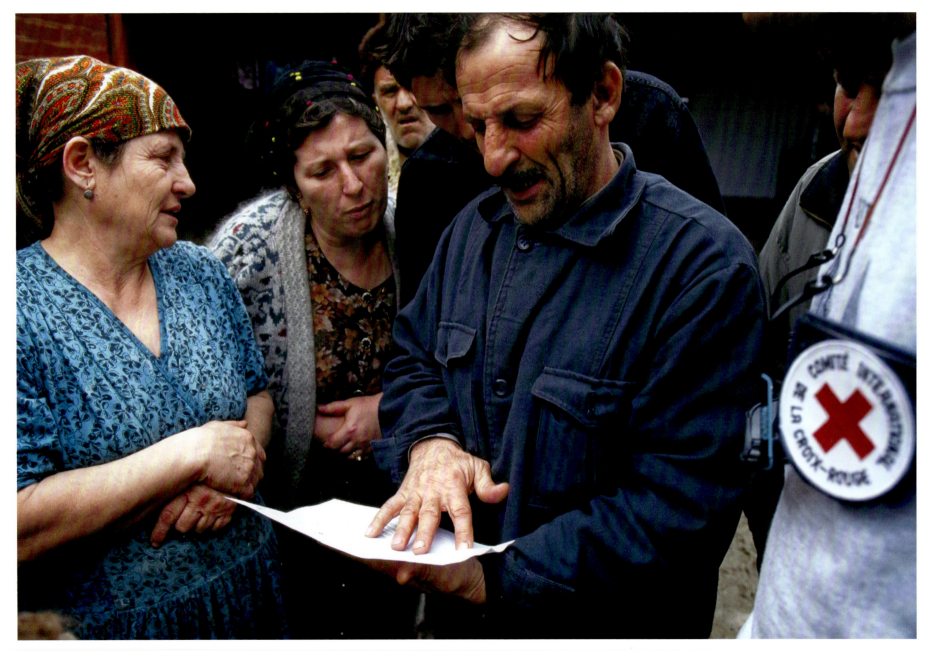

A Chechen family receives a Red Cross message from a son who has been missing during the war.

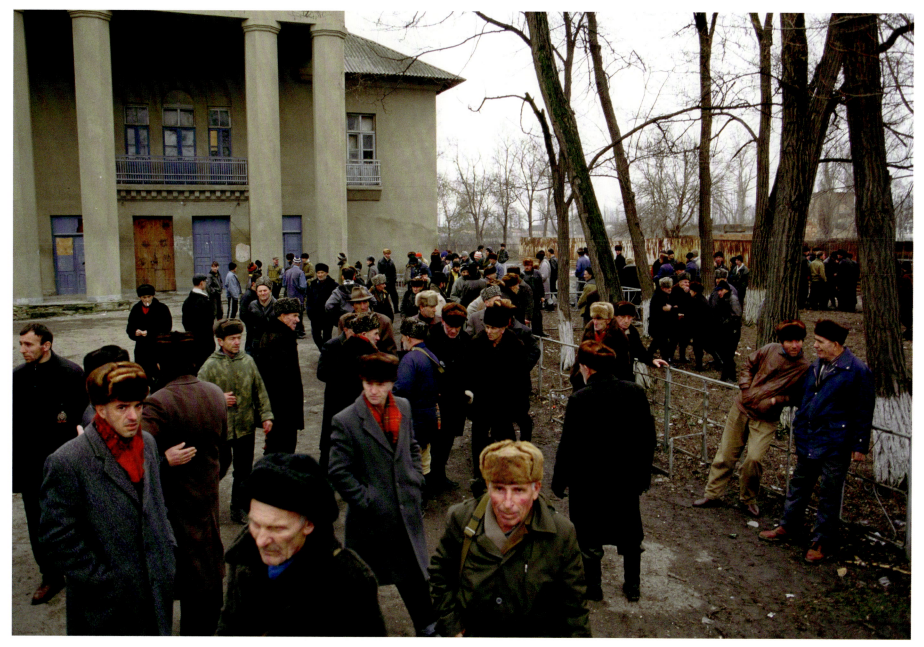

Men gather and talk anxiously in the town square of Achkoy-Martan while heavy bombardment occurs across the river in the nearby town of Samashki.

On January 23, 2005, Russian forces took retribution for the destruction of an armored personnel carrier that had wandered into the town of Samashki and was blown up by Chechen fighters. I was with a team of delegates in Achkoy-Martan, across the river from Samashki. Helicopter gunships and artillery were pounding the town. We were in radio contact with an ICRC team in Samashki and the situation was changing moment to moment.

There is a feeling at times like this akin to the moments before a car crash, when it seems you have all the time in the world to check your seat belt and prepare for the collision. Time seems to slow down the moment before impact—then it all returns to normal speed in a flash. The days in Chechnya were like an extended car crash, without the collision. Especially days like this when the rockets and shells were flying and exploding nearby.

Our team across the river radioed that they were taking shelter in a civilian home. We parked the Land Cruisers in an open field until warned by locals that they were too exposed, so we drove to a medical clinic close by. Medical supplies packed in the back of one of our Land Cruisers were given to the clinic staff. People wounded by the fighting arrived constantly and heavy bombardment and fighting went on throughout the day. Just before dark, we made our way across the bridge, met up with our colleagues on the other side and convoyed back through heavy destruction to the delegation in Ingushetia.

An ICRC nurse in Chechnya, January 1995.

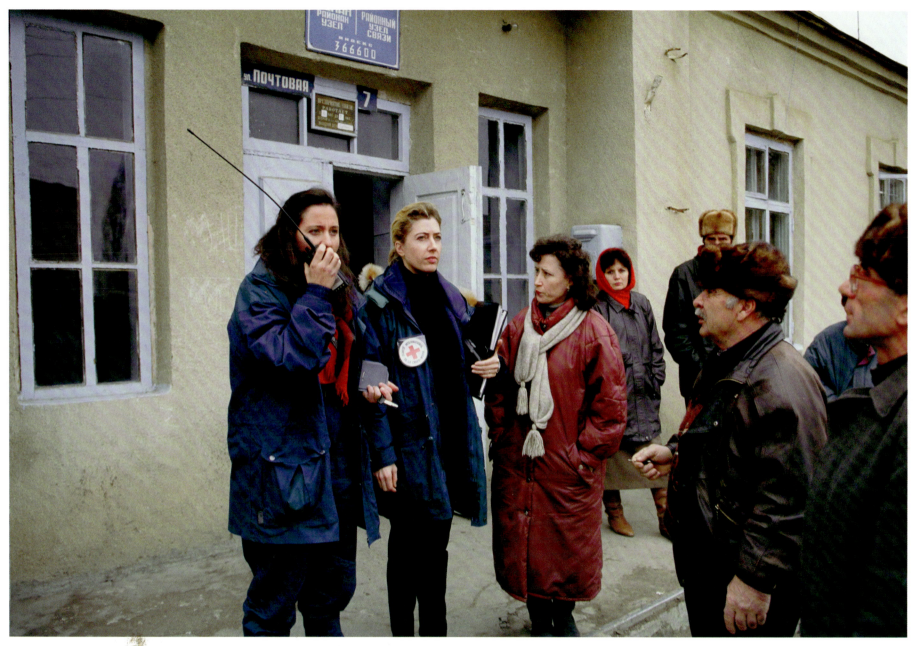

ICRC delegates respond to a rapidly changing situation in Achkoy-Martan; across the river Russian forces were rocketing Samashki.

While driving back, going slowly through an area that had seen intensive fighting, the windows were rolled down so we could hear shooting and so the force of nearby explosions would not blast the window glass into the vehicle. I saw a Chechen fighter standing over a Russian soldier in a ditch that ran alongside the road. They struggled and the Russian was killed by a gunshot to the head. The fighter looked up and locked eyes with me, then he saluted skyward shouting "Allahu Akbar."

The next morning we returned to Atchkoy-Martin to meet with the village leaders about their needs and the current situation. As we sat down I recognized the man across the desk as the fighter who had locked eyes with me the evening before. He pulled a handgun slowly out from under his leather jacket and laid it on the desk in front of him. In a calm but emotion-filled voice, he explained that he was a ballet teacher and how much he abhorred violence. His brothers and friends had been killed and he hoped we could understand why he was compelled to do this. In that moment I understood and I will always carry these vivid memories of the two extreme sides of the same person with me.

ICRC Statement: "In the early hours of 17 December 1996, six delegates of the International Committee of the Red Cross were assassinated in a brutal attack by gunmen at the ICRC hospital in Novye Atagi, near Grozny. The hospital opened on 2 September 1996 with the sole purpose of relieving the suffering of victims of the conflict in Chechnya. These activities came to an abrupt end in the early hours of 17 December, when masked individuals, armed with guns fitted with silencers, broke into the hospital compound. They burst into the building where the delegates were sleeping and cold-bloodedly shot six of them dead at point-blank range. The victims were: Fernanda Calado, Ingeborg Foss, Nancy Malloy, Gunnhild Myklebust, Sheryl Thayer, and Hans Elkerbout."

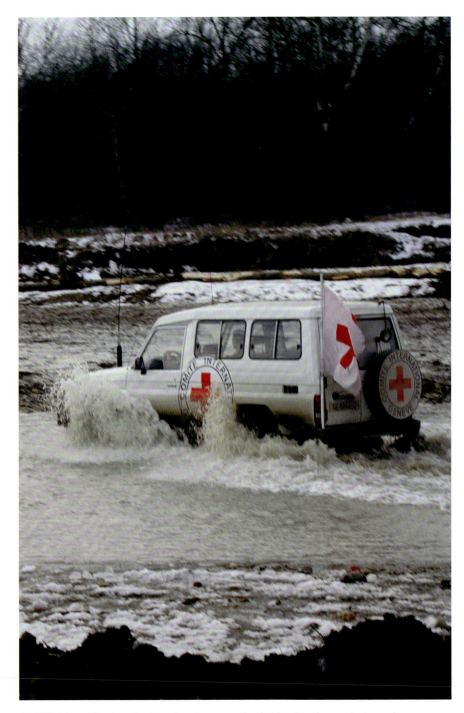

An ICRC Land Cruiser fords a river because the bridge has been destroyed.

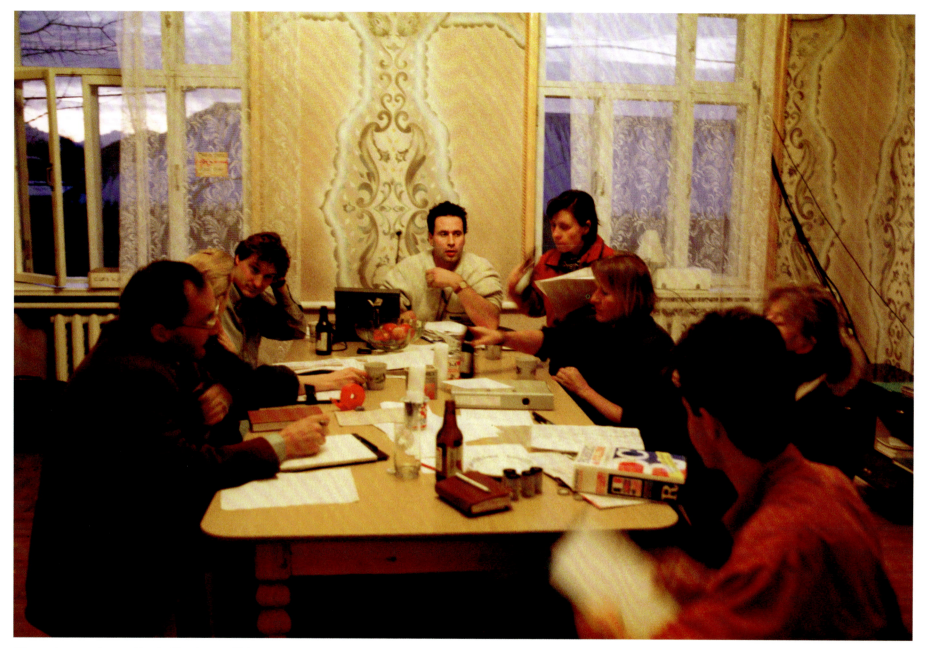

After an intense day working in Chechnya, ICRC delegates meet together at the delegation in Nazran.

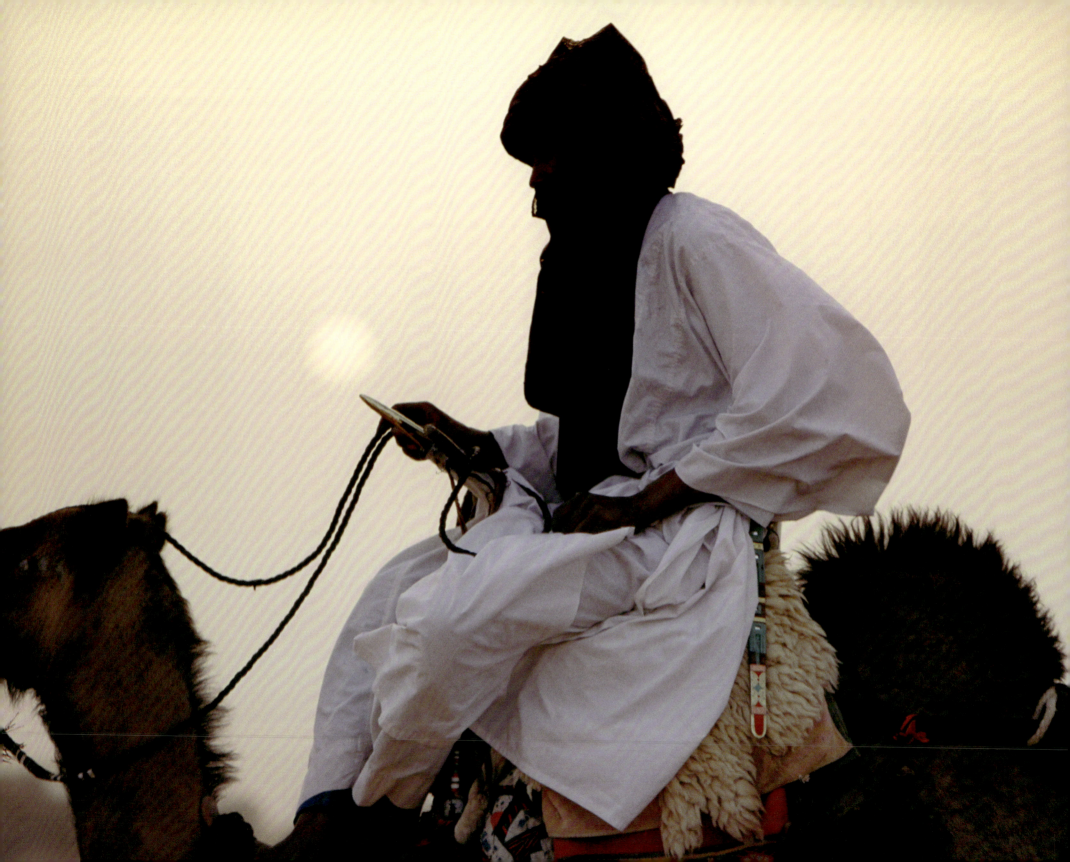

Desert Calm

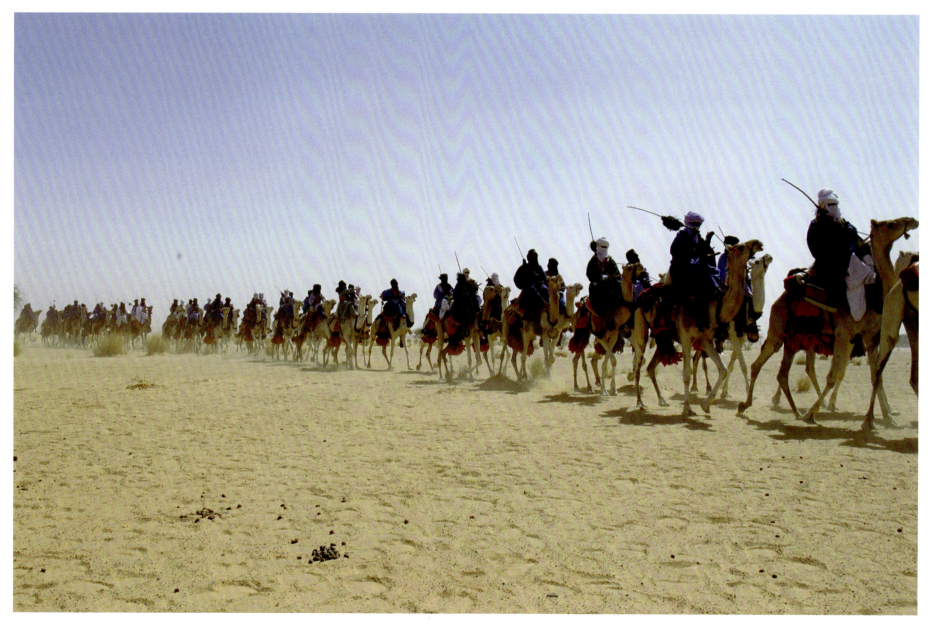

A procession of Tamachek speaking Tuareg riders arrive to participate in a truth and reconciliation discussion hosted by the ICRC in Mali, 1997.

The riders came thundering out of the desert, with hundreds of camels pounding the sand into swirling clouds around their feet. The dignified Tamachek camel riders, dressed in fine turbans and robes, had come for peace and reconciliation discussions hosted by the ICRC. I was struck by the vivid beauty of the scene unfolding on this hot and dusty January day in 1997. We were south of Kidal, the northernmost city of Mali in a place called Djiounhan.

It felt like an ancient sacred ritual was taking place as the participants rode in and set up their tents at this desert encampment. The place was a common gathering spot. A hillside of large round boulders seemed to have bubbled up from deep within the earth and provided a natural windbreak. The low traditional leather Tuareg tents set in the desert sands at the edge of the rocky hills blended in easily with the landscape.

The desert wind carried the sound of drumming and the high-pitched wailing from women sitting in tight clusters on the sand. The women drummed, clapped and trilled into the wind. The deep indigo pigment from their robes had rubbed off on their skin, turning it a purple hue. One woman poured water on a drum as the hot dusty wind and intensity of the ritual grew. Men on camels trotted in tight circles around the groups of women drumming and calling out. A tremendous energy filled the air.

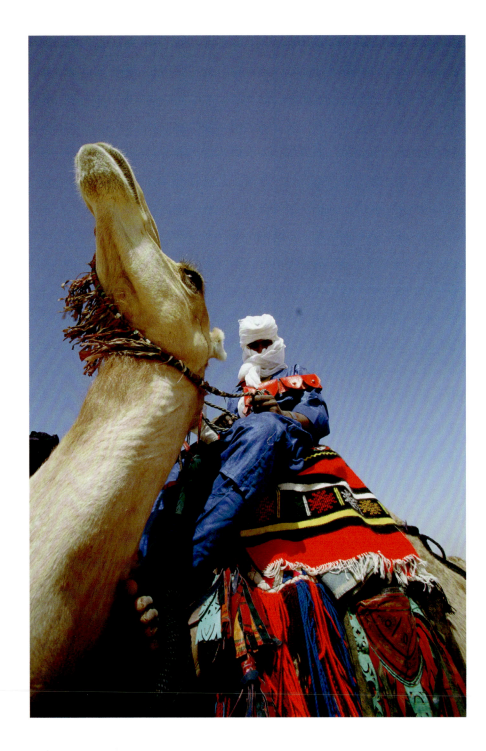

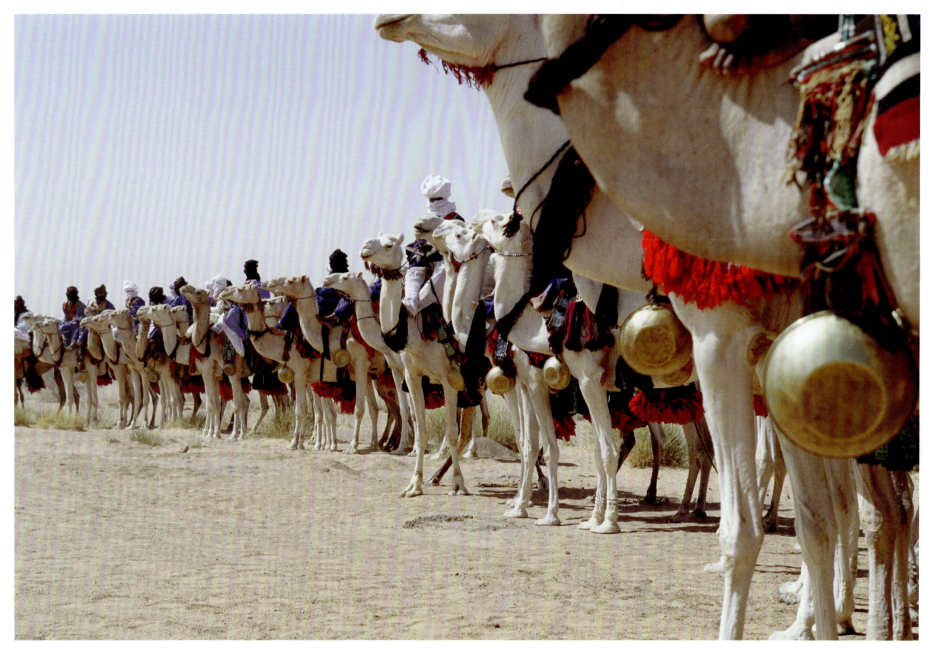

Tuareg riders line up in a semicircle at the beginning of a gathering in the desert south of Kidal.

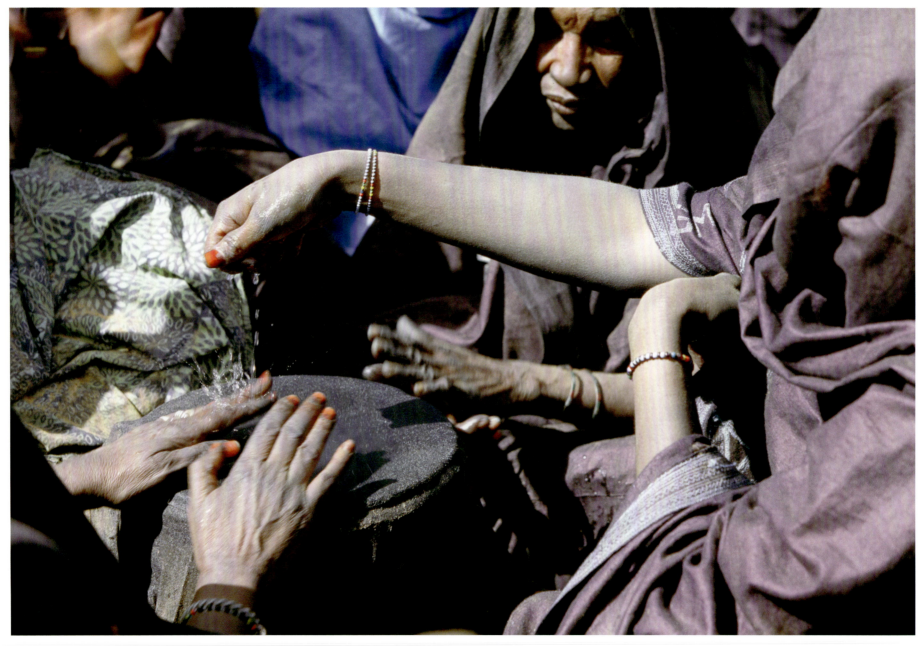

A woman drips water onto a drum while others wail, trill and call out as camel riders circle around them.

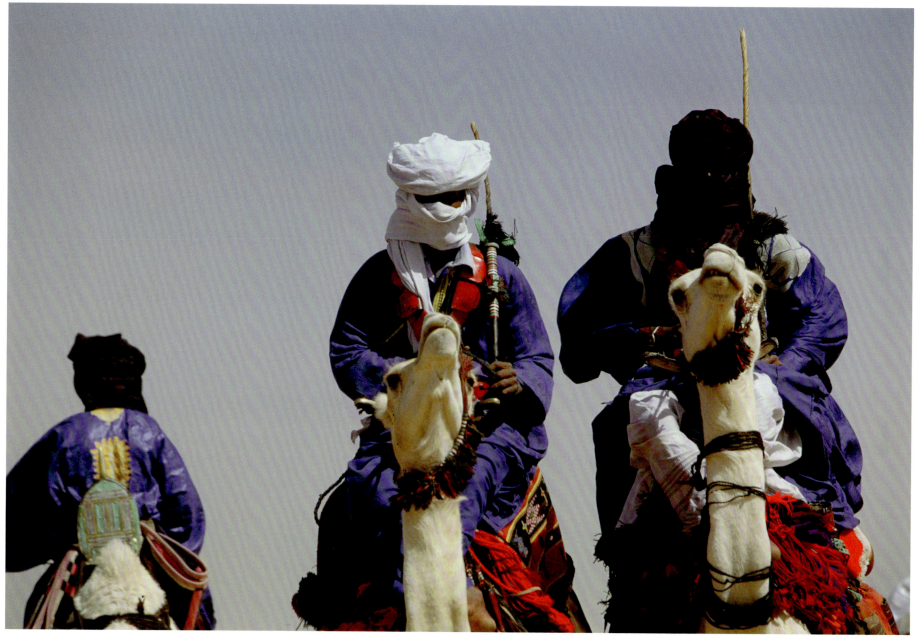

Tuareg men wearing fine robes ride into the gathering on their camels south of Kidal.

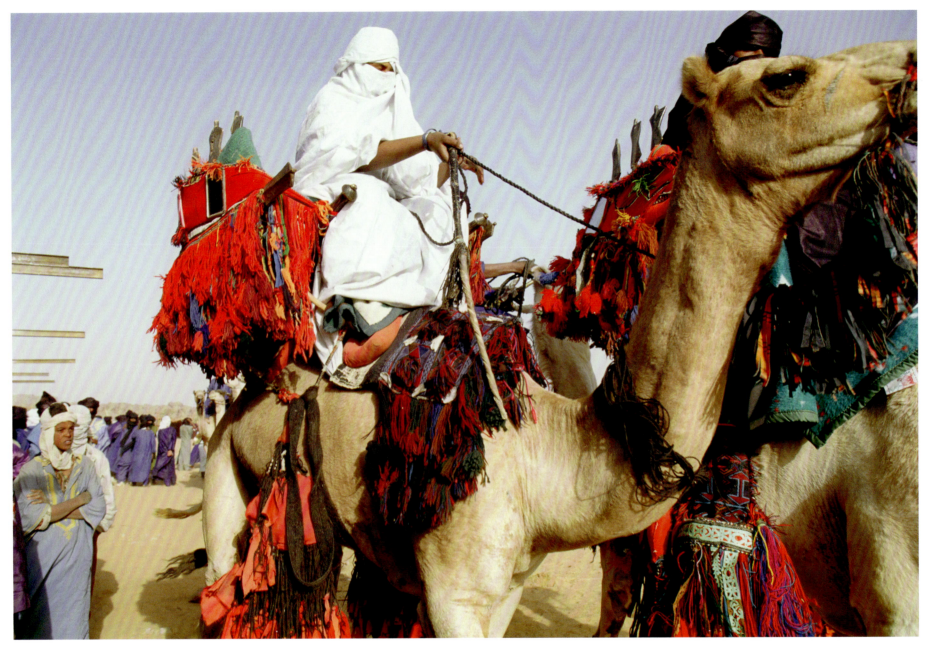

A woman camel rider arrives at a gathering of Tureg tribes in northern Mali.

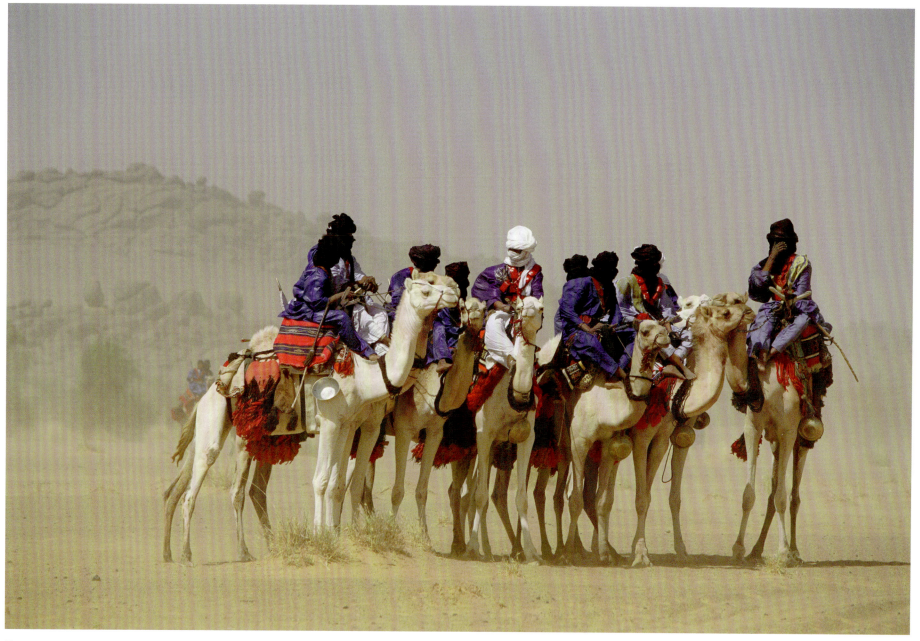

Tuareg camel riders talk in a group as a dust storm blows through the gathering south of Kidal.

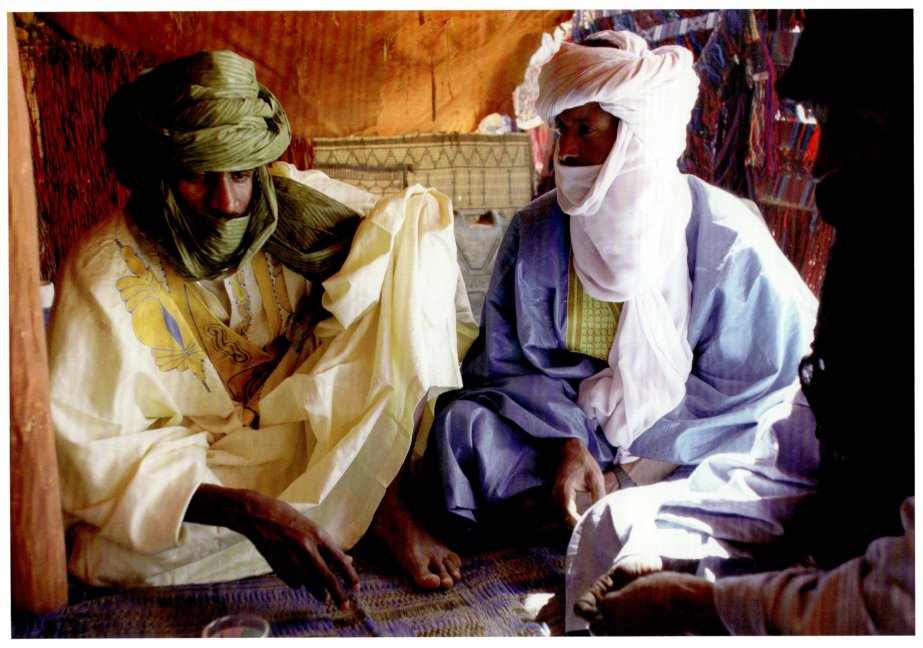

ICRC staff converse inside the delegation tent at a unique meeting of tribes in northern Mali.

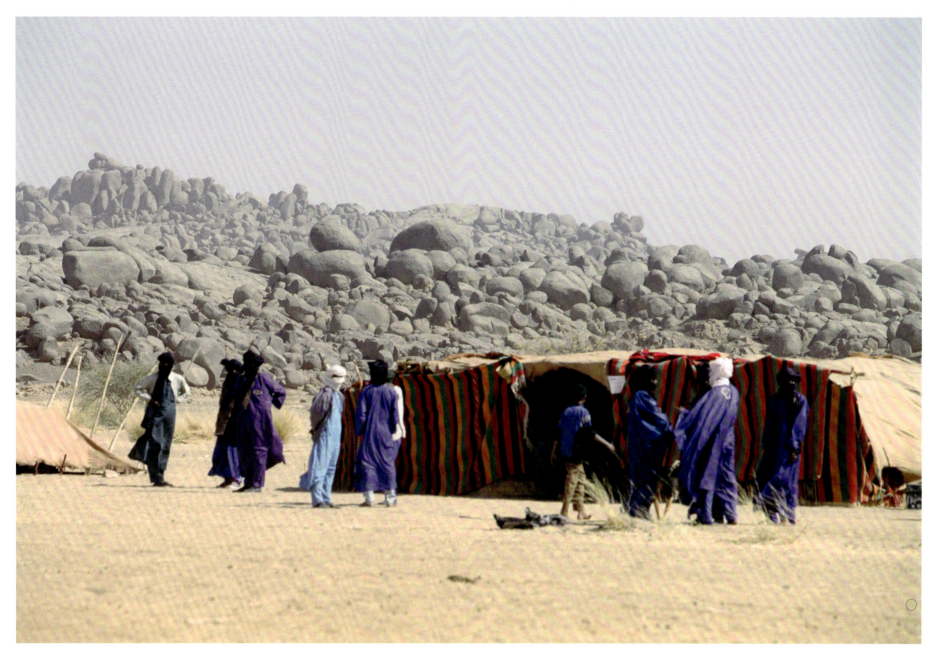

The ICRC delegation tent is set up on the edge of the desert near a hillside of boulders that provides a natural break from the wind just south of Kidal.

After two days of dialogue the meeting dispersed when a large sandstorm came blasting in out of the deep desert. The air was so filled with fine dust that it got inside my camera lenses and in between the glass elements. Changing each roll of film was a challenge. My camera bag still has a tint of dust from that desert storm impregnated in it to this day.

Gao, a small city in the northeast of Mali on the river Niger, is the northernmost ICRC subdelegation. From Gao I joined a number of missions into the desert areas of the north and back. For a few days I traveled with a medical team vaccinating for measles and polio. We moved from one nomadic settlement to the next. Our guide was a local imam (a religious leader), both navigator and an interlocutor with the Tuareg people. His internal compass and ability to navigate the desert landscape was remarkable. We seemed to be wandering in the middle of nowhere when over a hillside appeared a nomadic encampment. The imam approached the people first and explained why we were there. Women and children came forward for their shots and to receive the familiar yellow vaccination records.

At sunset we set up camp in the desert and slept under the open night sky ablaze with stars. The medical team carried enough supplies for three or four days in the desert before returning to the subdelegation in Gao for resupply. There were places in the desert where we would meet up with other teams for the night and get resupplied with critical medicines.

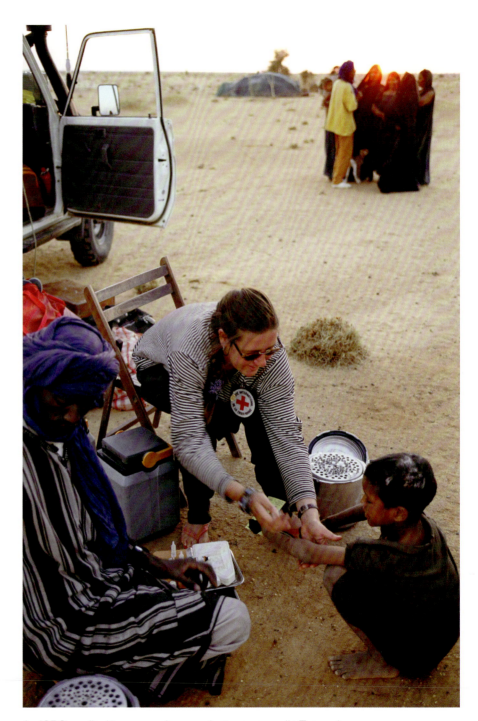

An ICRC medical team member vaccinates a nomadic Tuareg boy.

The city of Gao, which is home to the northernmost subdelegation of the ICRC.

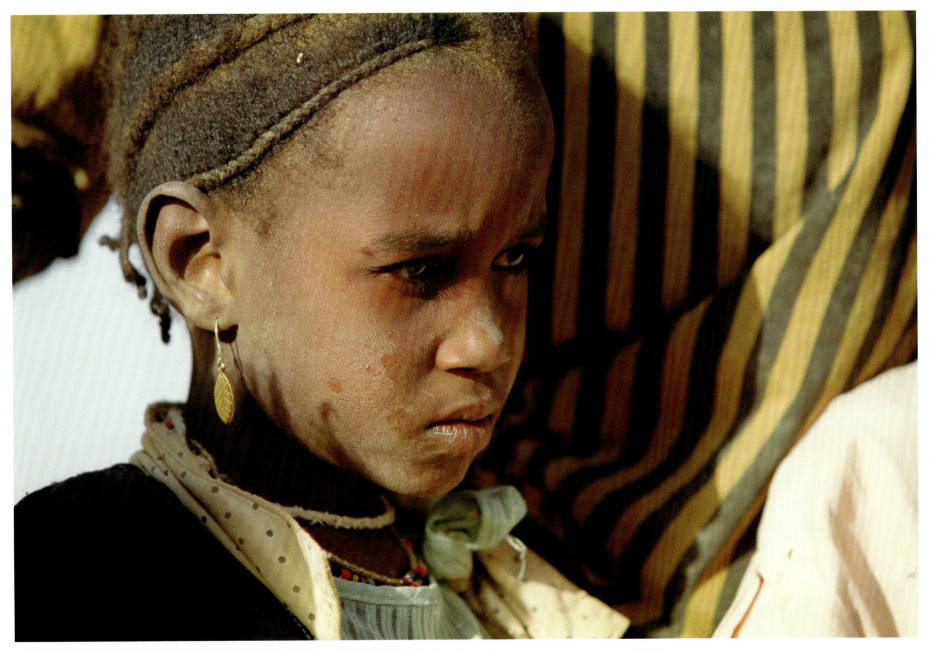

A girl waits anxiously for a measles shot in a remote desert encampment in Mali.

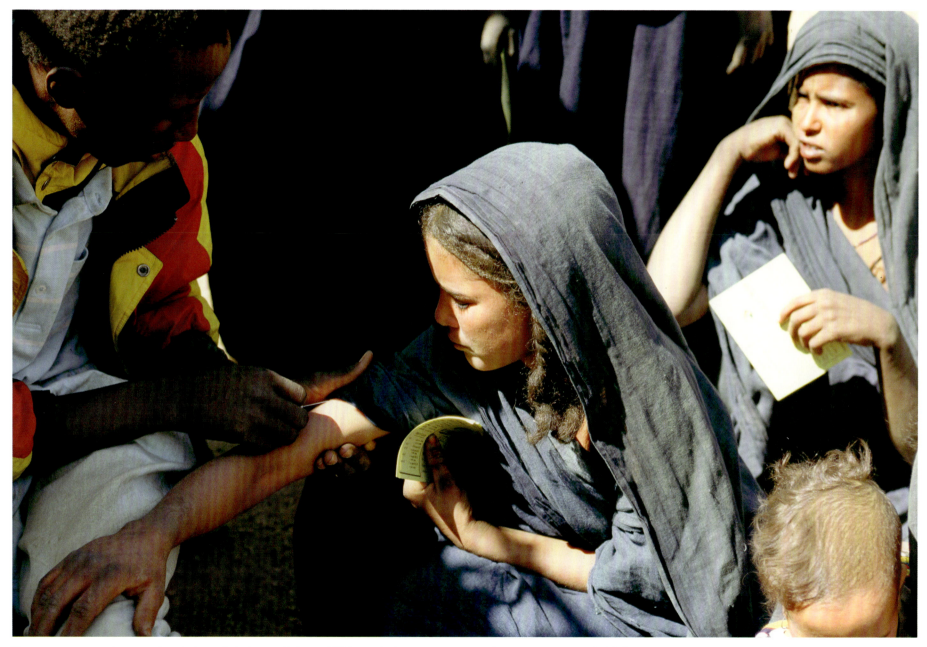

Tuareg women receive measles shots and shot records by an ICRC medical team at a remote desert encampment in Mali.

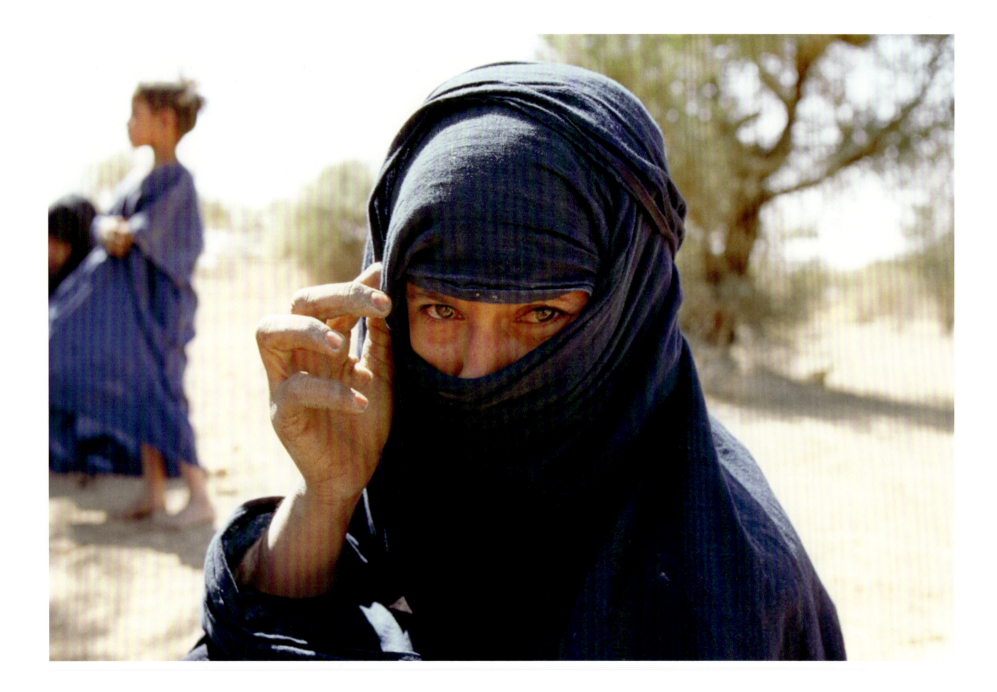

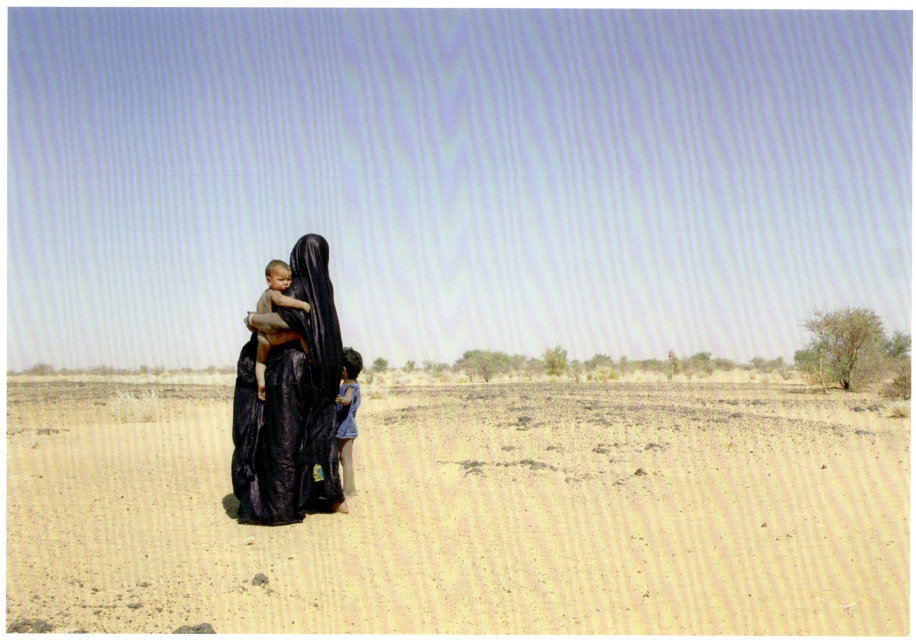

A mother and her children walk back to their tents after receiving vaccinations.

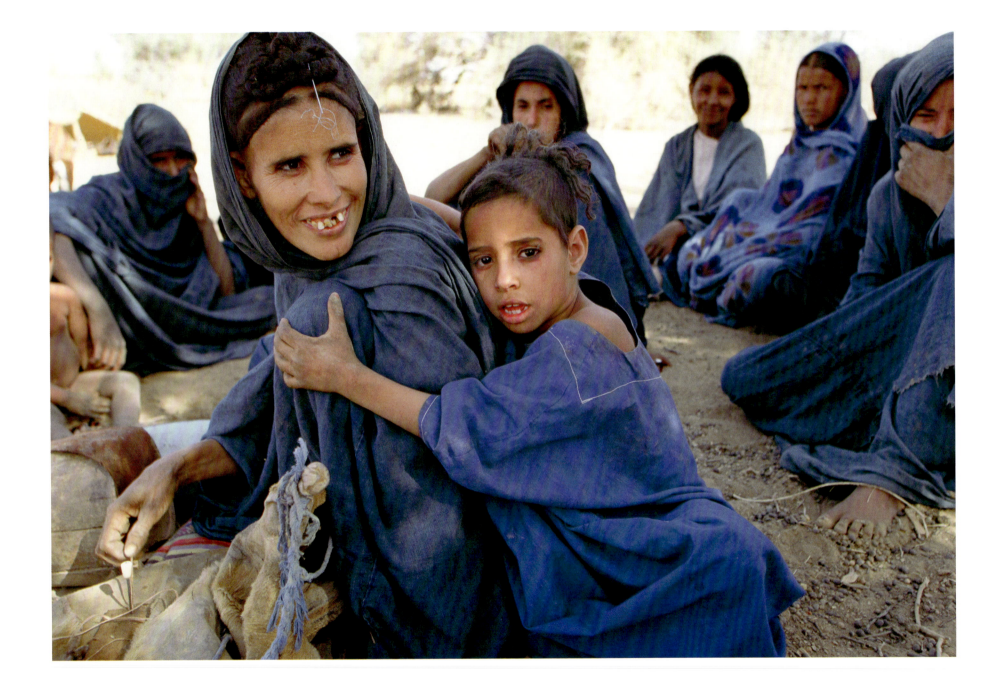

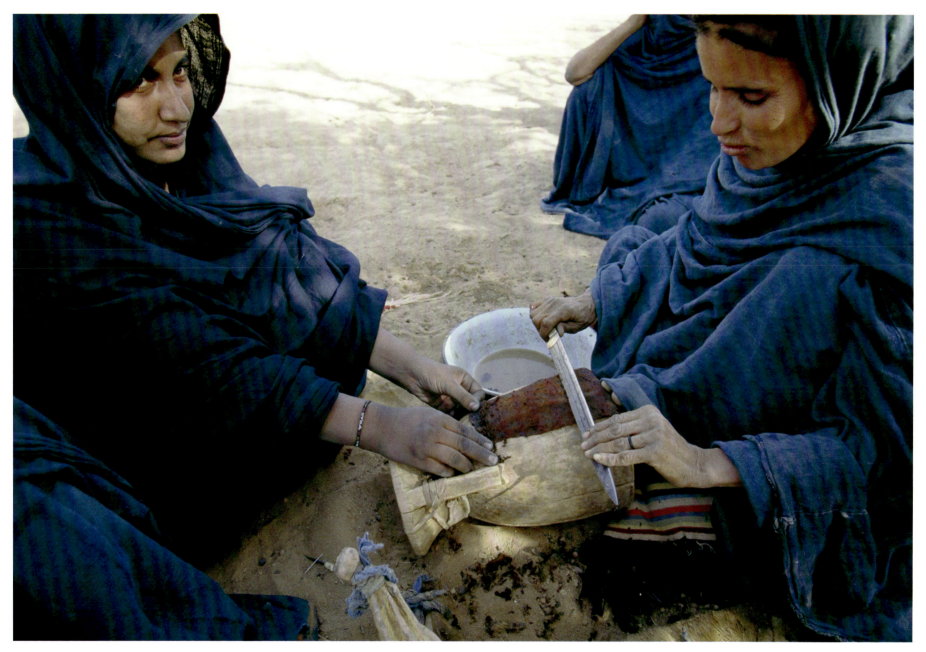

Women work on preparing leather patches to fix goatskin water bags while the men are out gathering water at a well a day's walk away.

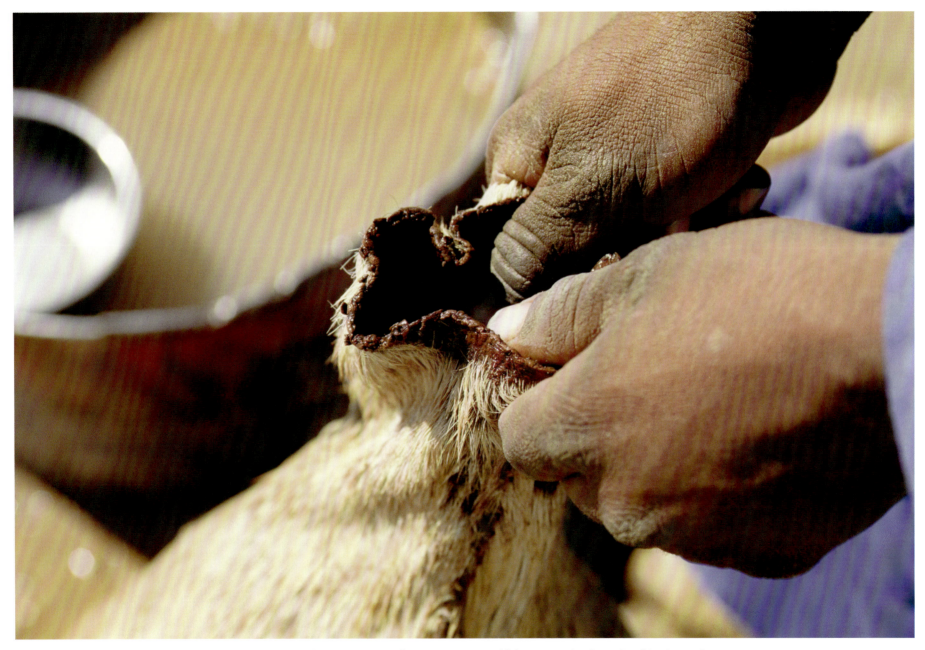

Goatskin sacks store water from a well and are carried on donkeys to nomadic encampments, which may require days of walking to reach.

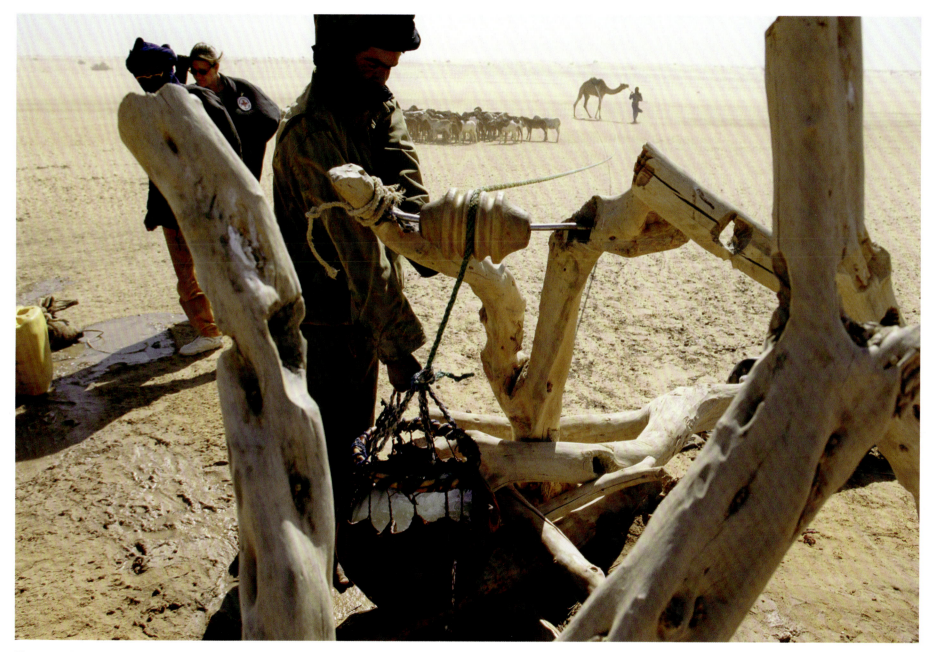

The camel in the distance has pulled up a skin bucket of water from a desert well; the length of rope shows the depth of the well.

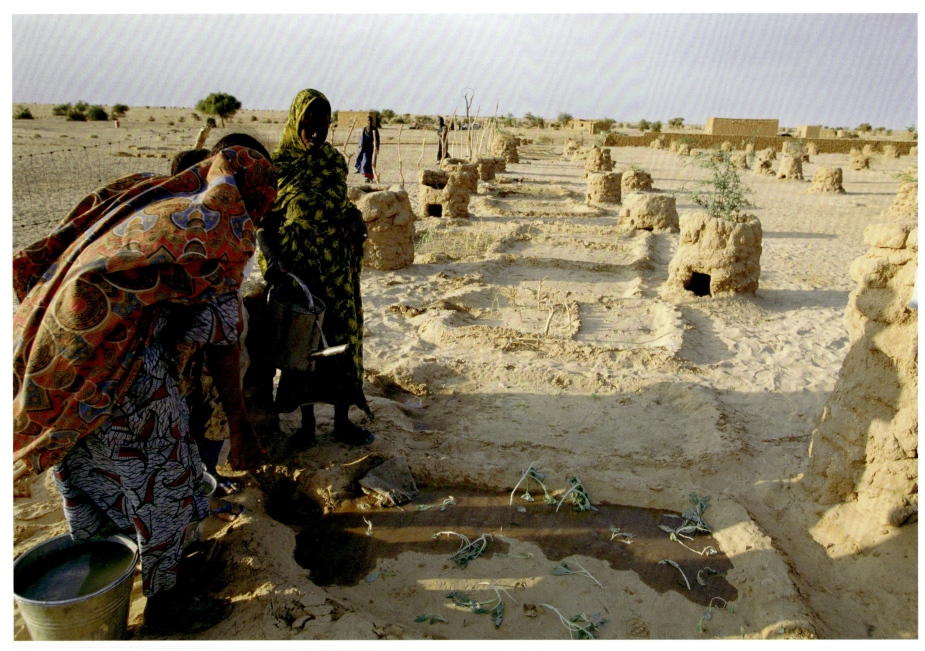

Girls water a garden with buckets of water carried from a hand-pumped well.

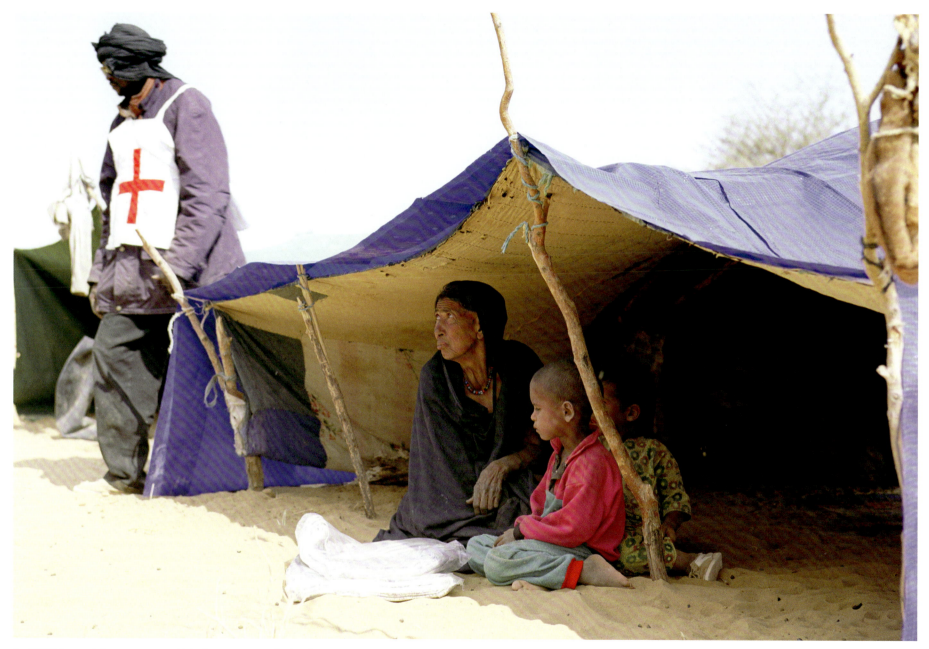

An ICRC team delivers tarps and blankets to nomadic families in need north of Gao.

The contrast was vivid between the browns of the desert and the greens near the Niger in Mali. One afternoon, while photographing a fisherman casting his net from a canoe on the Niger, I almost tipped us over swatting at swarms of mosquitoes. I returned to the United States two weeks after that day on the Niger. I had a fever of 106°F when I walked into George Washington University Hospital near Georgetown. I mentioned that I might have malaria and the admitting doctor smiled, saying they had never had a case at this hospital. It turned out I had falciparum malaria, mainly found in Africa. The nasty critters had incubated for fourteen days in my liver and were going all out to take over my body; this would surely kill me if not properly treated. Soon I was lying on a waterbed with ice water circulating through it and an IV drip of quinine in my arm. Lying on an ice bed with a high fever was a perfect form of torture; I would have told any of my secrets to get away from it. A constant stream of medical students came through to examine me. An oddity at the time, yet now with climate change increasing both the range and seasonality of malarial mosquitoes, this disease will become more commonplace in the future.

The Niger is a highway of commerce stretching to the ocean. For centuries merchants have brought tea, sugar and goods up the river to exchange for the high quality salt that comes from deep in the interior of Mali. The salt is mined from an ancient lake in Taoudenni, cut into blocks and carried in caravans of hundreds to thousands of camels. They travel across the desert to Timbuktu and the Niger, a journey of three weeks. I was invited to join one of these caravans.

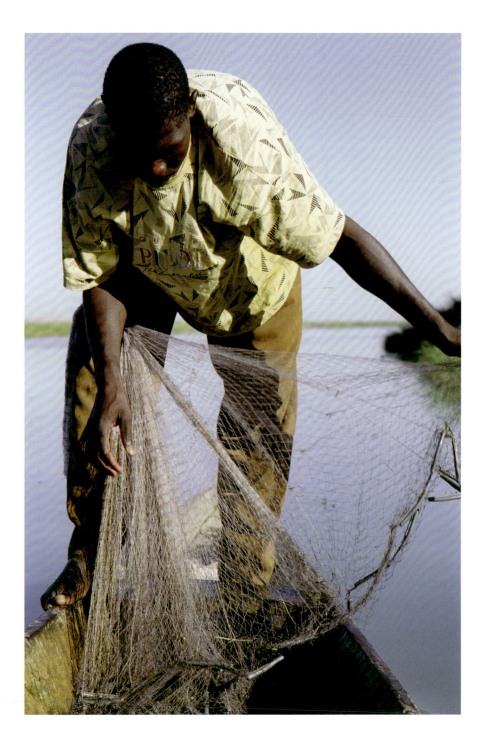

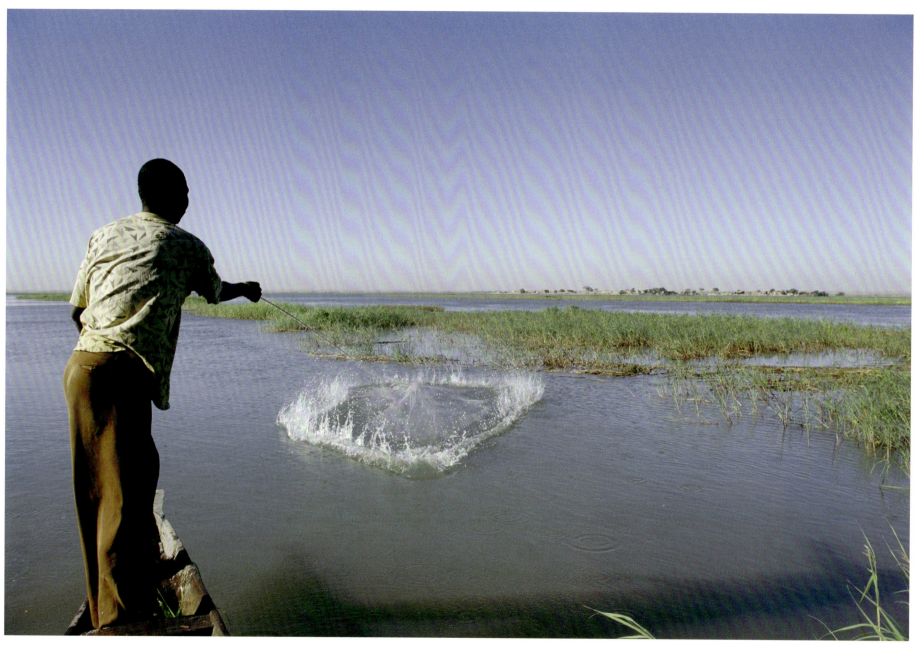

A fisherman casts his net from a canoe on the Niger River in Mali.

One night in the desert, while sharing tea around the fire at an overnight camp site, I heard of the Ipeket for the first time. The Ipeket, or "the hidden ones," are a Tuareg nomadic tribe that are caretakers of ancient sacred texts and teachers of young students selected from different tribes. It was exciting for me to hear of people stewarding sacred texts. Printing and fine books are in my lineage; my great-uncles ran one of the finest printing presses in America—the Grabhorn Press. Two brothers, Edwin and Robert Grabhorn, moved from Indianapolis to San Francisco in 1920 and established the Grabhorn Press. For the next forty-five years they were one of the foremost producers of finely printed books in America. The idea of seeing physical books, handwritten illuminated manuscripts, made my blood stir. In two days permission came through the desert network for me to visit and photograph the Ipeket.

Lessons were in full swing when we arrived at a remote encampment of tents. A group of students was reciting aloud from wooden boards that were covered with handwritten text from sacred books. There was a serious tone and devotional sentiment in the student recitation. The books were gorgeous. Devoted elders and scholars showed me some of the texts that they had on hand. Others were stored at a desert library of sorts; the building had been constructed with support from the ICRC. In Mali I witnessed the basic dignity of a culture being protected.

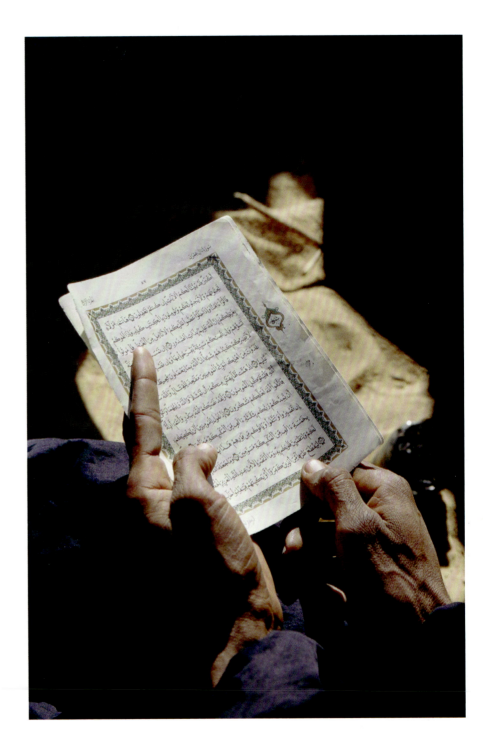

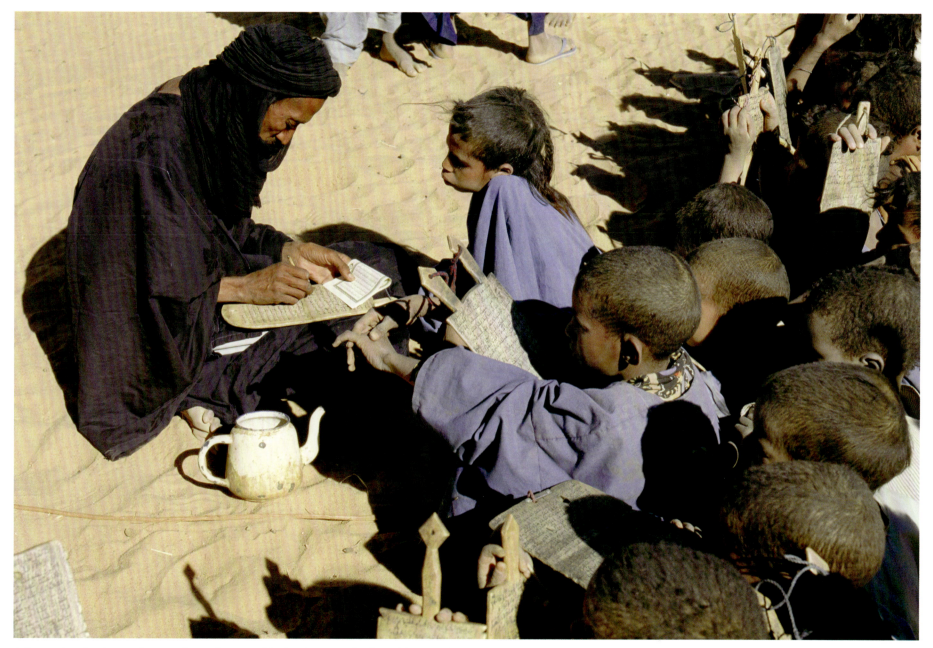

A Tuareg teacher transcribes sections of a sacred text onto a wooden board for a student to recite from.

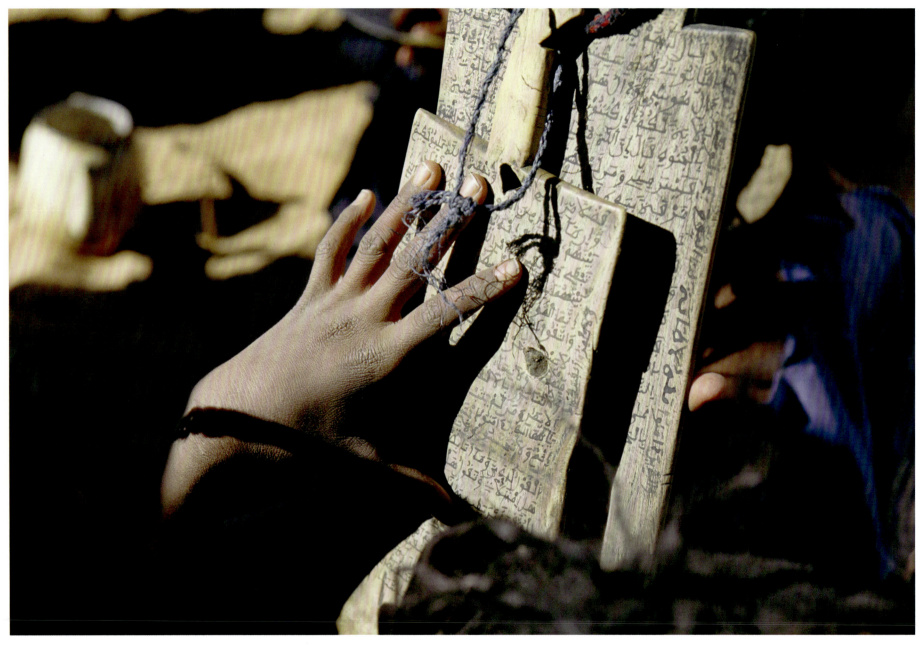

Students recite lines written on wooden boards at a desert school encampment in Mali.

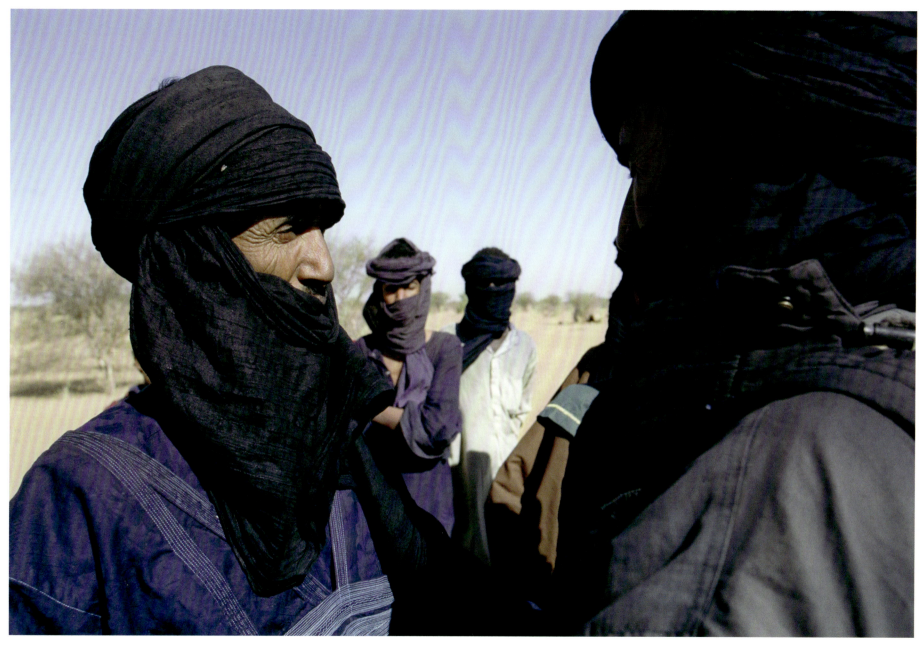

Tuareg men talk together at a remote desert encampment where teaching and studying occur.

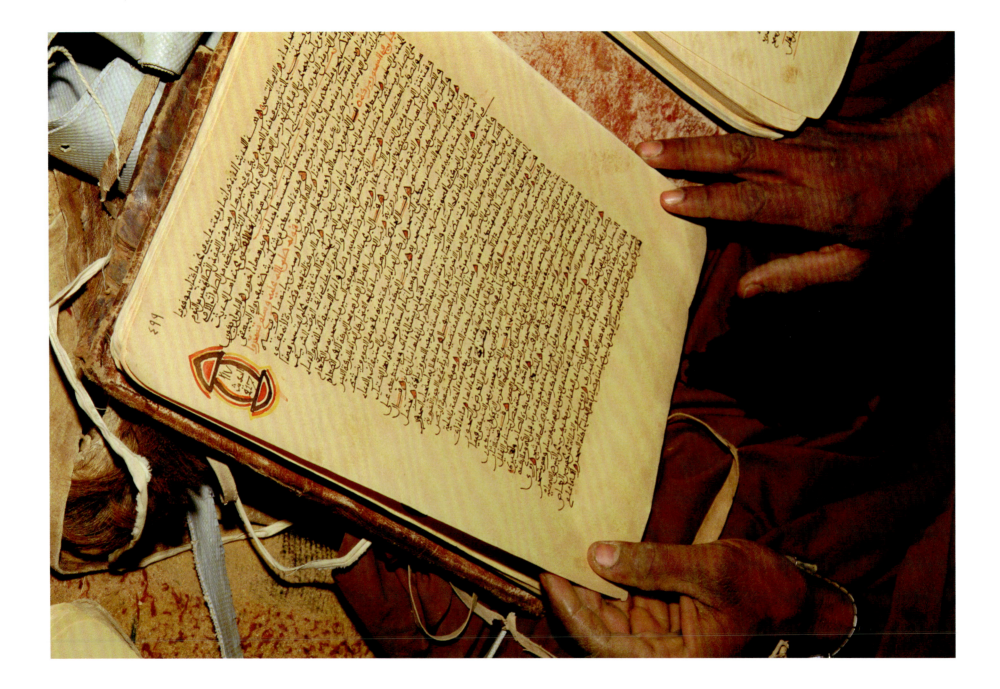

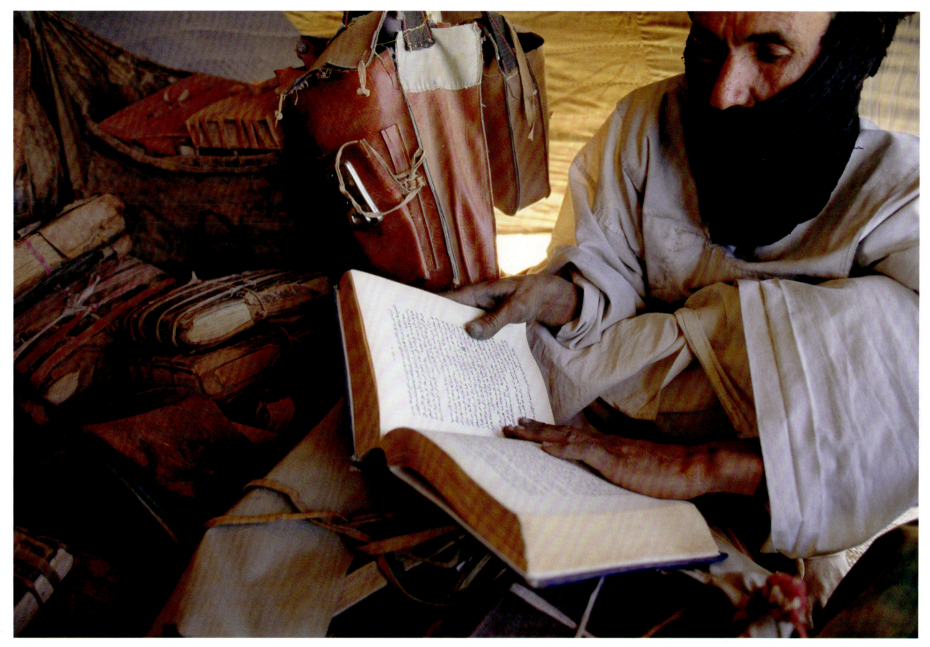

A Tuareg scholar reverently reviews a book in a tent where they are stored.

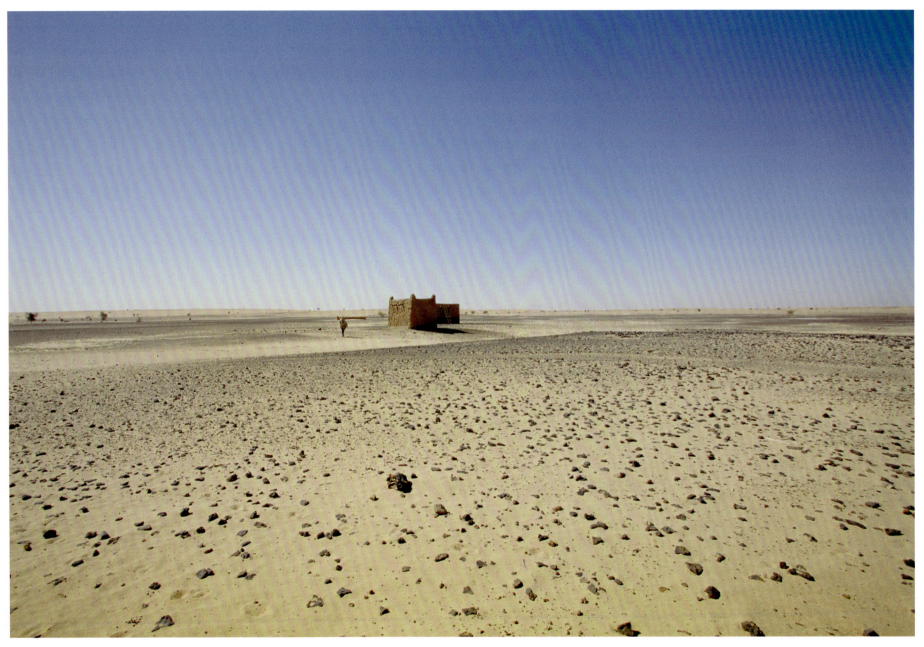

A desert storage house for sacred books and texts built with assistance from the ICRC.

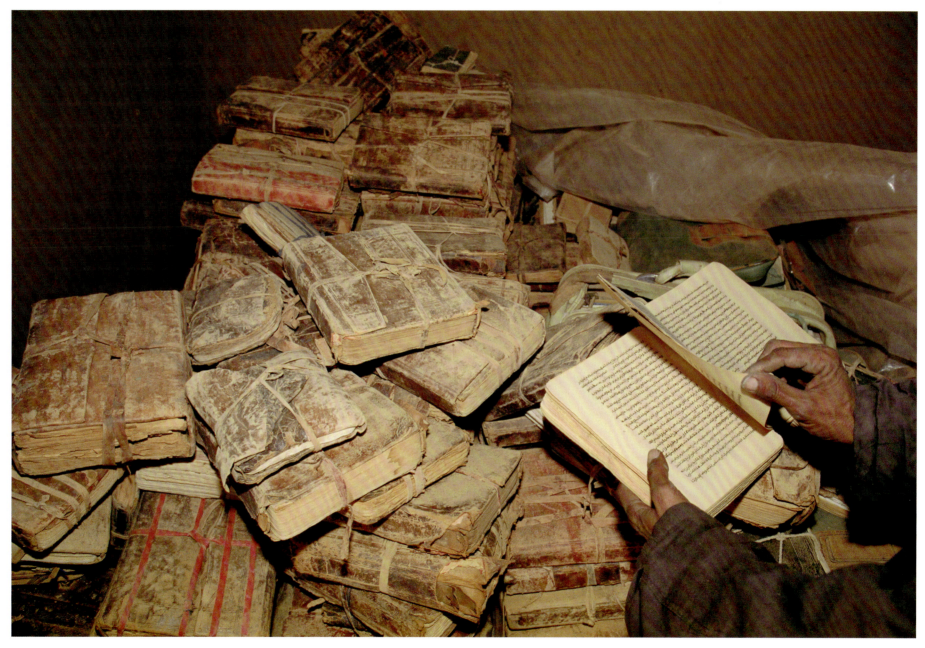

Inside a storage house for sacred texts a man reviews an open book from a stack.

A few years after returning from Mali I moved from Georgetown to a ranch with expansive skies and open unobscured views as far as the eye could see. It was a peaceful place of piñon, juniper and adobe buildings outside of Santa Fe, New Mexico. The architecture, the landscape and the brilliant star-filled night skies took me back to Mali. I could almost hear the imam's call to prayer in the early morning stillness of New Mexico. As I write these words I can see the sky above the mountains of Santa Fe billowing with smoke as fires rage. The land, withered by years of drought, is in an explosive condition. Winds build each day and fan the flames into massive fires. Water is becoming scarce. I remember the tension in the air around the desert wells in Mali. Tensions will build here in the southwest if there are further years with little rain and as climate-induced drought alters the landscape.

The United Nations Environment Program estimates that 375 million people worldwide will be affected annually by 2015 by climate-related disasters. Each year there are more deadly sets of tornadoes, more costly hurricanes, more flooding and more droughts. The scientific community has known about climate change for quite some time. The rest of us are starting to experience the early effects of a centuries-long process of increasing change in the Earth's climate. Changes that will only get worse if we continue to generate carbon pollution. Global environmental feedbacks are beginning to accentuate and accelerate the planet's warming and chaotic responses will become more likely.

I am an optimist yet I wonder if humanity is up to the global challenge we have created. Climate change is as real as war. As the impacts increase there will be more conflict and war over water, food and arable land.

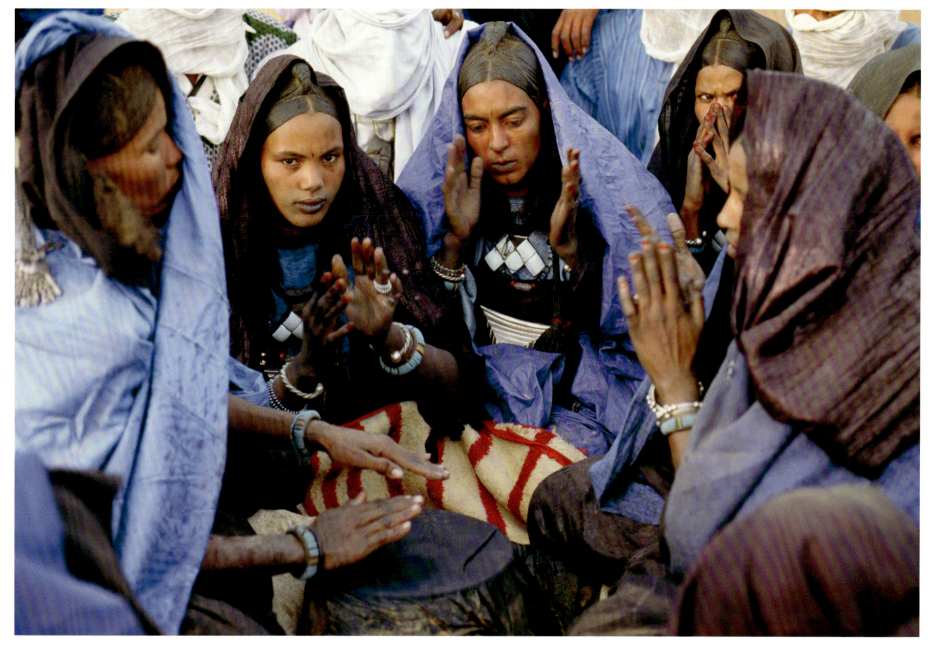

Tuareg women drum, clap and sing in high-pitched wailing trills at a desert gathering in northern Mali in 1997.

Families in War

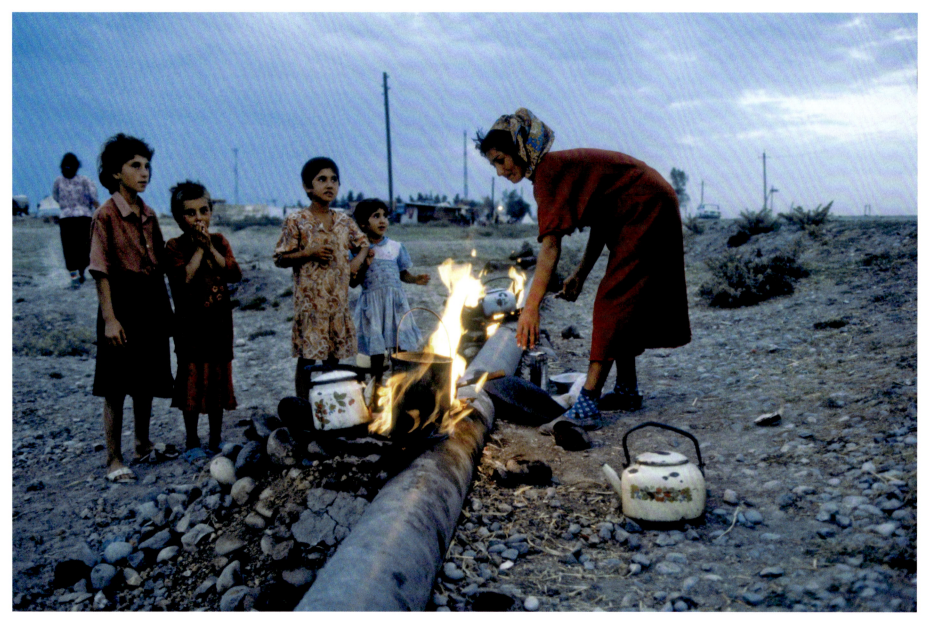

Food cooks on an open flame from a hole made in the gas pipeline that passes through their refugee camp in Azerbaijan.
Opposite: Schoolgirl in Guatemala.

In July of 1994, a long line of train cars were parked at the end of the rails on the western border of Azerbaijan. The hot afternoon sun turned them into ovens. Each car had an extended family living inside. Blankets and sheets were hung as dividers to create a degree of privacy. A gas pipeline running alongside the railroad track had holes pierced in it that were lit on fire for cooking. A sprawling tent encampment extended from the train cars across a flat plain into the distance. As the shadows lengthened, the air carried a mixture of the smell of wood smoke and food cooking. The families living here were mostly groups of relatives: women, children and the elderly who had fled the fighting in nearby Nagorno-Karabakh. Men of fighting age were conspicuously absent. Nagorno-Karabakh is a landlocked mountainous region between Azerbaijan and Armenia, where heavy fighting occurred between 1991 and 1994. The struggle for the region escalated after both countries gained independence from the Soviet Union in 1991. Large numbers of people were pushed from their homes and villages, creating populations of displaced people within Karabakh and refugees across the border in Azerbaijan.

In many places around the world this is what happens when conflict erupts. Families who have lost their young men, homes, gardens, animals and livelihoods flee the fighting to survive. Often they regroup and try to rebuild their lives just outside the conflict zone and these refugee communities continue to grow until the fighting stops. When ethnic cleansing is used as a tactic of war these communities become overwhelmingly large as entire villages are forced to leave and often the people cannot return home.

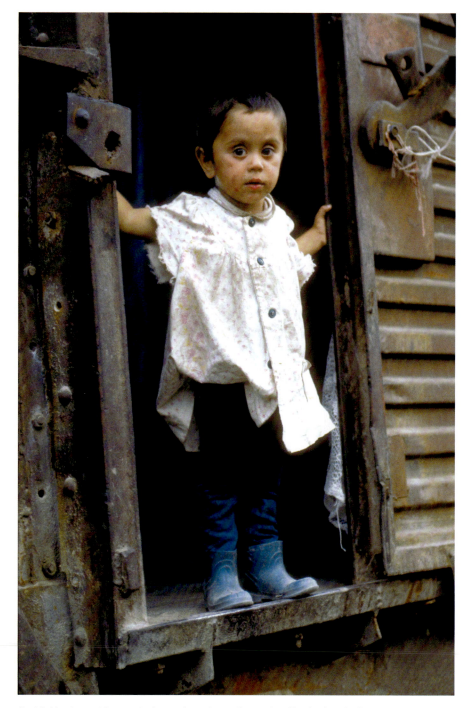

A child looks out from a train car housing refugee families in Azerbaijan.

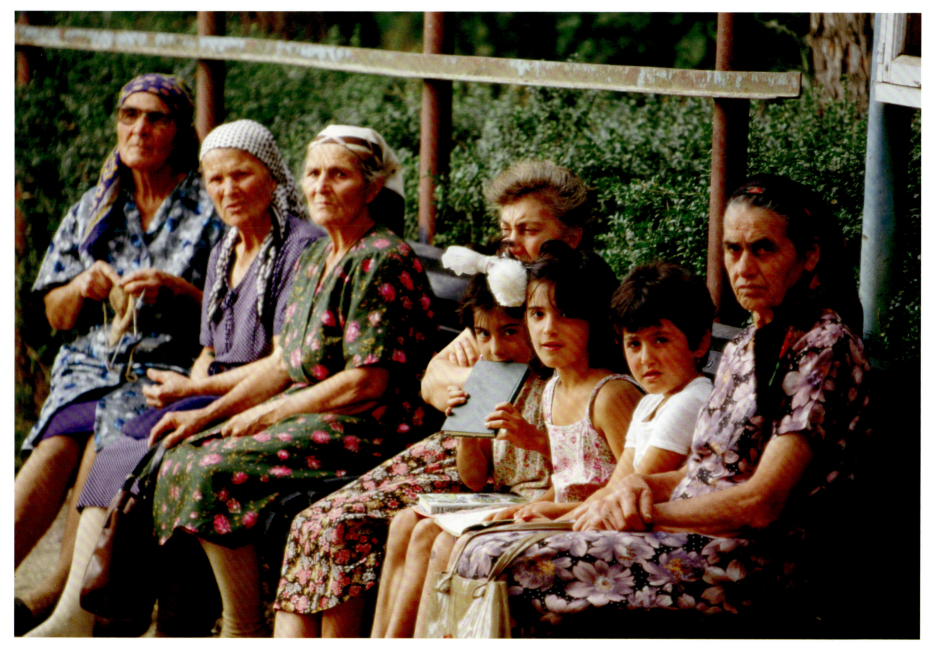

Women and children sit on a bench at a remote village in Nagorno-Karabakh during an ICRC food distribution.

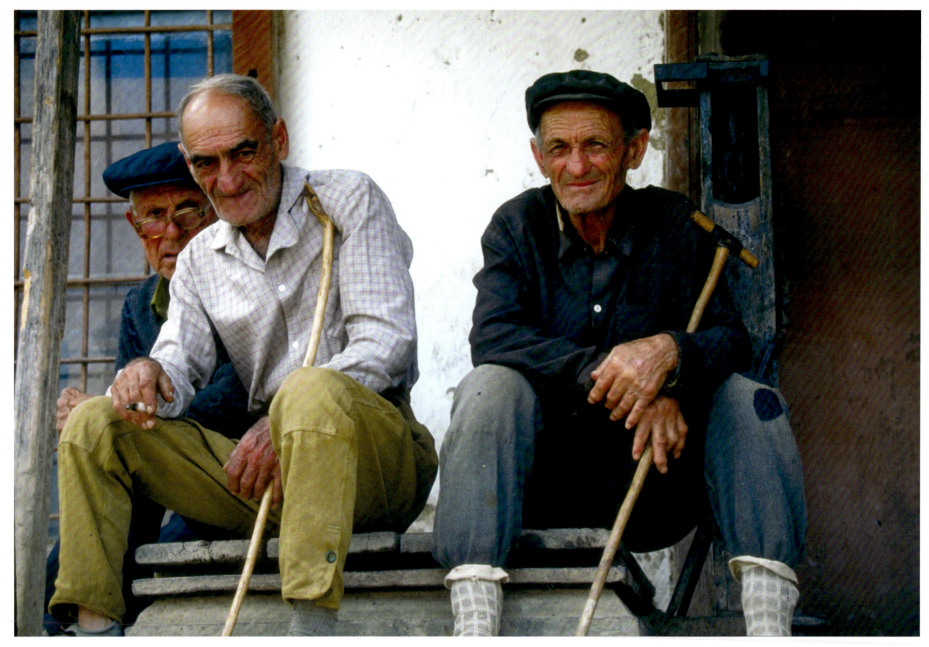

Three elderly men in Nagorno-Karabakh.

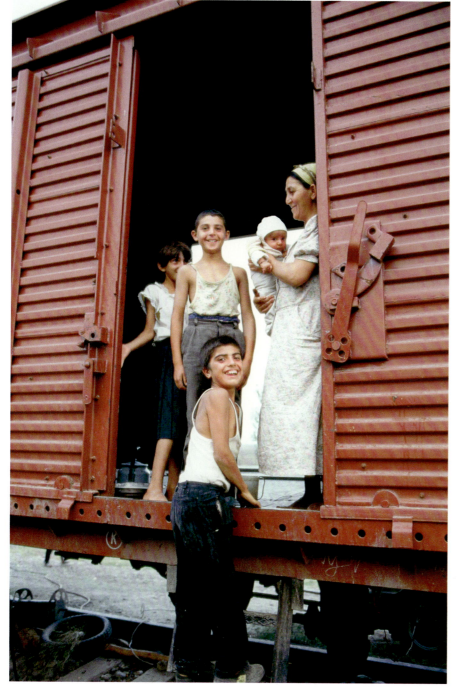

A refugee family in the doorway of their train home in Azerbaijan.

An elderly woman waits at a food distribution area in Nagorno-Karabakh.

The victims most affected by war are women, children, the elderly and the injured or sick. When humanitarian laws are broken and urban or rural civilian populations are targeted in the fighting, it is these civilians who bear the brunt of the wounding and death. In Chechnya, I photographed a young boy who had been with his mother in a group of people waiting in line for water at an outdoor hand-pumped well when a fighter jet dropped a bomb on the group. The boy was behind a truck and shrapnel from the blast ripped off his legs above the knees. I don't know what the military objective was; I only know that there were many civilian casualties and many injured villagers. These days the news is full of civilian casualty counts from drone strikes, suicide bomb blasts and the shelling of cities and towns; it has become the new normal in our collective experience.

Despite the suffering, there is a resourcefulness and inner resilience that can be seen in times of conflict, particularly in the faces of the children. Their spark of innocence, constant curiosity and sense of wonder were present even in hard circumstances. The children and young adults I saw who had taken up arms and joined the killing had lost that spark. Their eyes became haunted, distant and haughty, the spark obscured behind experience beyond their years.

In Liberia I met boy soldiers whose stories chilled my blood. Their experience of war had nothing to do with honor, courage and standing up for a just cause. They were caught up in a situation that forced them to revert to the base instincts that lie just beneath the surface of us all.

Mother and child in Nagorno-Karabakh.

Grandfather watches over a child sleeping under a train that is their refugee home in Azerbaijan.

Boys at an ICRC school lunch program in Sarajevo, Bosnia.

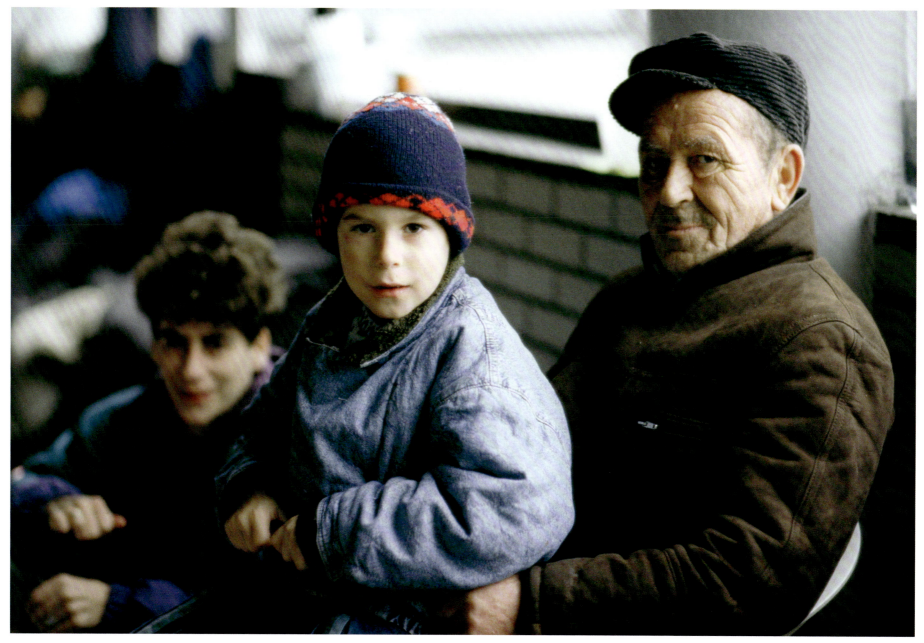

A family waits in a camp for displaced people in Bosnia.

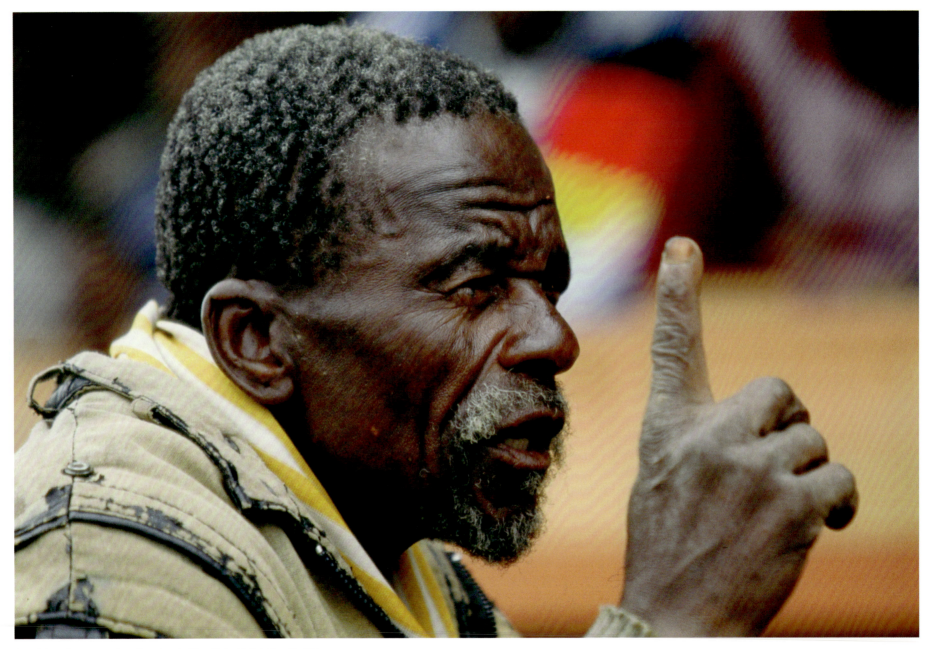

An elder discusses the situation in KwaZulu Natal, South Africa.

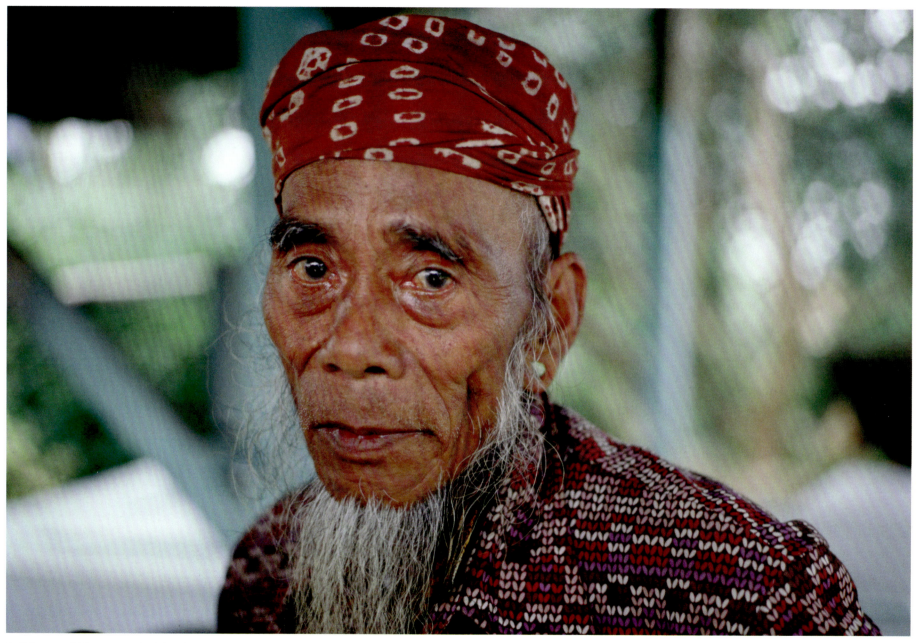

A 106-year-old farmer on the island of Mindanao, Philippines.

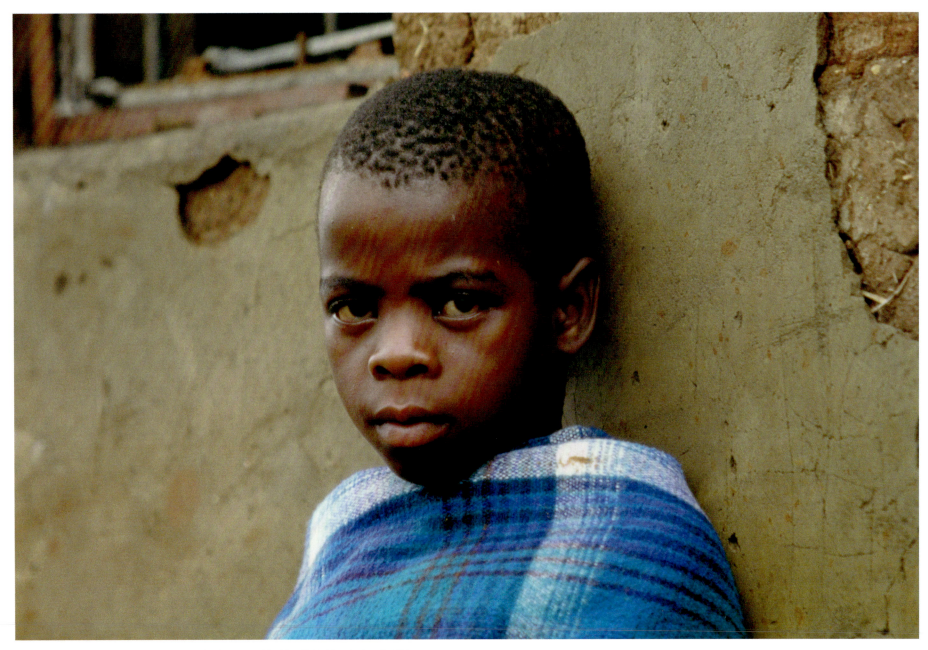

A young girl whose village was recently destroyed in KwaZulu Natal, South Africa.

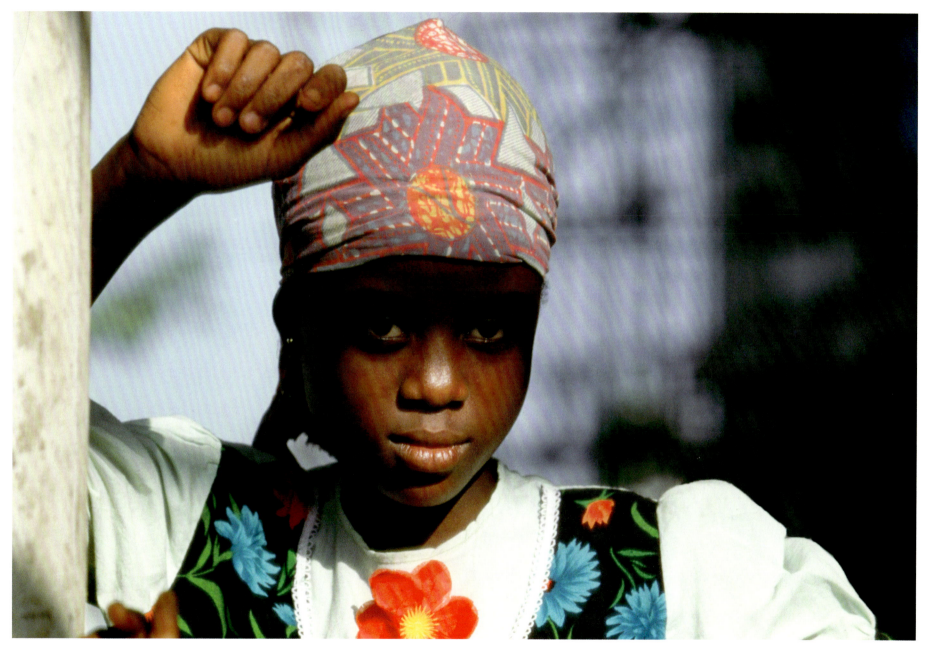

Displaced girl in Monrovia, Liberia.

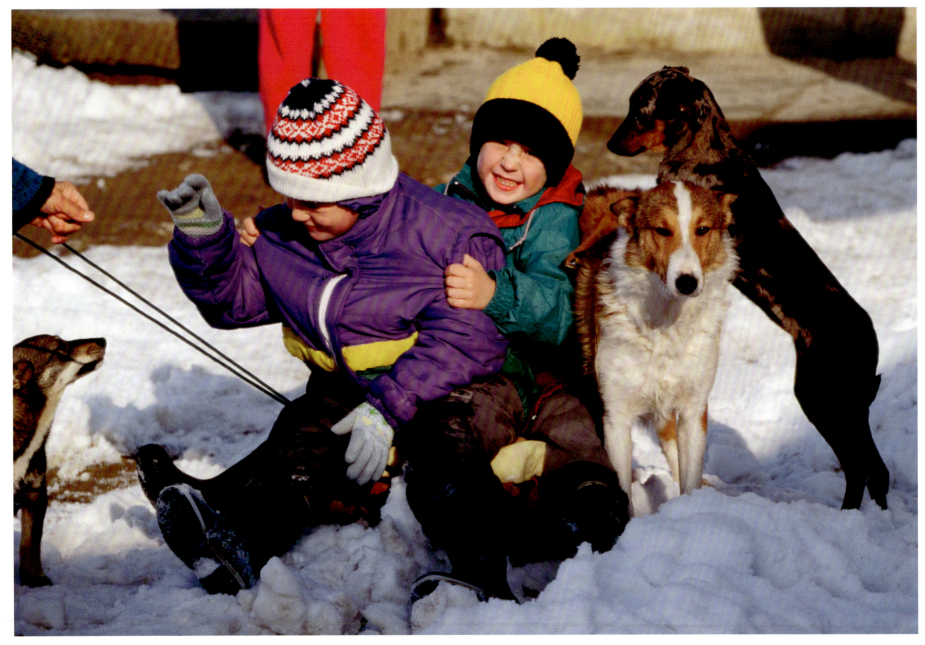

Bosnian children play in the snow with dogs at a refugee camp in Croatia.

Orphaned children in Colombia.

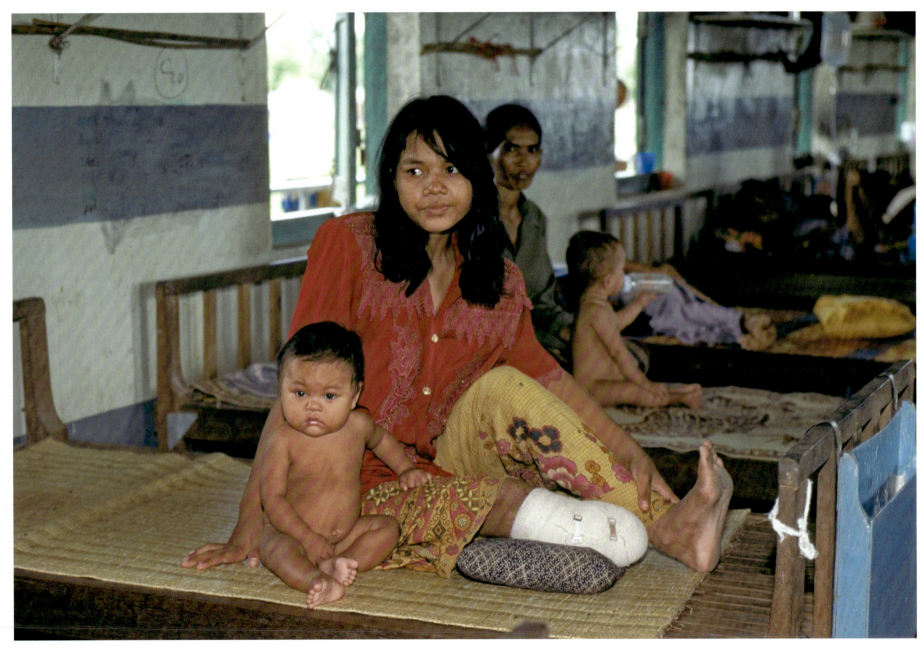

A land mine took the leg of this young mother, who found refuge in an ICRC hospital in Cambodia.

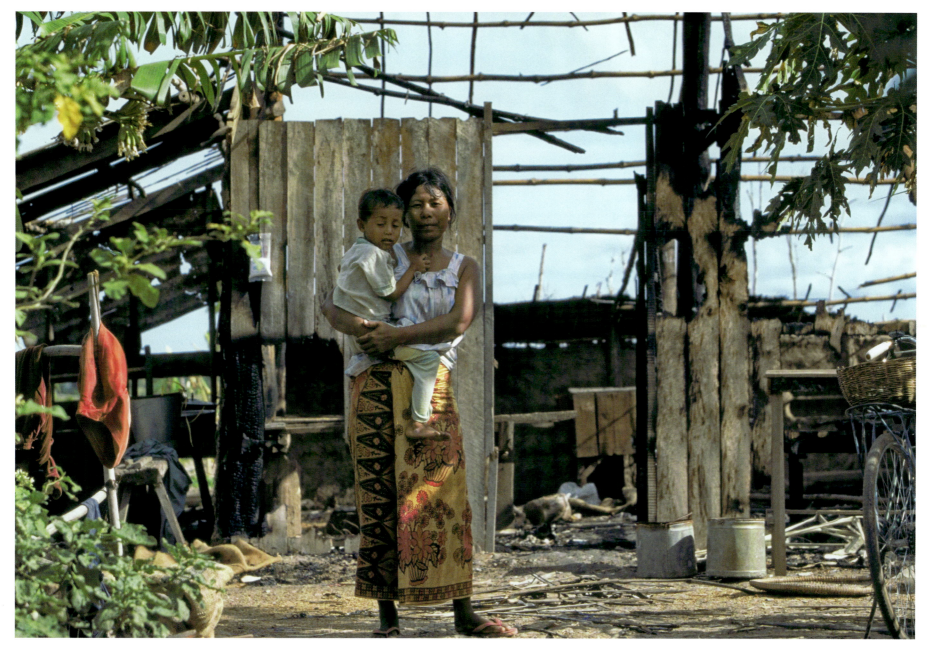

Their house, destroyed in the night by rebel fighters in western Cambodia, leaves this mother and child with no option but to travel to a camp for displaced persons.

Bhutanese refugee camp in southeastern Nepal.

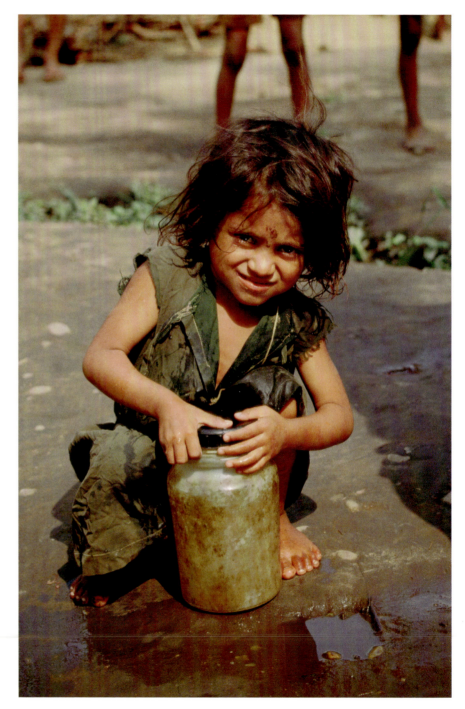

A girl seals the lid of her water jug at refugee camp in Nepal.

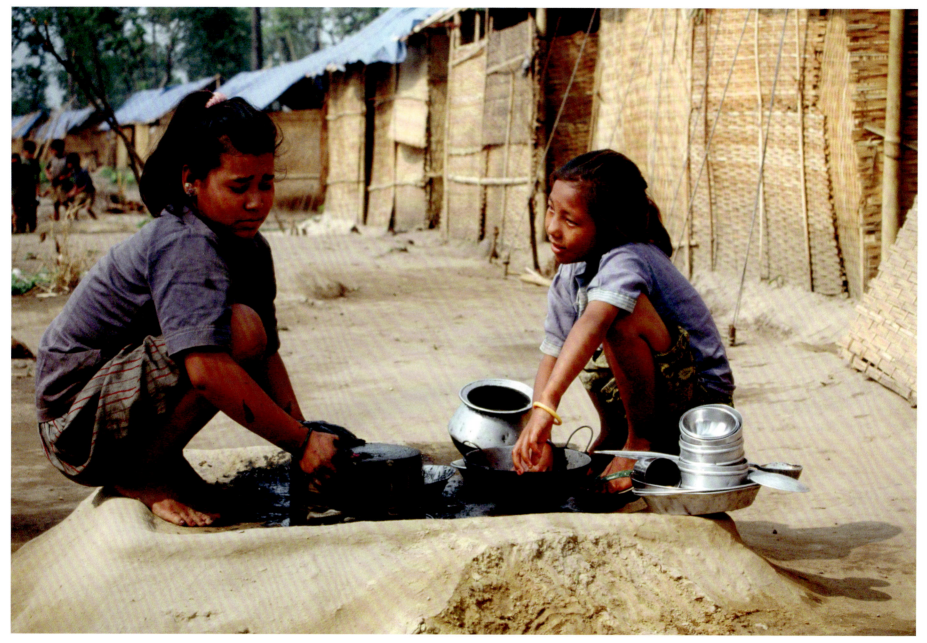

Scouring dishes with mud at a Bhutanese refugee camp in Nepal.

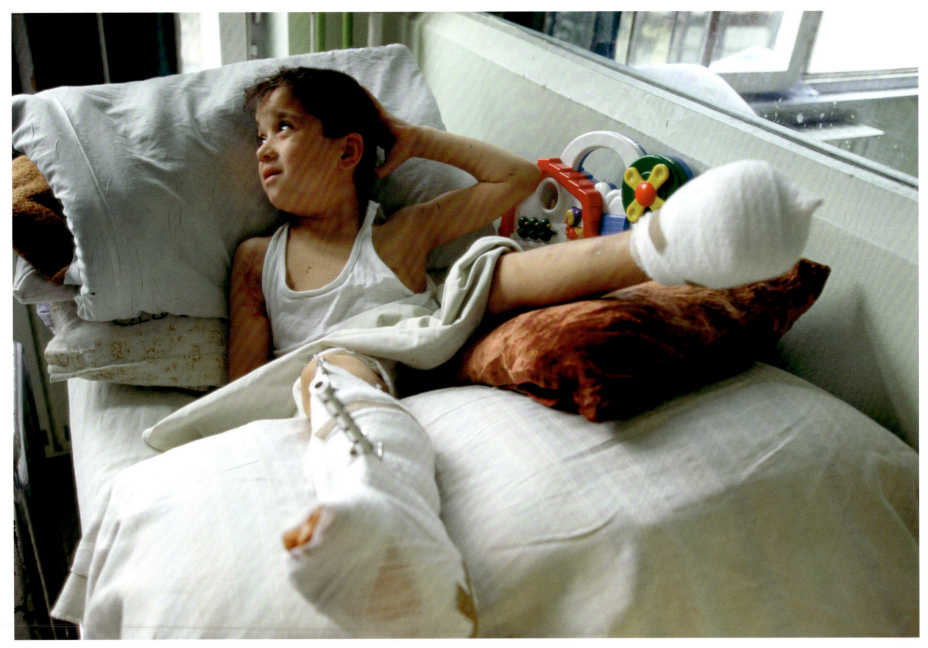

A boy in a Sarajevo hospital recovering from land mine wounds.

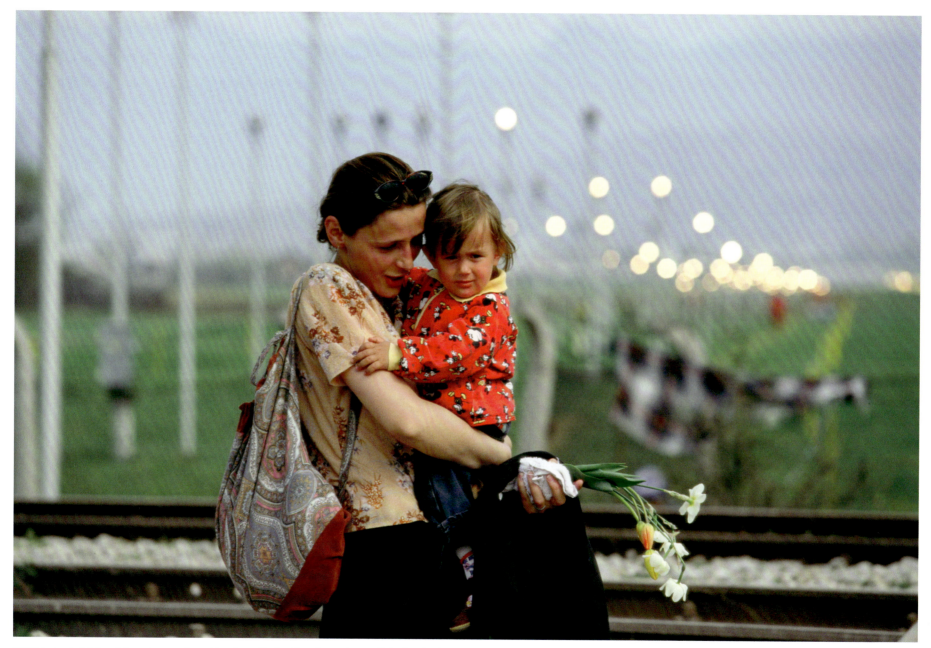

Mother and child walking along railroad tracks with the Sarajevo airport flight line in the background. This area was heavily mined until recently.

High school boys hang out near their destroyed school buildings in KwaZulu Natal, South Africa.

A young student in Guatemala.

In the heart of humanity lies the sacred duty of caring for those most vulnerable. Children thrown together by conflict express this adult duty with each other quite naturally. Many of the children I met were extremely mature for their age. I remember a young Rwandan boy who had lived in a refugee camp for many months in what was then Zaire, on the edge of Lake Kivu. When he offered me flowers, a rarity in the camps, I could see in his eyes that he was offering much more. I could also see the strength he gained through his friendship with the other boys.

The exposure to suffering stirred in me a desire to make a difference for someone, for a single person where I could observe a tangible benefit. I saw time and again that following this instinct often leads to more suffering than relief. I remember being roundly scolded by a Buddhist monk in India after I gave a large rupee note to a crippled beggar. He explained that this would only lead more people to begging, anticipating such a large reward. I was only trying to ease my own inner pain by convincing myself that I was helping another in need. It happens all the time in subtle and not so subtle ways. Both on the personal and collective levels, we often act to ease our conscience instead of truly inquiring into the situation of another. There were orphaned children I met whom I wanted to pick up and take home. Yet I did not know the circumstance of their lives enough to respond with such an act, nor had I contemplated the resources with which to follow through. The question of what is appropriate action in a world that has tens of millions of refugees is important. Who will open their homes, their wallets and their hearts to make a difference beyond the emergency responses to war?

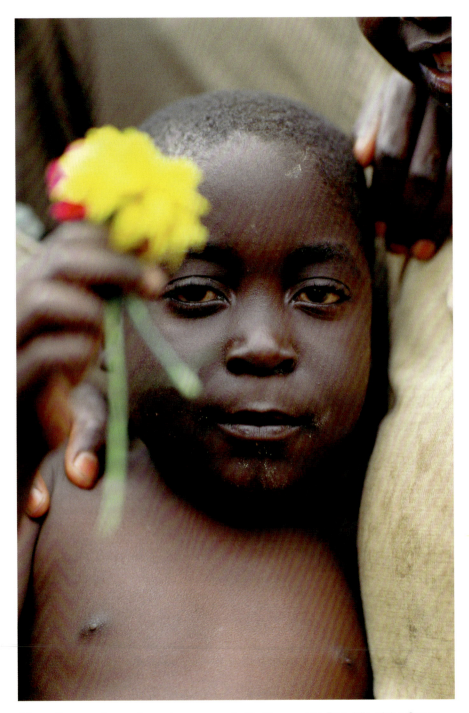

A boy offers me flowers in a refugee camp in the Democratic Republic of the Congo.

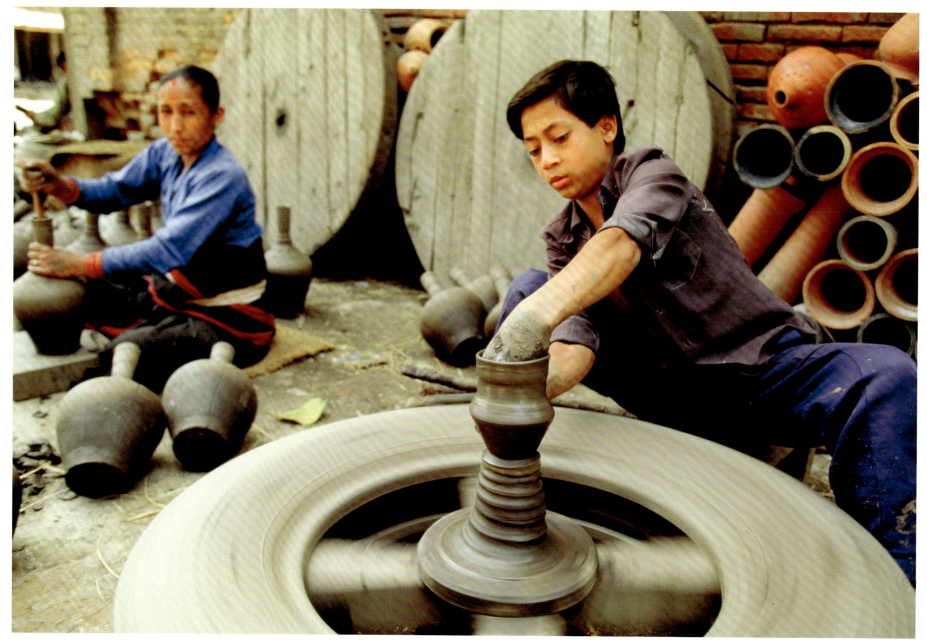

A young man throws a pot on a kick wheel under the watchful eye of his mother in Nepal.

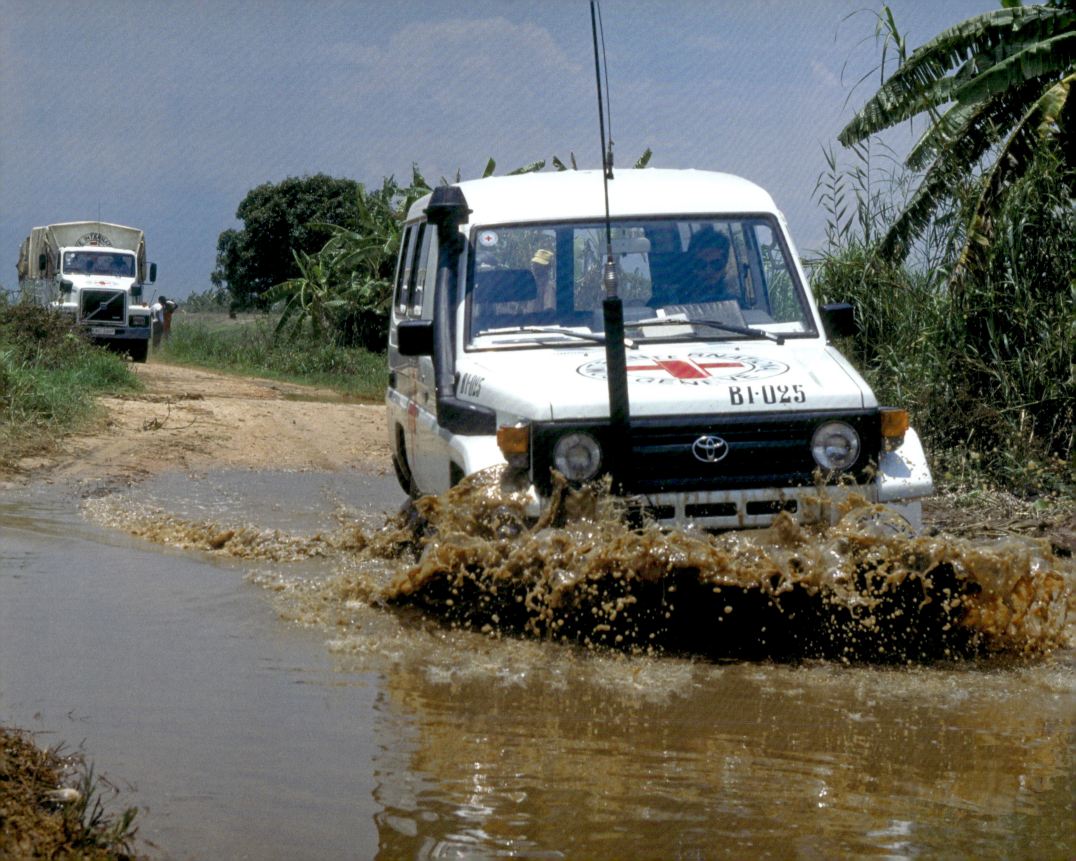

Humanitarian Activities in War

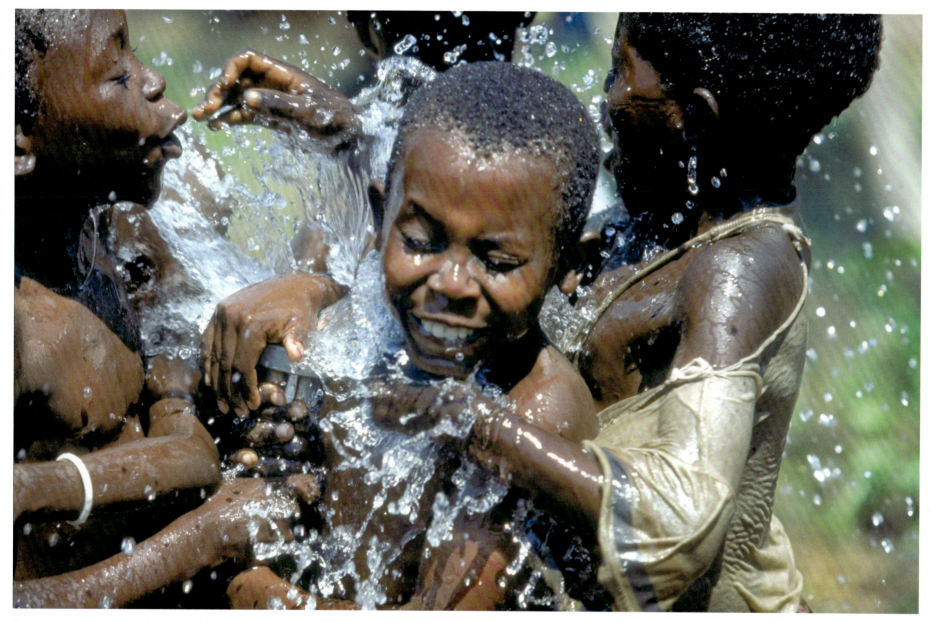

Boys play in freshwater being released from a tanker truck that got stuck in wet sand in Burundi, 1995.
Opposite: An ICRC Land Cruiser leads a convoy of trucks loaded with freshwater in large bladders, Burundi.

Water

My stomach churned as I watched young boys drinking from the edges of a mud puddle in the road. It was hot and humid. The blazing sun turned the recent rain into a haze above the ground. If I had taken one sip from that puddle I would have become violently ill. Cholera was rampant in this area of Burundi, but after the freshwater supply was cut off during recent fighting, people resorted to drinking the dirty water.

In mid-October 1995 an ICRC convoy of vehicles delivered freshwater to people in desperate need. The convoy consisted of two tanker trucks filled with water bladders led by two Land Cruisers—standard ICRC practice. The delegates in the lead vehicles negotiated passage at each military checkpoint en route. Strict procedure was always followed when operating in a conflict zone.

Three of the delegates whom I photographed in Burundi died eight months later. They were killed when the two lead vehicles in a convoy, like this one, were fired upon. Soon afterward the entire operation was shut down as threats continued. Clean water is the most basic human need and access to it sometimes becomes a tool for waging war, with dire consequence to civilians.

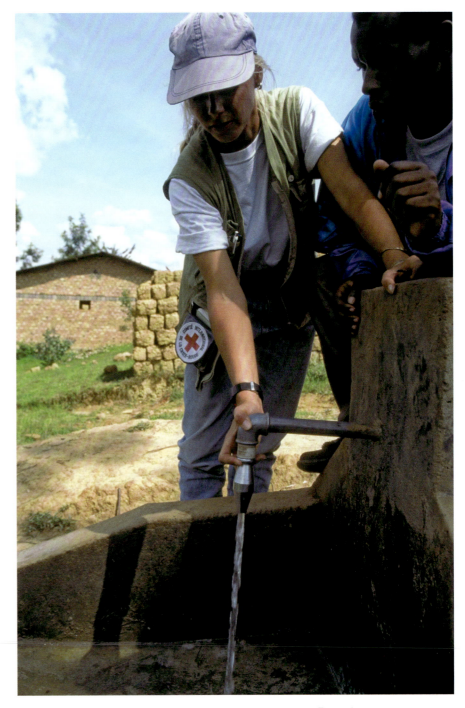

An ICRC delegate checks on a newly installed standpipe in Rwanda.

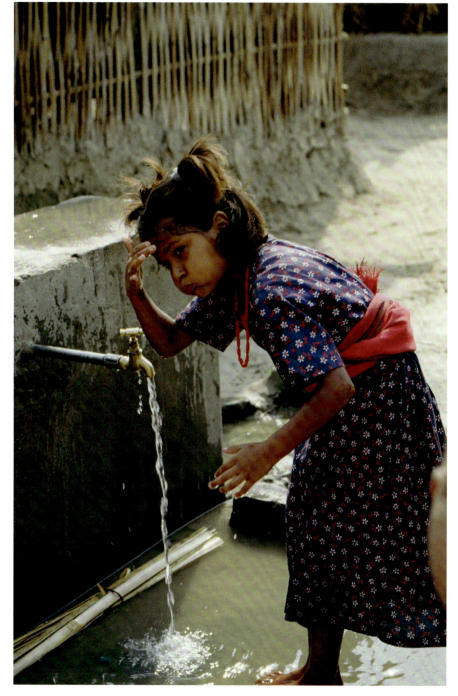

A girl washes at a standpipe at a refugee camp in Nepal.

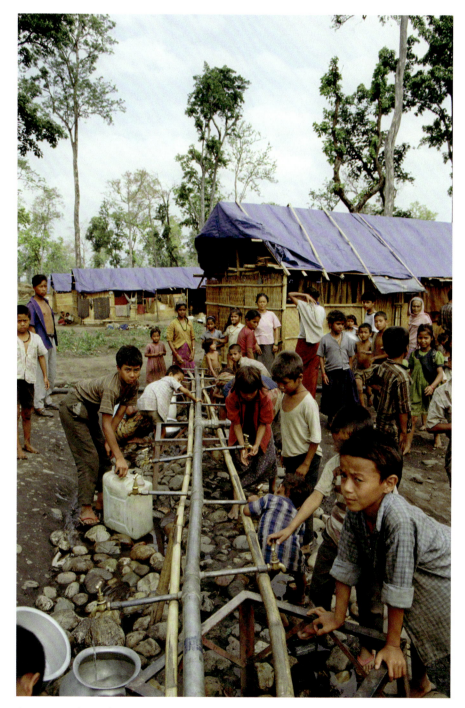

A communal standpipe at a refugee camp in southeastern Nepal.

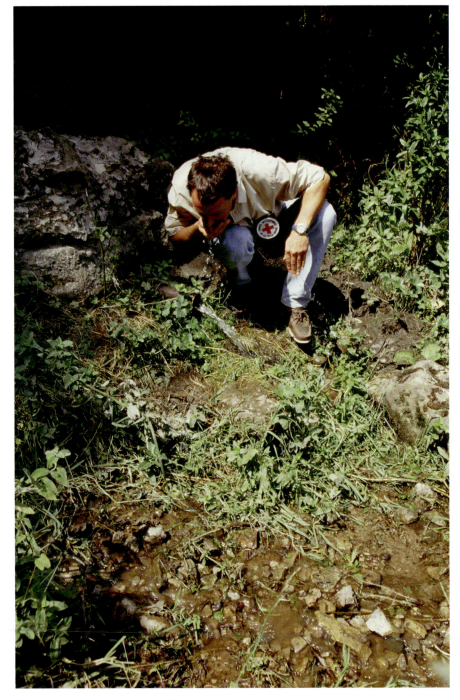

Tasting water from a spring in Nagorno-Karabakh.

Clean water flows in Sarajevo, in great part due to Fred Cuny's work.

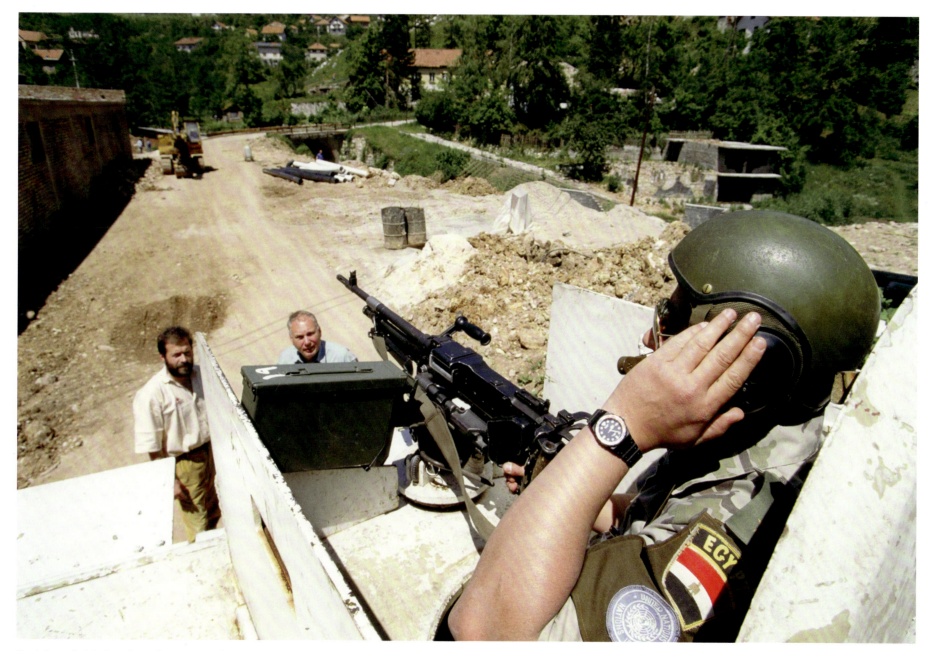

Fred Cuny (in blue) and a colleague speak with a UN security officer providing security at an Intertect water purification project in Sarajevo, 1993.

Medical

An ICRC medical team traveled one morning from Bujumbura, the capital of Burundi, to a remote area where they set up a temporary medical clinic in a two-room schoolhouse. People had walked to the clinic from around the area. They came quietly and stood in line waiting their turn. There were a wide variety of medical problems, from festering wounds to an overdue expectant mother. Many had stomach illnesses from the lack of clean water and sanitation. A baby needed minor surgery and stitches. A few hours after setting up the clinic a long line of people waited outside. A group of soldiers came walking up the road, fully armed. Most of the people scattered into the bush. The soldiers wanted some aspirin, which they were given, and they departed. Slowly at first, then more rapidly, people came out of the bush and took their respective places in line.

It surprised me how frightened the people were of the soldiers, even with the presence of the ICRC, yet given the killings that had been committed by ethnic groups on each other, it was entirely understandable. The civilians were Hutus and the soldiers were Tutsi. At other times and places the roles were reversed. I had felt this kind of animosity for the "other" in Bosnia and each conflict zone I had been in. It feels like an electric charge to the system. Your spine tingles and the hair stands up on the back of your neck. This instinctual response lies just beneath the surface, unconscious, until precipitated by a perceived threat.

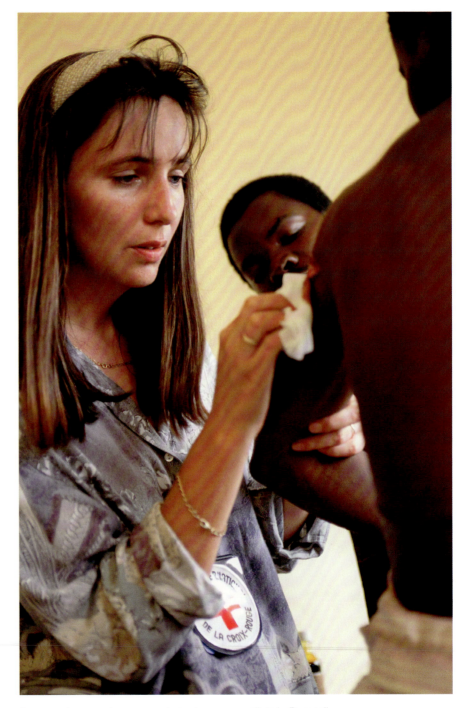

A nurse cleans a deep wound at a temporary clinic in Burundi.

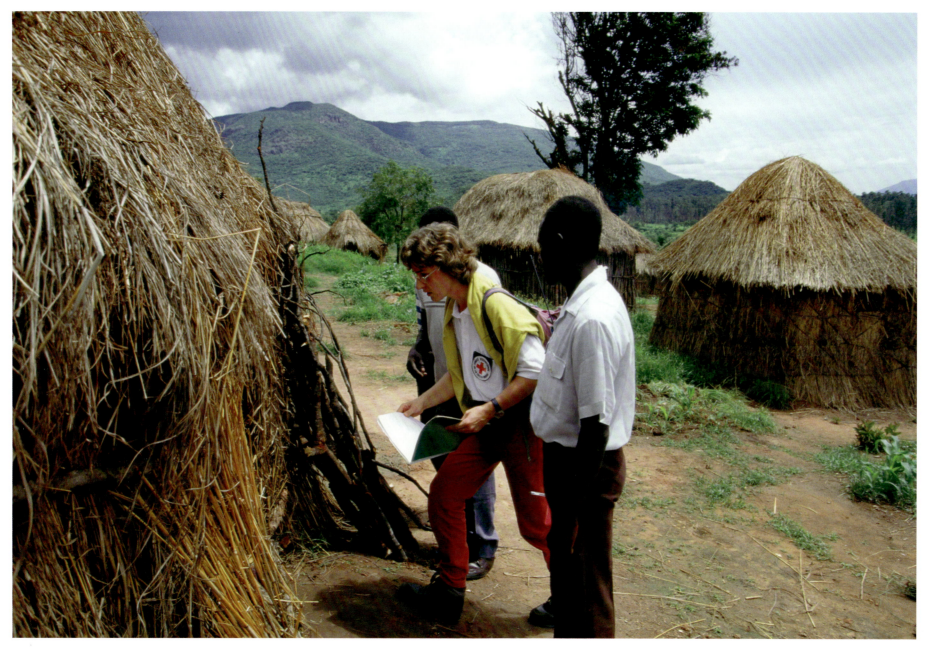

An ICRC nurse enters the hut of a patient at a remote medical clinic in Angola. She has flown by small plane, then ridden a bicycle to get to this clinic.

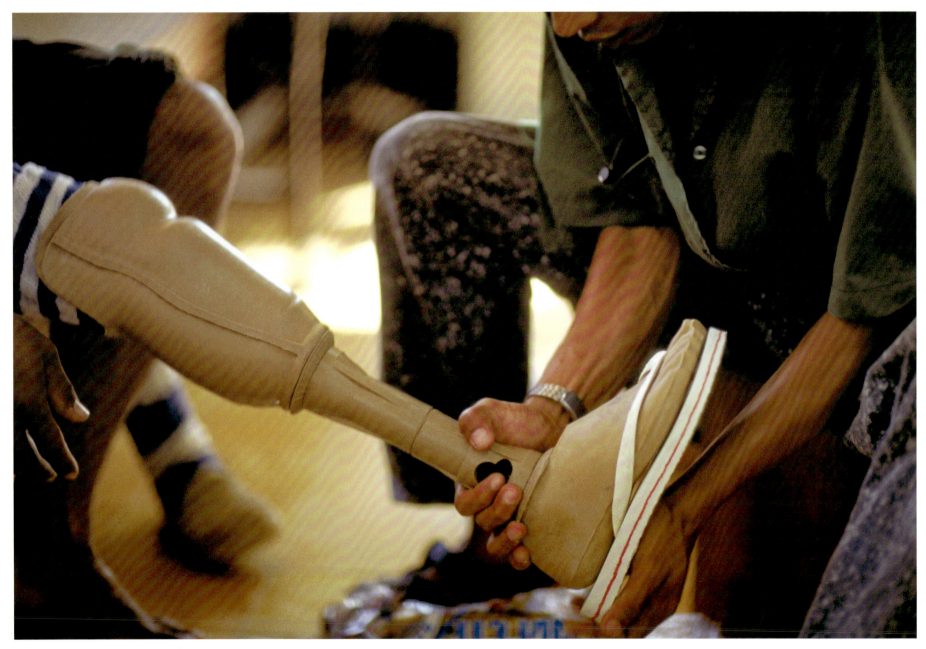

Fitting a new prosthetic leg for a land mine victim at the ICRC rehabilitation center in Battambang, Cambodia.

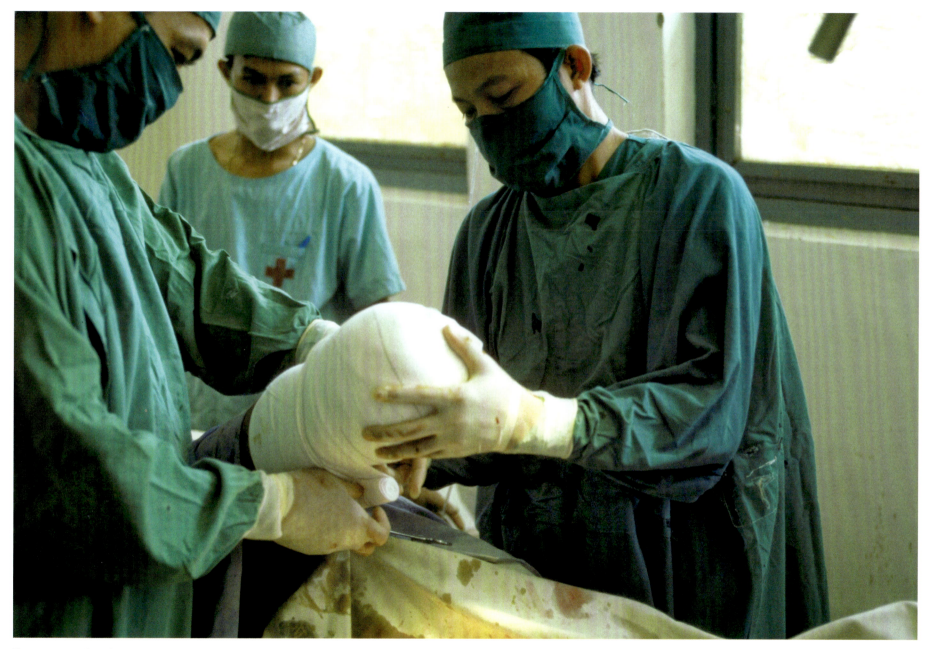

Doctors complete the amputation of a land mine victim's leg in Cambodia.

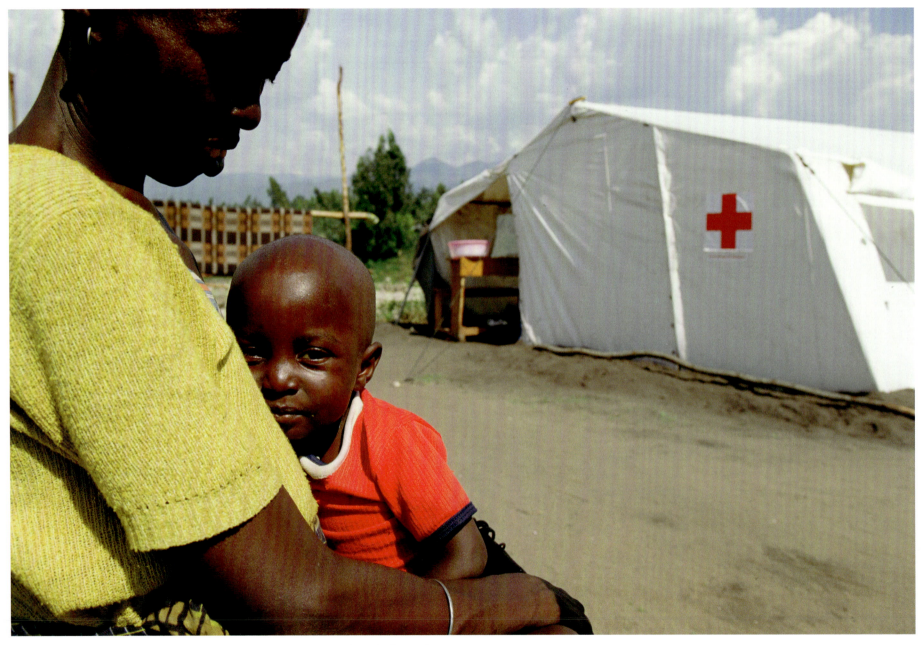

Mother and child wait for treatment at an ICRC clinic for cholera patients in Burundi.

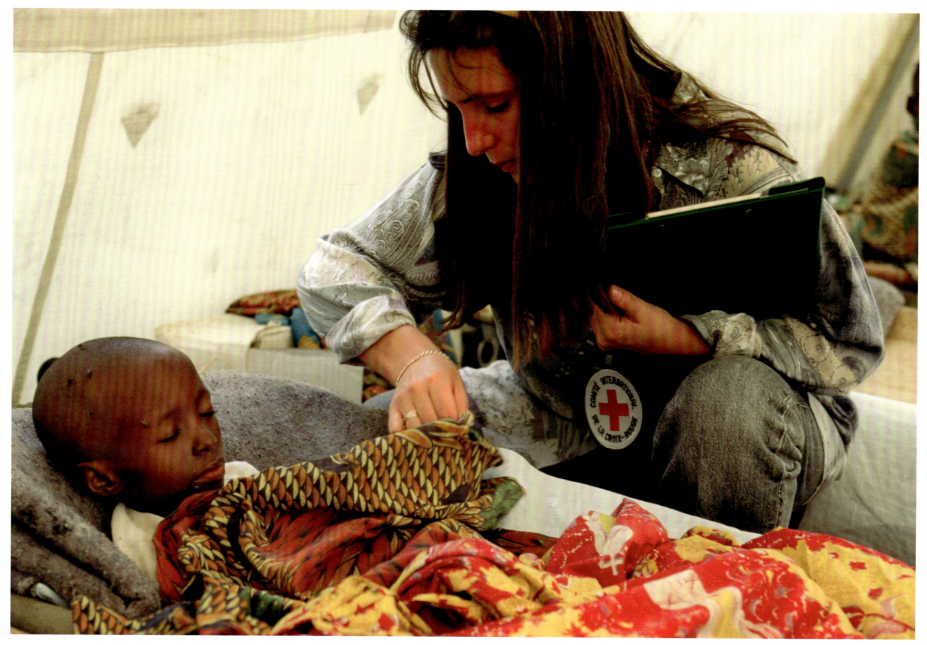

An ICRC nurse checks on the condition of a cholera patient in Burundi.

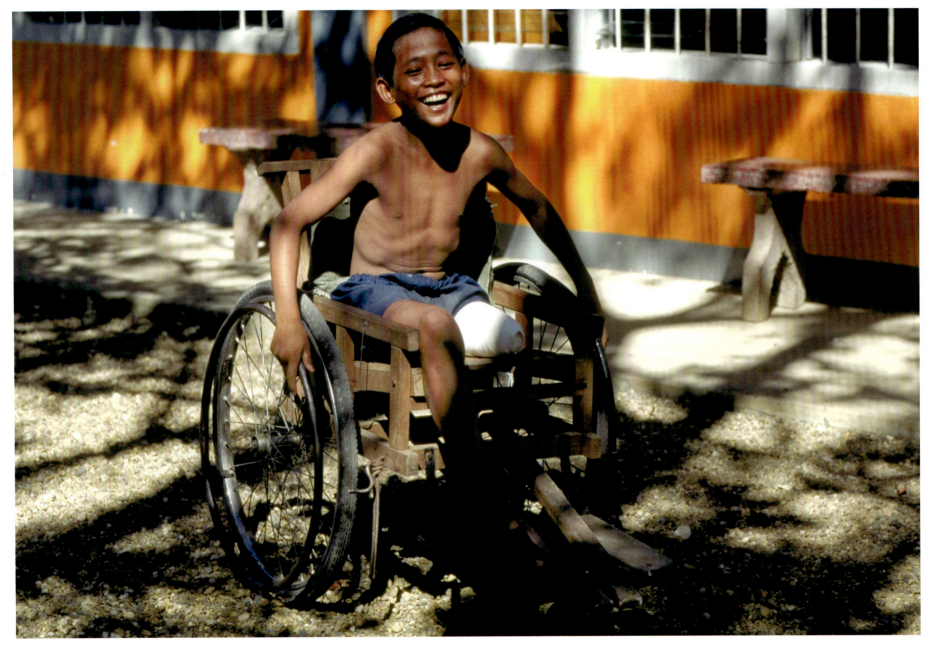

A boy who lost his leg to a land mine is happy because today he gets a new prosthetic leg at the ICRC clinic in Cambodia.

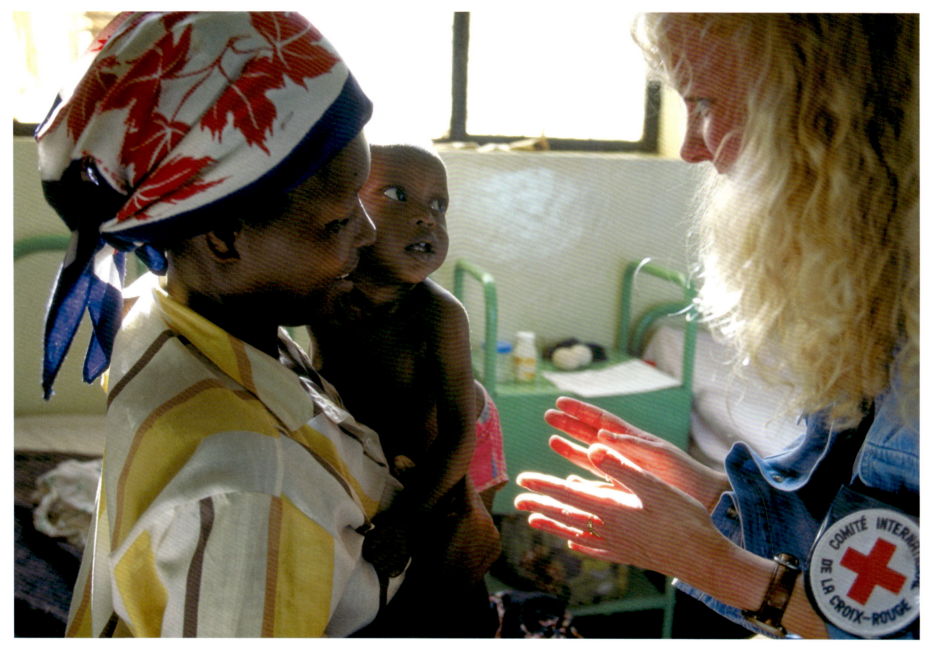

An ICRC nurse checks on a child's health at a clinic in Rwanda.

Relief

With the last rains of the season in early June it was a good time to plant crops in Burundi. I joined a relief convoy delivering seeds to people in the north. When we rolled up hundreds of people were waiting patiently in lines and clustered in small groups. It was threatening to rain, so there was a very palpable urgency to the activity. Truckloads of seeds were offloaded and people submitted slips of paper that confirmed the household for which the seeds were being received. There was a remarkable degree of accountability displayed on both sides. I witnessed relief distributions like this many times, and they were always efficiently run operations. Not once did I observe violence during a distribution. Sometimes there were heated arguments about identities or quantities, yet groups tended to be accountable and self-policing. People always seemed to know when someone was trying to cheat the system.

The seeds were treated with great care. I watched children picking up spilled seeds one at a time. It was good to see relief aid that would assist in helping people help themselves. Maintaining the dignity of self-preservation is almost as important as feeding urgent hunger. Even though these seeds would give only temporary relief, the thought of land turning green as soon as these seeds sprouted brought a smile to my face.

Relief is one of a wide range of activities the ICRC conducts in conflict zones to promote economic security and sustainable livelihoods. Emergency food and household items are at one end of the spectrum and microeconomic initiatives at the other, all under the mission of protecting victims of conflict.

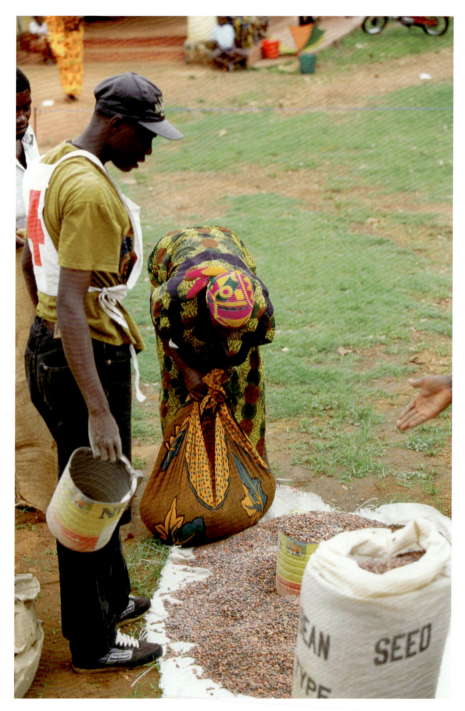

Seeds are distributed for planting in northern Burundi.

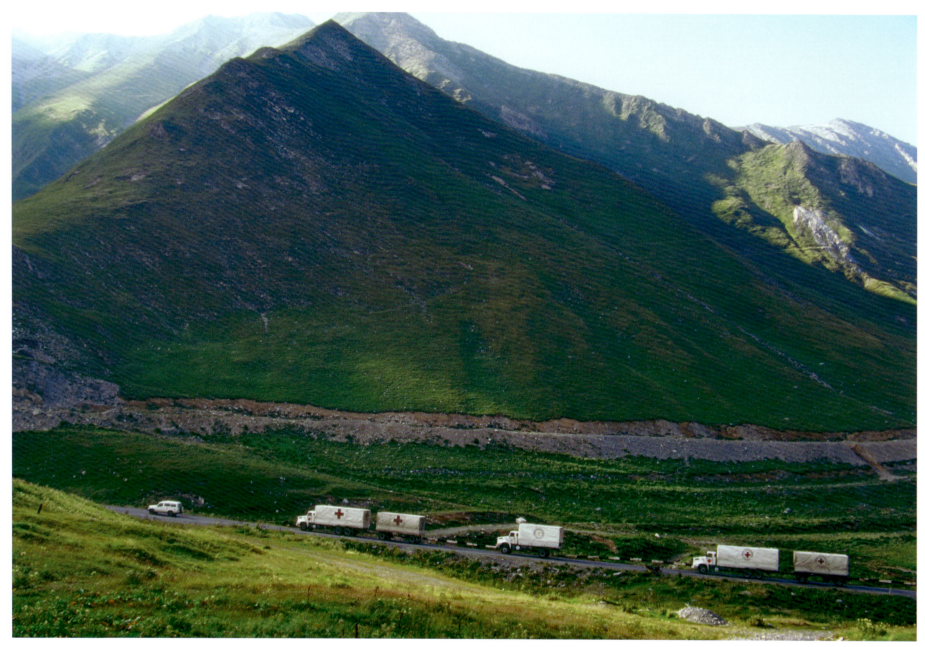

A relief convoy summits the Caucuses mountain range on the way to Tblisi, Georgia.

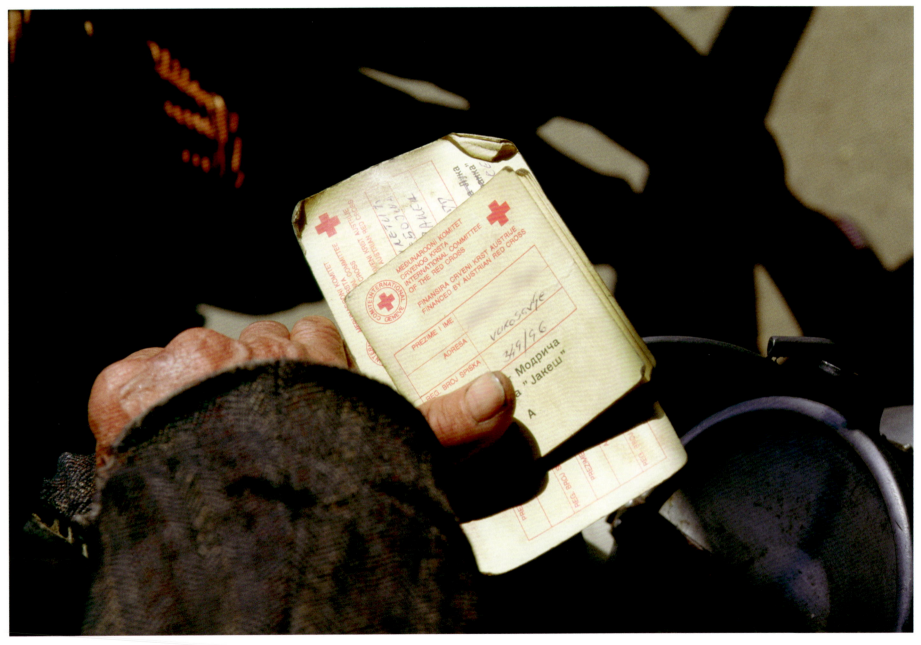

An elderly man holds his ICRC ration card and ID papers at a soup kitchen in Bosnia.

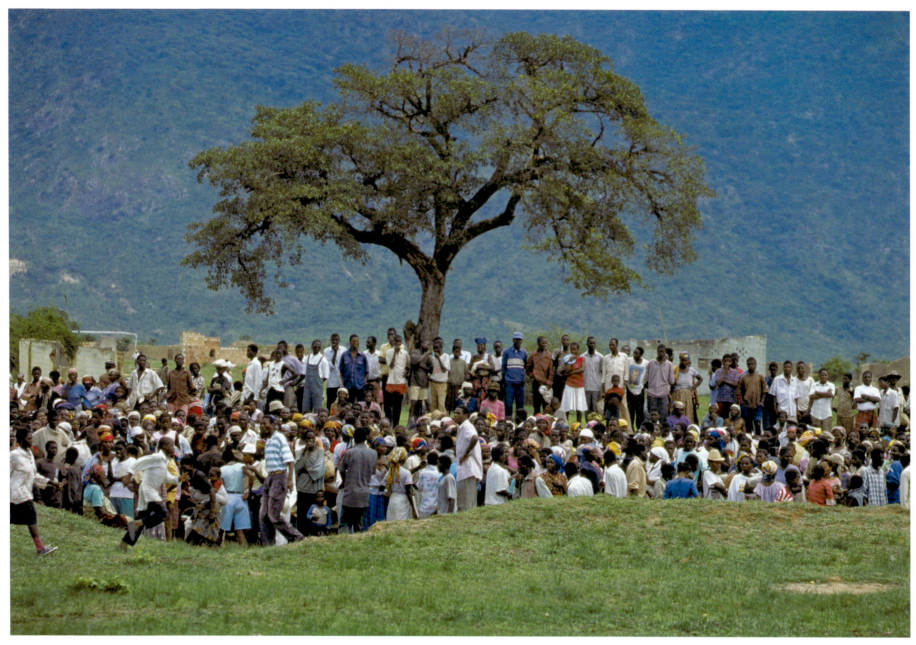

A village waits for trucks from an ICRC convoy of food relief in Angola to be unloaded.

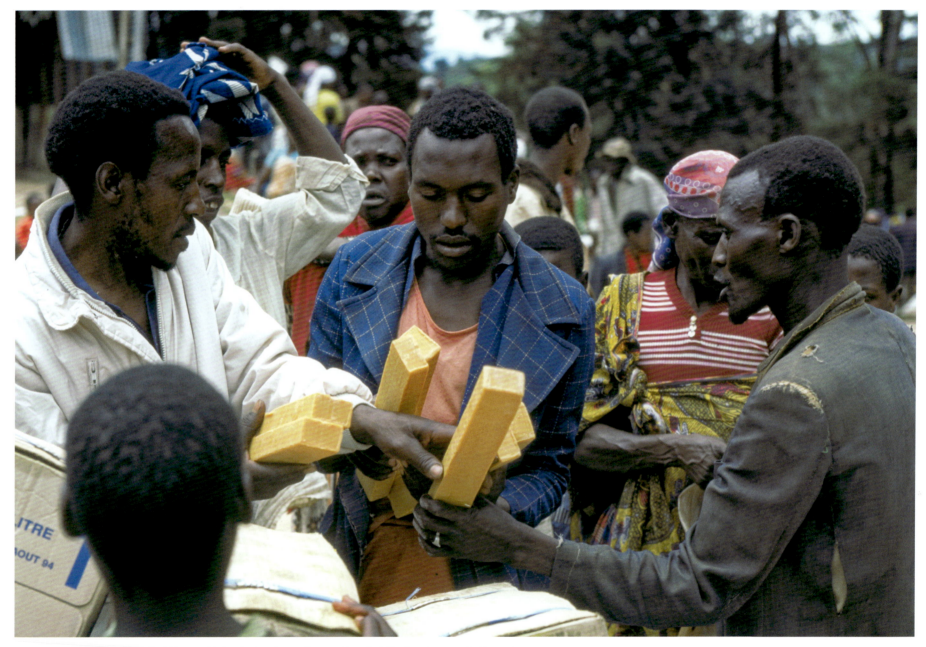

Blocks of soap are distributed along with basic food supplies at this relief distribution area in Rwanda.

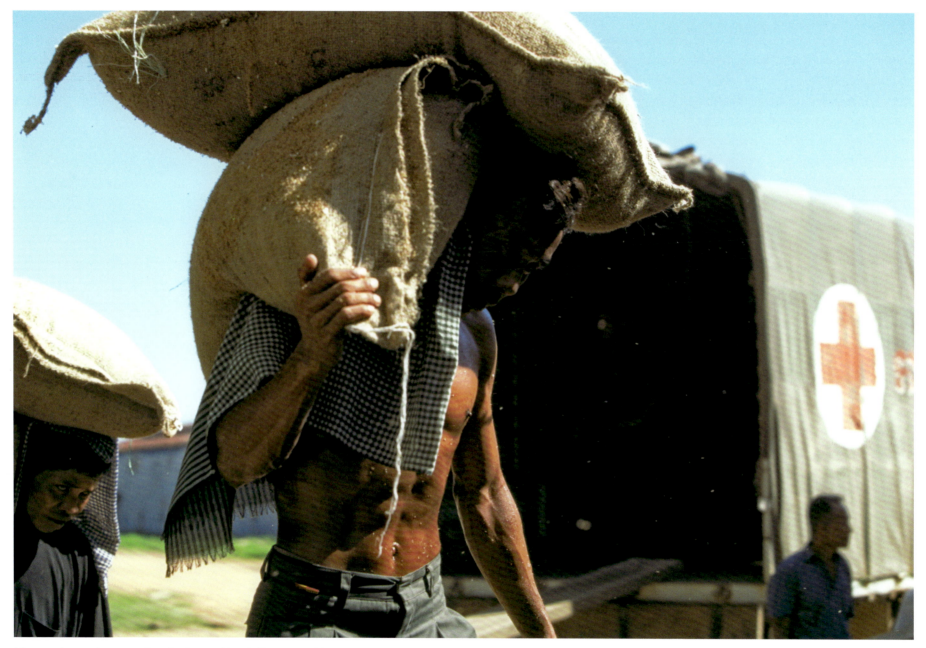

Men, each carrying a two-hundred-pound load, fill a truck with bags of rice in Cambodia.

Prisoners

The smell of unwashed humanity was almost overpowering before we entered the room. I was with two ICRC delegates about to talk with prisoners in their place of detention. On entering the room I could not see anything, only darkness. The pungent smell washed over us and the murmuring of many human forms could be heard. About fifty men were packed into the room and appeared out of the darkness as our eyes adjusted. There was only one small window high on the wall of the group cell. Plastic bags with their belongings hung on the walls. Basic items brought by the ICRC provide a degree of dignity for the prisoners. A toothbrush, some soap, a small kit of personal items—these bring a sense of belonging to the family of man. The nutritional quality and quantity of the prison food was monitored, and the prisoners' medical needs were sufficiently attended to. At this prison in Burundi the ICRC nurse had a special spark in her eyes. I could see that she was a talented nurse and took joy in her profession. Unfortunately, I learned years later that she had died of an illness contracted while working in the prison.

When issues arise during a prison visit concerning living conditions or the treatment of prisoners, they are taken confidentially to the prison authorities or local officials. Prison officials may review and censor Red Cross messages coming in or going out of the prison. This transparency, confidentiality and neutrality allow the ICRC to do its work and to continue returning to places of detention to serve the prisoners. Delegates work with the local authorities to prevent abuse and to improve the treatment of detainees and their living conditions. Providing a long-term process and a returning presence gives hope and a thread of connection for those detained in armed conflicts. My grandmother passed this hope along to others in her small town in Indiana when she received a Red Cross message from my father imprisoned in Germany during World War II.

A prisoner of war in Azerbaijan writes a Red Cross message to his family in Armenia.

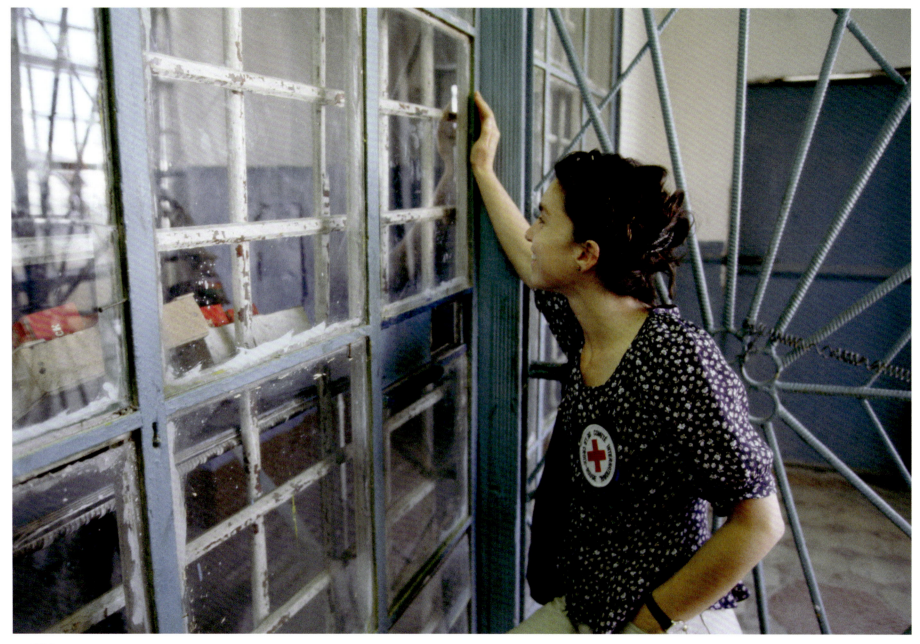

An ICRC delegate waits to be let in for a scheduled visit at the entrance to a prison in Azerbaijan.

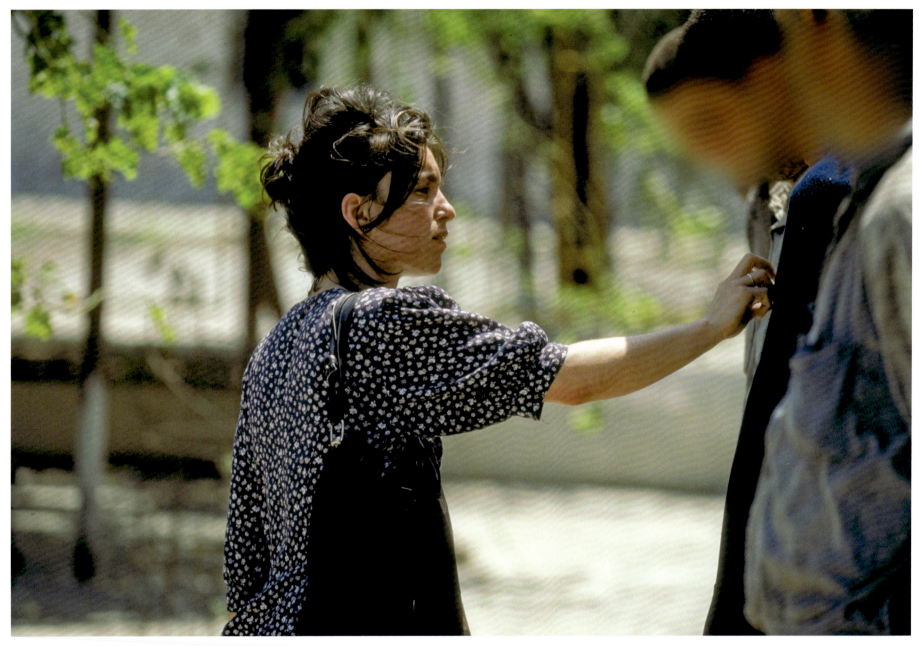

An ICRC delegate talks with prisoners of war about their conditions at a prison in Azerbaijan.

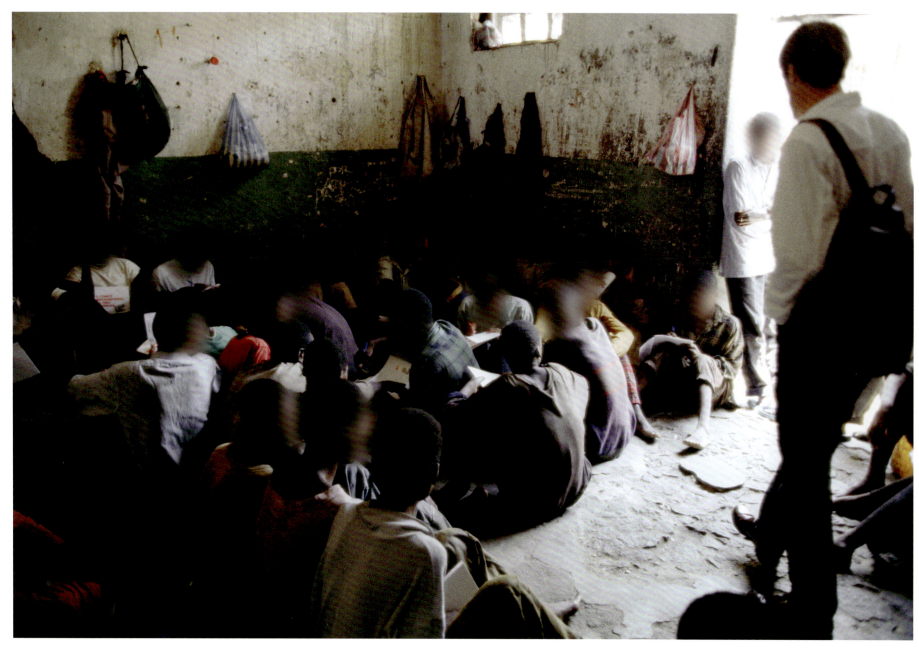

An ICRC delegate helps prisoners fill out Red Cross messages in their place of detention in Angola.

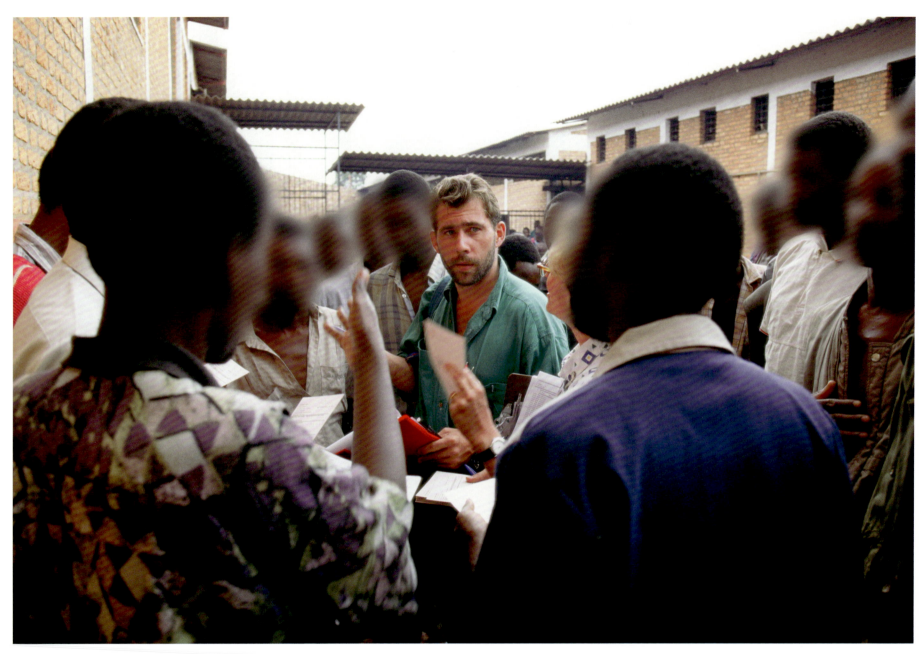

ICRC delegates register prisoners and give them Red Cross messages to fill out in their place of detention in Burundi.

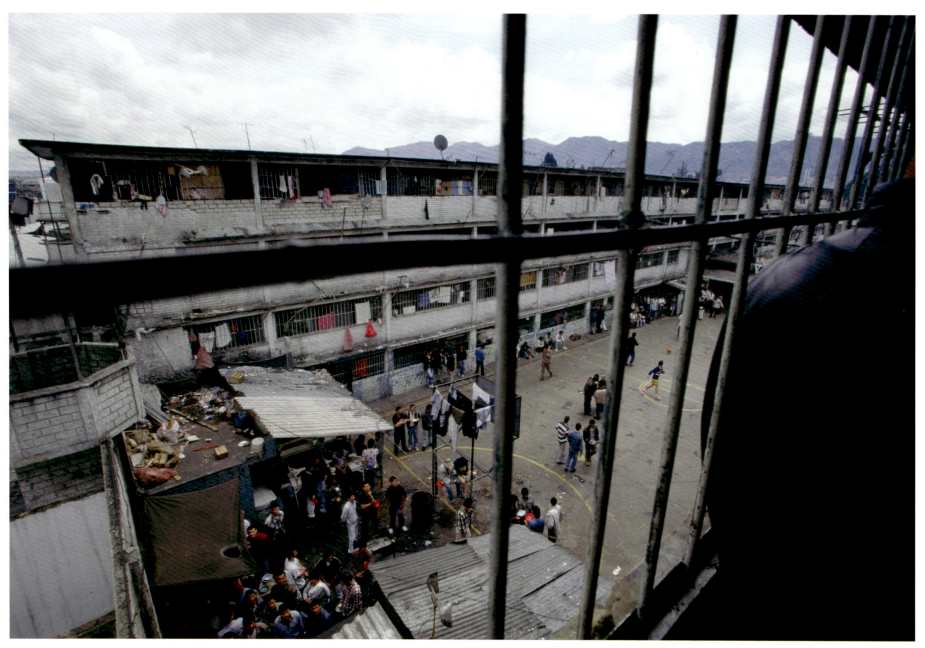

Looking out from the *guerrilleros* section of a prison in Bogotá, Colombia.

Tracing

When I first learned of the tracing, family messages and repatriation activities of the ICRC, I did not think it would be interesting to photograph. How wrong I was. Family contact is a fundamental human need. In the turmoil of conflict, family members can become separated in minutes. The anguish and uncertainty that spouses and parents face about the fate of their child, spouse or relative may last for years. In conflict zones the ICRC acts as a postal service for families separated by fighting. Through its tracing service and relationships with national Red Cross societies, it helps to reestablish family connections or clarifies the fate of those who remain missing.

In Rwanda, during the massacre of 1994, there was a mass exodus of more than two million people. Many walked with what they could carry into neighboring Zaire across Lake Kivu from Rwanda. Refugee camps in Zaire, now known as the Democratic Republic of the Congo (DRC), came to house millions of people. Many children were separated from their families and the only way for them to get back in touch was through the Red Cross tracing service and through family messages. Bulletin boards posted around the camps became a kind of lost and found for separated family members. When children living in camps in the DRC were reconnected with their parents back in Rwanda, the ICRC would (when possible) facilitate their safe return. I traveled with one such group of children who were transported in a convoy of Land Cruisers across the border in Bukavu, DRC, and made the long drive to reunite with their families in Kigali, Rwanda. I tried to imagine the terror, suffering and pain of separation these children must have experienced when walking in the other direction, fleeing the killing with millions of others. The roads had been filled with a solid mass of humanity walking out of Rwanda for weeks.

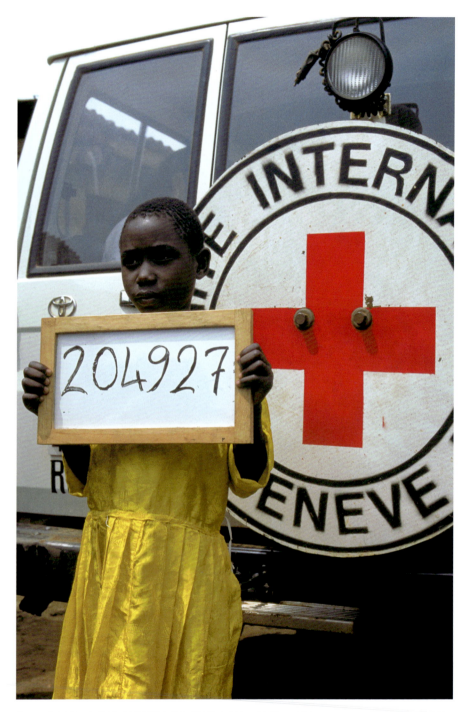

An orphan is photographed by the tracing team in Rwanda.

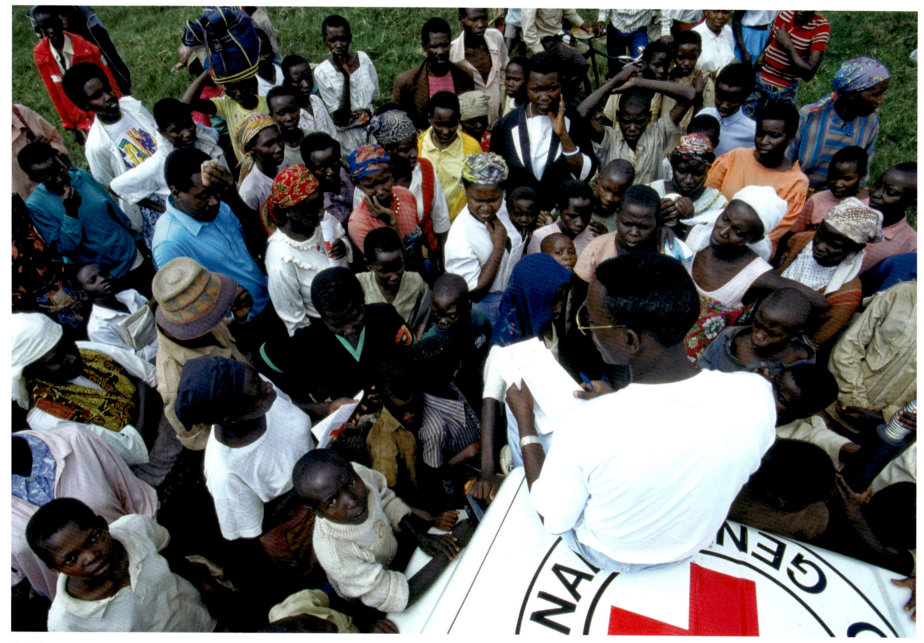

Red Cross messages are distributed at a marketplace in Rwanda.

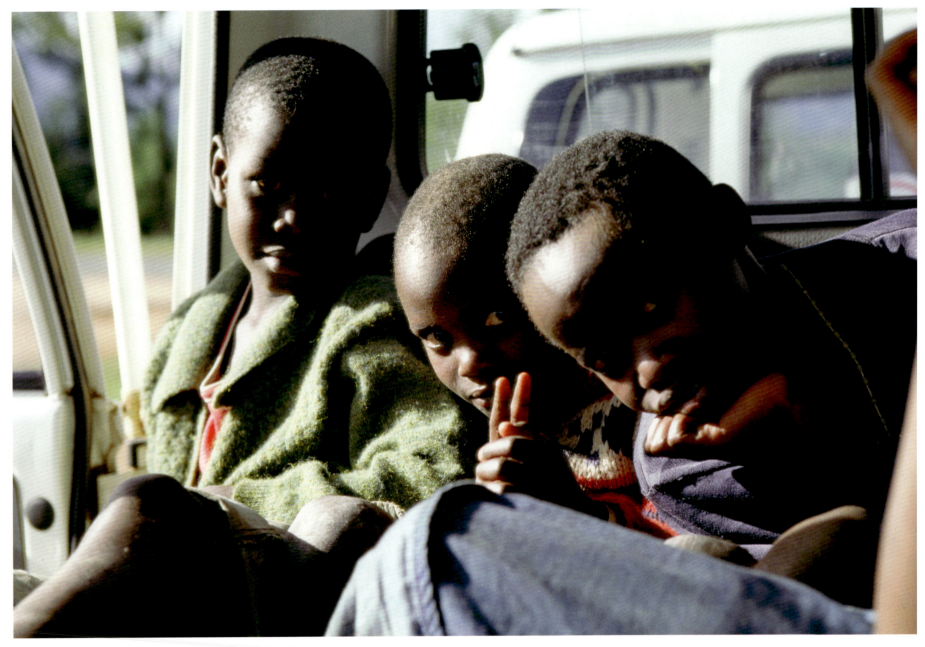

Children who have been separated from their families returning to Rwanda to be reunited.

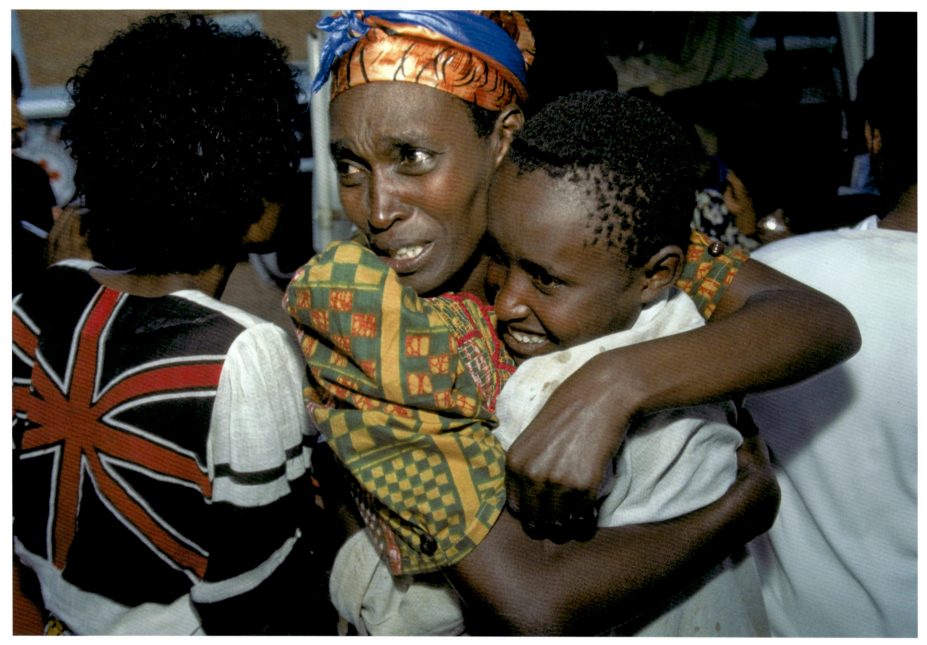

Family reunion in Rwanda.

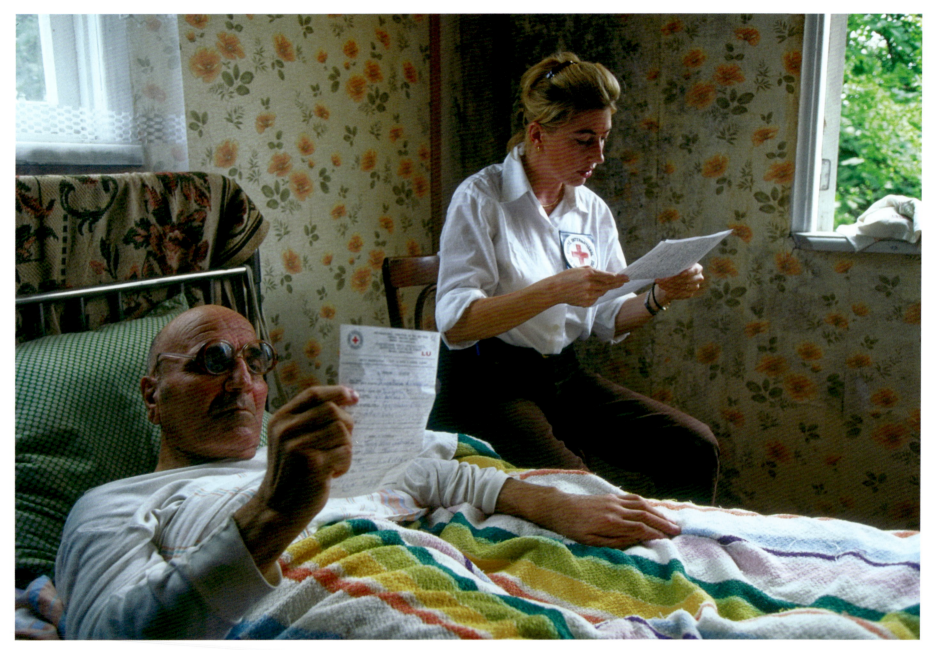

Reading Red Cross messages to a bedridden man in a remote part of Abkhazia.

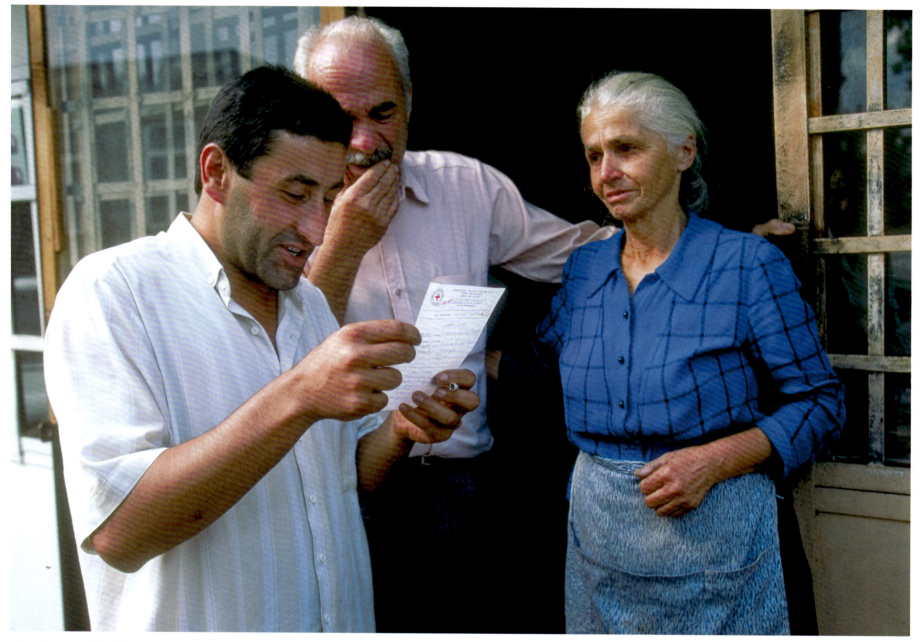

A family reads a Red Cross message from a missing family member in Abkhazia.

Protection

The ICRC provides a degree of protection to the civilian population through their visible presence on the ground during conflict. Because of their unfettered access and ability to cross lines of fighting, ICRC delegates are often the only witnesses at certain times in a war. Their neutrality, impartiality and confidentiality are the "safe passage" on which their lives and work depend. Sometimes in a conflict there are parties that do not want the ICRC to be present. By targeting delegates they are sure to stop the relief work and the ability to act as a witness, at least for a time. There are also times when the needs on the ground are so urgent that the work continues despite the risk. Bosnia in 1993 was one of these times and places; Land Cruisers were armored to protect against snipers, and the work continued. This physical protection for delegates is needed only when humanitarian laws are broken and workers are targeted.

Real protection comes to both the people and the humanitarian workers when civilians, soldiers and officials understand the work of the ICRC and international humanitarian law (IHL). Delegates teach the basics to civilians in many ways—through impromptu presentations, plays and skits, radio and media, printed materials and discussions. More extensive training sessions are given to standing military forces, prison officials and the briefings of soldiers at checkpoints.

Protection in a formal sense encompasses a wide array of activities, all of which collectively are conducted to ensure the full respect for the rights of the individual. These rights are spelled out in different bodies of law from human rights law to international humanitarian law and refugee law. IHL is a specific set of rules that seek to limit the effects of armed conflict for humanitarian reasons.

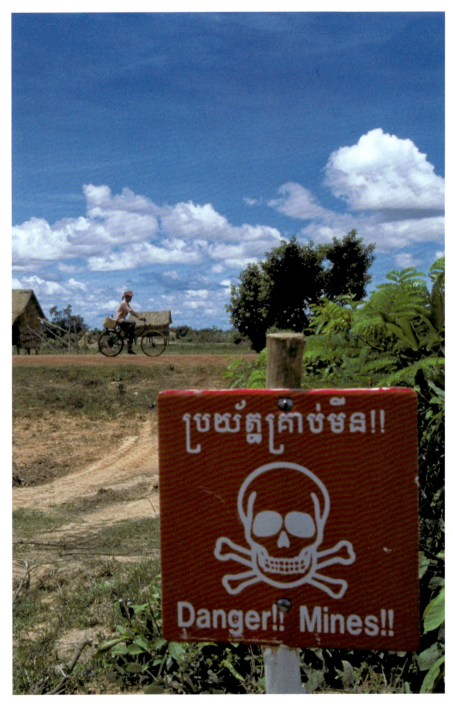

A warning sign for land mines in Cambodia.

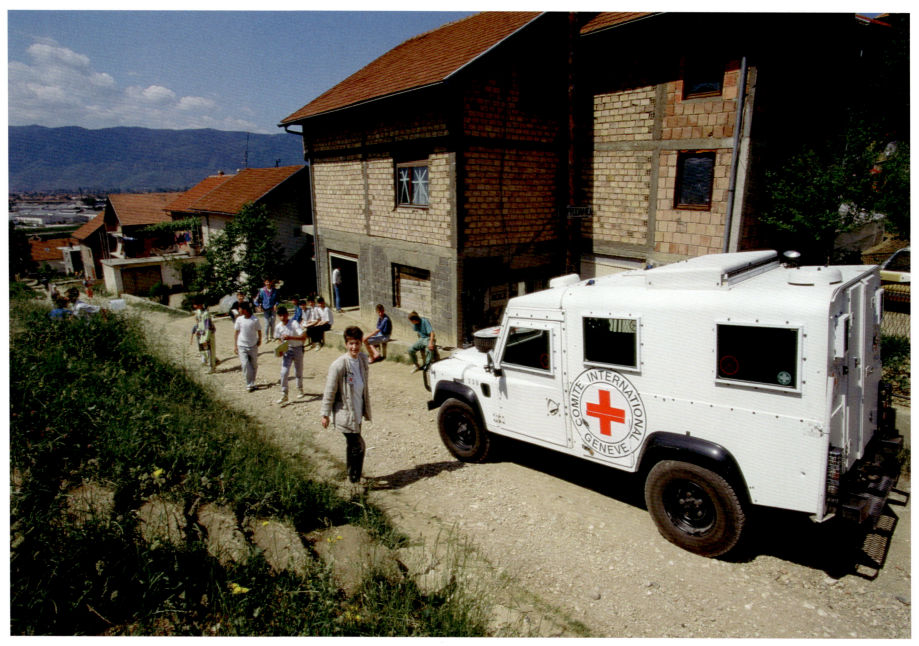

An ICRC armored Land Rover in Bosnia.

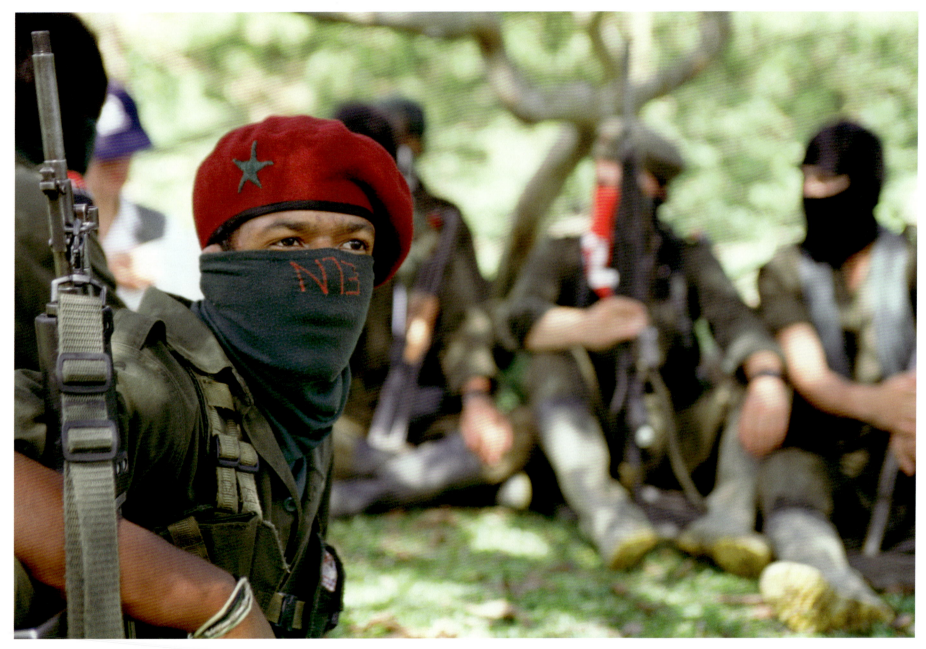

Rebel Ejército de Liberación Nacional (ELN; National Liberation Army) soldiers discuss the Geneva Conventions in Colombia.

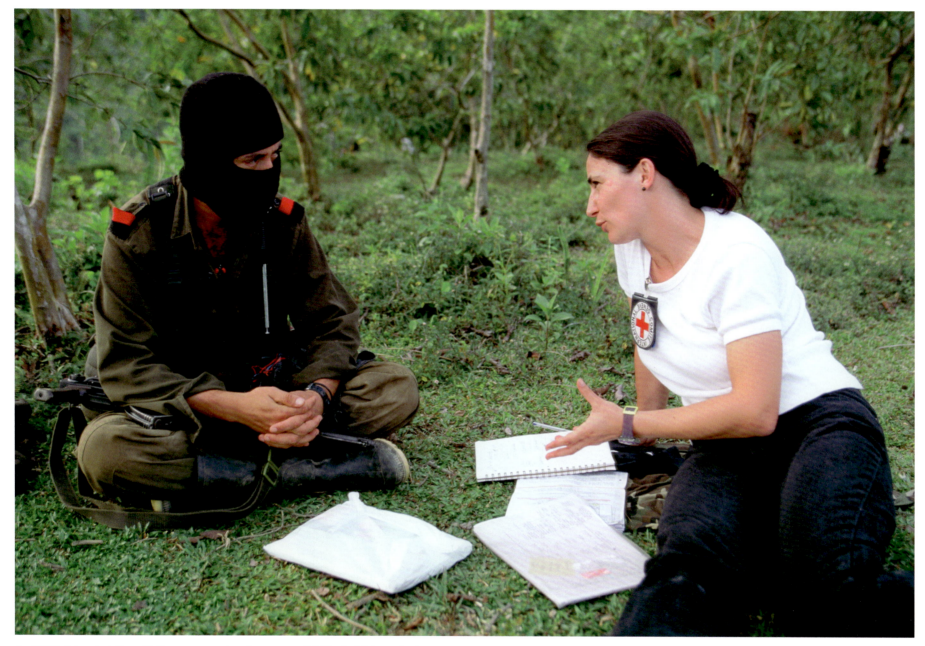

An ICRC delegate talks with the commander of a group of ELN rebel fighters in the remote countryside of Colombia.

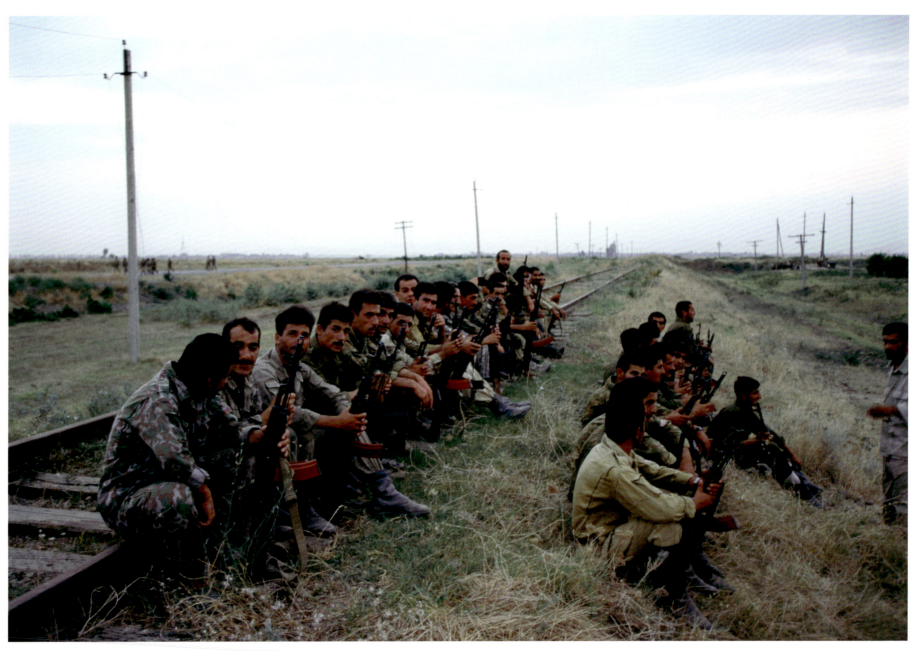

Soldiers wait for a presentation by the ICRC on international humanitarian law at a front-line position in Azerbaijan.

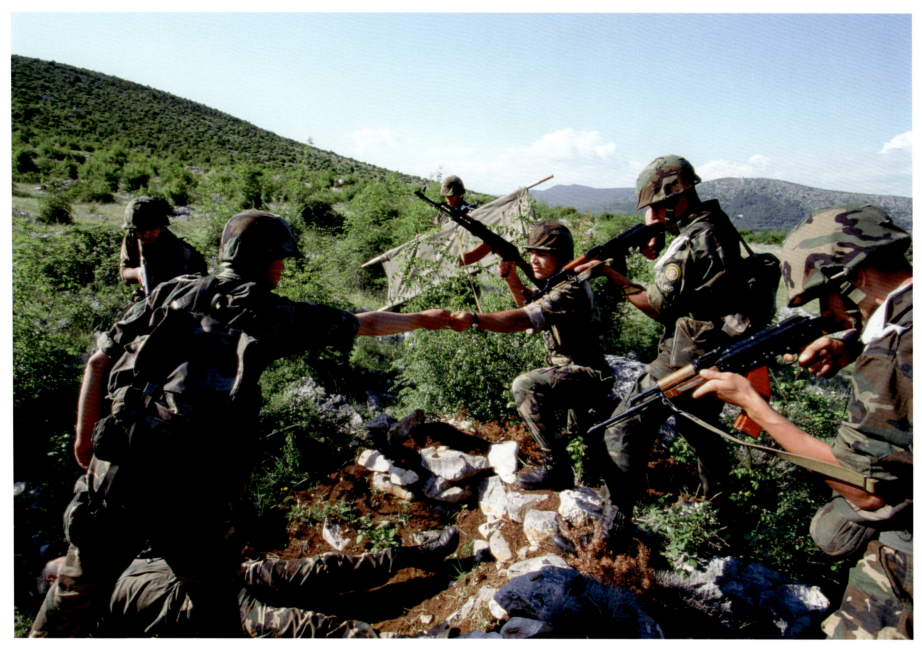

An ICRC-conducted training exercise for soldiers in the rules of war in Bosnia.

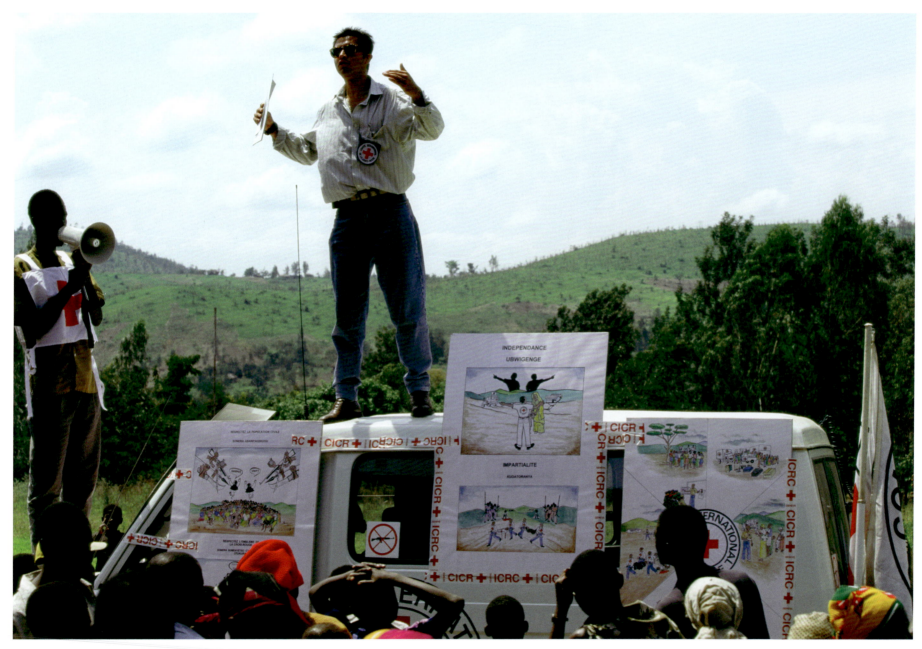

An ICRC delegate gives a roadside briefing on the role of the ICRC to a group of people near a marketplace in Burundi.

Children with an ICRC comic book that describes their activities in the local Chechen language.

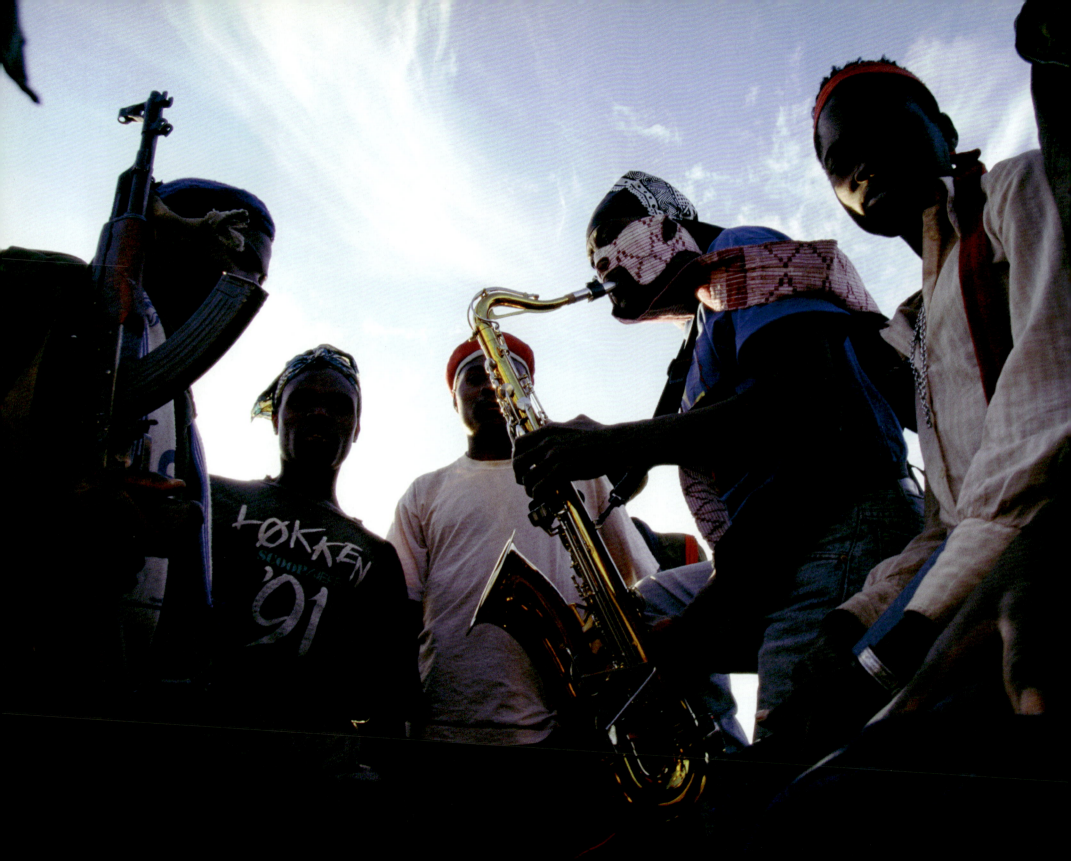

Musicians Go to War

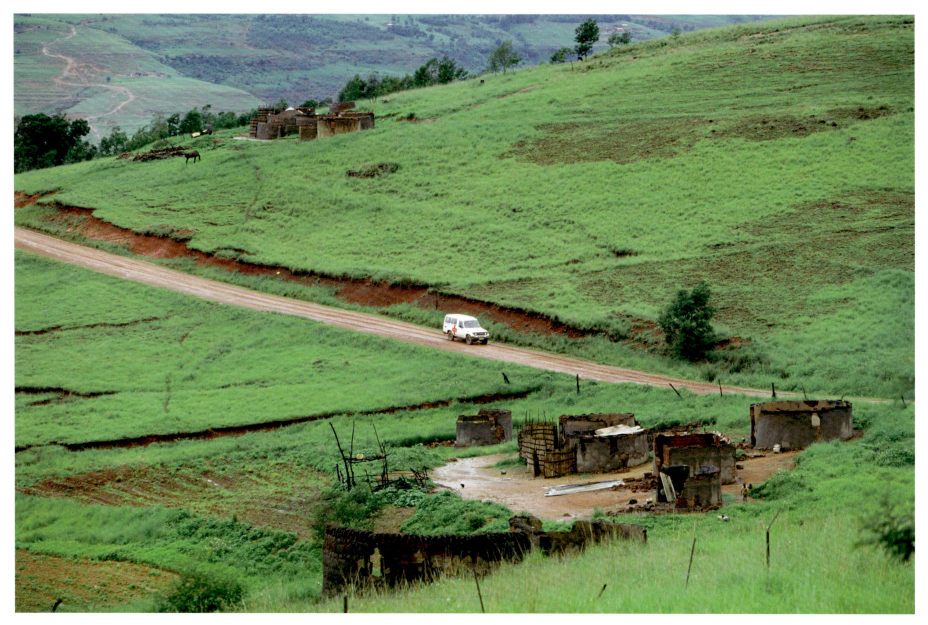

An ICRC Land Cruiser drives past houses that were recently destroyed in local violence, KwaZulu Natal, South Africa, 1996.
Opposite: Lagbaja plays his sax in the back of a truck filled with armed rebels in Angola.

Houses were ransacked and burned. Many men were killed. A few days later, Lucky Dube and a group of top African musicians arrived to experience war firsthand. They had joined an ICRC project and were beginning a continentwide tour of conflict zones, starting in South Africa. The ICRC hoped to communicate the boundaries of war and limits of conflict to fighters and civilians alike through the music that would come from their experiences. The project was inspired in Liberia during a time of fighting and conflict.

An ICRC delegate working in Liberia was hassled, to put it mildly, by child soldiers at a checkpoint on the way out of Monrovia. After days of such difficulty each time he went through the checkpoint he grew more despondent. On his last day he relaxed the rules and was loudly playing a song by the reggae musician Lucky Dube as he drove up to the checkpoint. The child soldiers were astonished that he liked Lucky Dube and that he was playing it so loudly and let him right through. As legend would have it, this was how the idea was born to enlist musicians like Lucky Dube to create music that might influence child soldiers, fighters and civilians across Africa and the world. They called the project Woza, which is South African for Wake Up.

In January of 1996 Lucky Dube, Papa Wemba, Lagbaja, Lourdes Van-Dúnem and Jubu Khanyile began a journey to fulfill this vision. Other musicians joined along the way as we traveled to Lokichokio, Kenya, via Rwanda, then across the continent to Angola and then up the western coast to Liberia. In South Africa the experience was raw and especially troubling for Lucky. He had grown up in the area and had not returned until now.

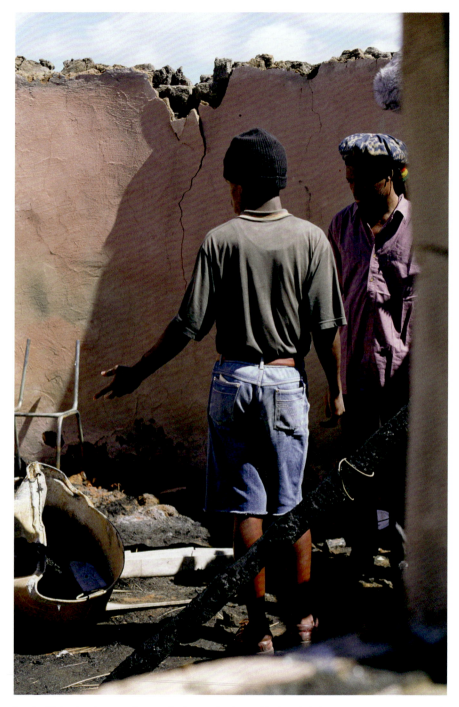

Lucky Dube is shown a house that was destroyed in local violence.

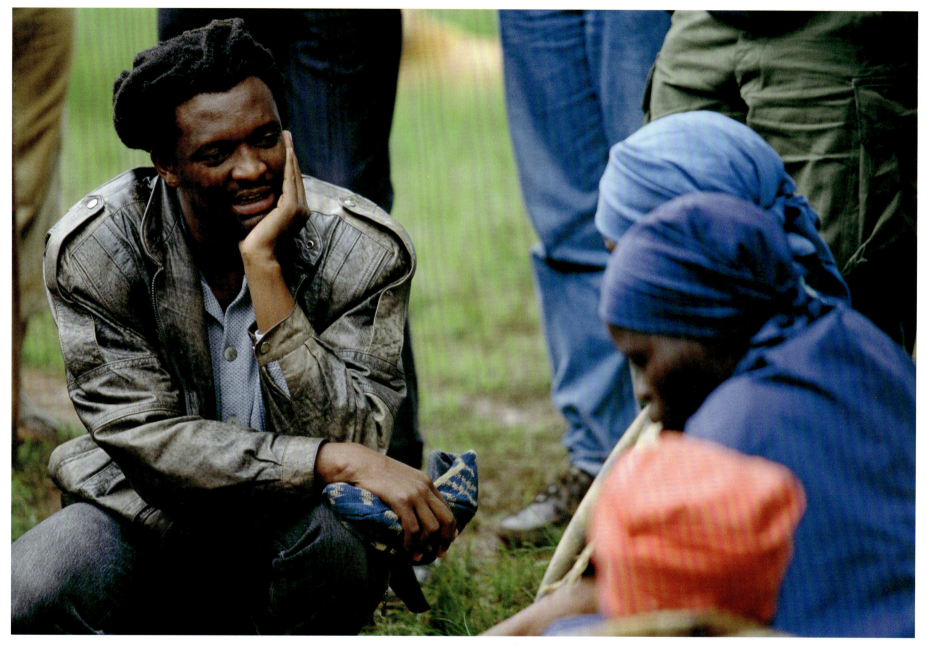

Lucky Dube, a South African musician, talks with women who lost their husbands in recent violence in KwaZulu Natal, South Africa.

Lourdes Van-Dúnem, from Angola, pounds out a rhythm on a chair and sings after hearing stories from victims of local violence in South Africa.

Lagbaja, from Nigeria, wails on his saxophone in a destroyed stadium in Kuito, Angola.

Papa Wemba, from the Congo, holds a young girl after hearing her very personal and disturbing story of a village massacre in South Africa.

Everywhere we went in Africa people shared their troubling stories and then someone would break into song and rhythm. It was a natural response coming from these remarkable musicians. Papa's high voice would rise in the air as a crying lament and the tears would flow. Lagbaja wailed on his saxophone a musical shout against the violence of tribalism. He wore a mask at all times as a visual reminder to not just look at his face and see immediately what tribe he was from.

As we left a tent community of families whose houses had been destroyed, the children and youth broke out in spontaneous song and dance. It felt like an uplifting, pure response to the musicians' presence. It was only later that I learned they were performing a tribal war dance of retribution for the violence that has been inflicted on them. The youth responded with what they knew and it seemed the spirit of retribution was the closest available. In that moment, I knew that it would take generations for the musical message being inspired on this tour to take root. It is a long road to changing such deeply ingrained responses.

Music is both a means of bestowing honor upon those who have died and soothing the soul of the survivors. It is truly a universal language, directly accessing the emotions that lead to healing. I remember a man in Sarajevo who, dressed in a fine suit, played the violin throughout the war in remembrance at the sites where people had been killed by snipers.

A young man looks out from a destroyed building in his village in KwaZulu Natal, South Africa.

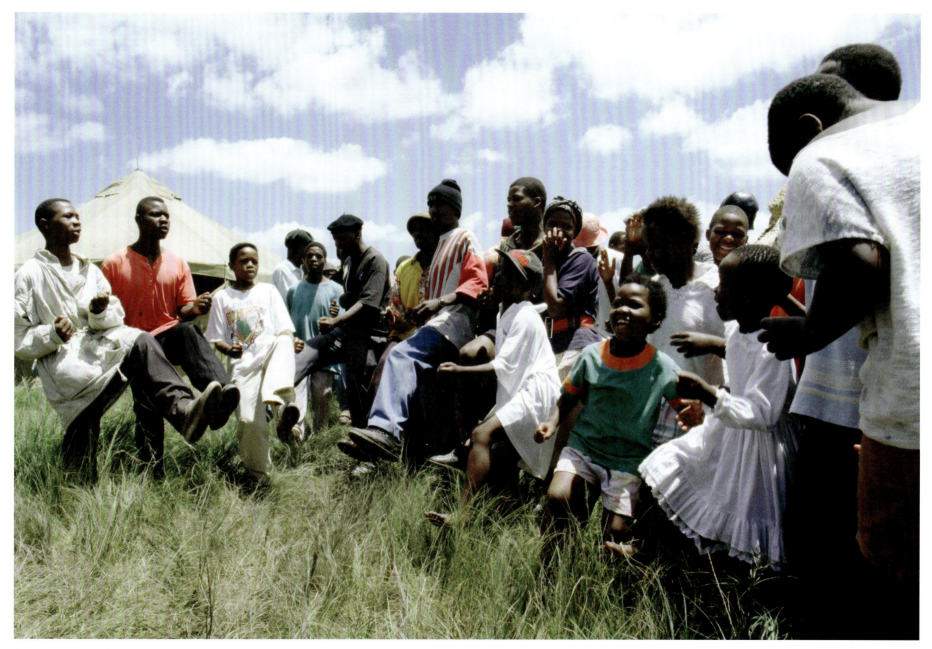

Teenagers and children break into dance and song outside a tent encampment that is their temporary home in South Africa.

Thousands of miles to the north of South Africa in the small village of Lokichokio, Kenya, an ICRC surgical hospital sits on the border with South Sudan. War wounded were flown in when permissions were received from Khartoom for border crossings. Amputations and war surgeries were conducted there almost daily. The hospital had become a training ground for doctors and nurses to learn about war-related triage and surgery. Arriving at the hospital was a big jump for the Woza musicians. I sensed walls being built up inside them when exposed to the emotions, sights, sounds and smells of a surgical unit. Only after their spontaneous musical responses had come forward did they lower their guard.

I know well the buffers and inner barriers necessary for survival in a hospital. As a child and young adult I was in and out of hospitals all the time. Every year I shattered one bone or another due to an undiagnosed genetic disease. The hospital in Lokichokio made the ones I had been in look like four-star hotels, yet it was by far the best hospital in the region. Many of the patients had walked or been transported for days before arriving at Lokichokio. This delay turned wounds that could have been treated simply at the time into amputations and extensive surgeries. In the hospital compound there was a manufacturing facility for prosthetic limbs and a rehabilitation center for amputees. One afternoon the musicians watched as a group of amputees played a vigorous game of volleyball while Lagbaja played counterpoint on his sax.

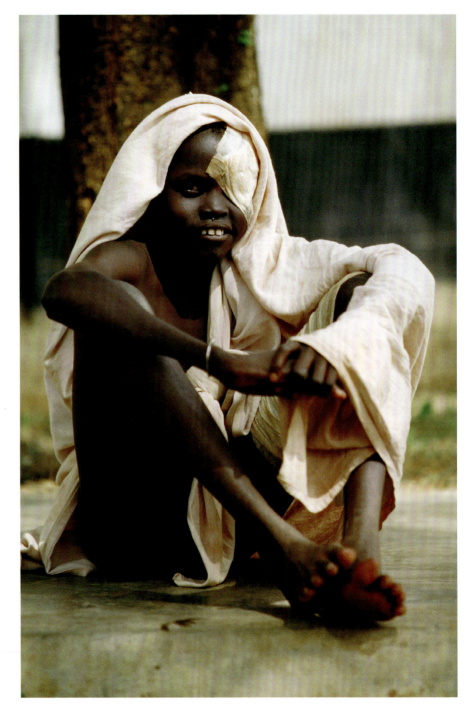

A young patient at the ICRC surgical hospital in Lokichokio, Kenya.

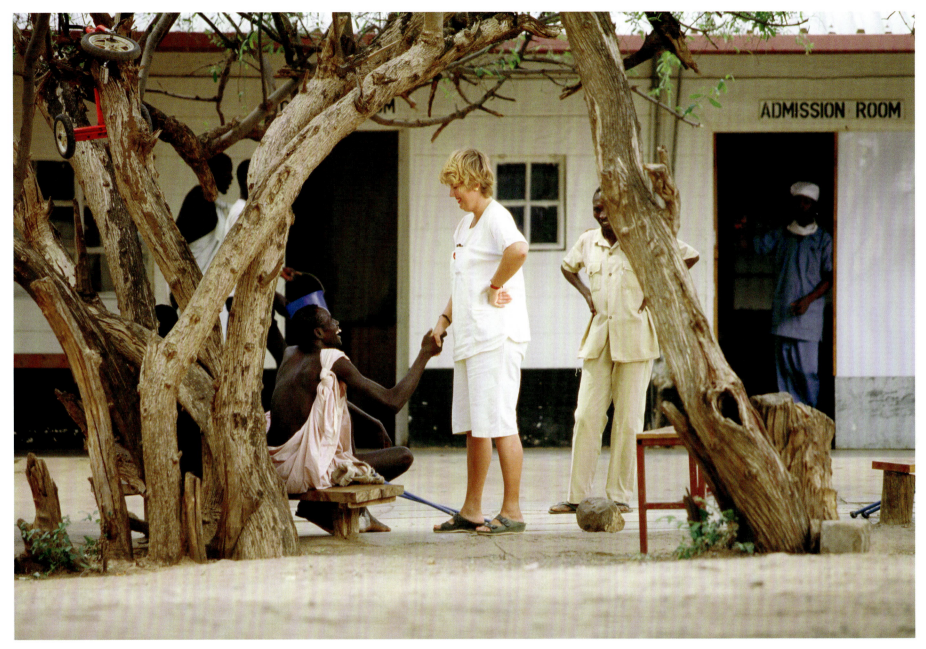

A nurse greets a resident outside the admissions room of the ICRC hospital in Lokichokio, Kenya, 1996.

Papa Wemba, Jabu Khanyile and Lagbaja tour the ICRC surgical hospital in Lokichokio, Kenya.

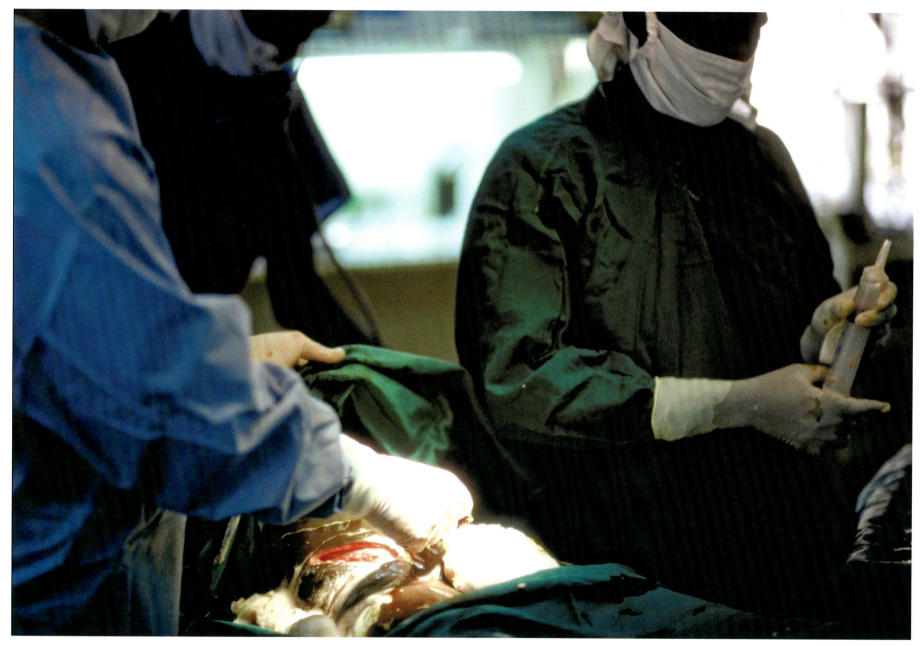

ICRC doctors at the beginning of a surgery at Lokichokio Hospital, Kenya.

Papa Wemba joins in spontaneous song with a man playing his hand-made stringed instrument at Lokichokio Hospital, Kenya.

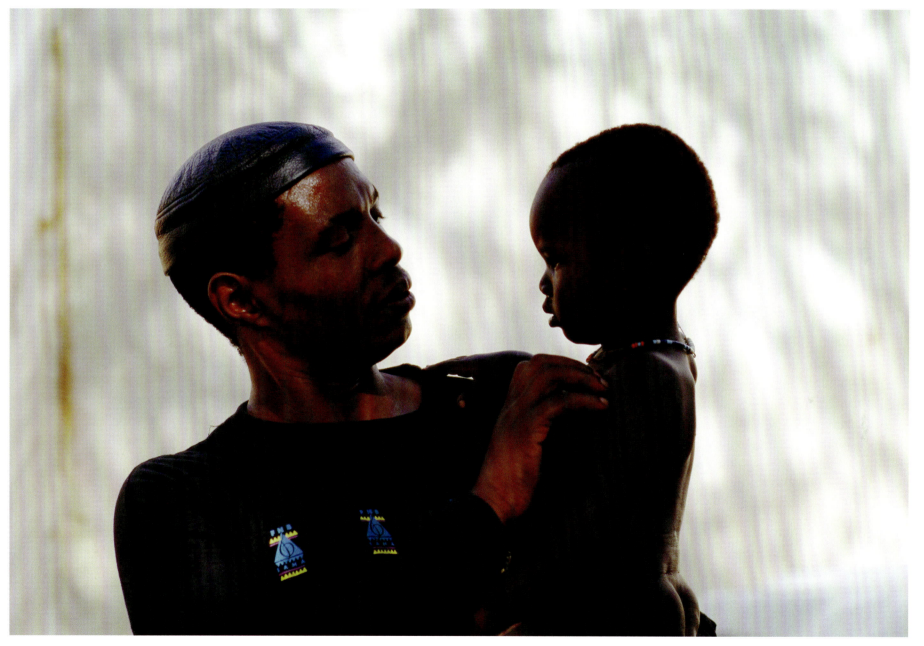

Jabu Khanyile holds a child outside Lokichokio Hospital, Kenya.

From Kenya the ICRC plane flew the Woza musicians across Africa to land on the west coast. Here in Angola they experienced a country dealing with the aftereffects of many years of civil war. Lourdesh was from Angola and she hosted us with a meal at her home in the capital city, Luanda, the first night. From Luanda we flew into the high plains, the planalta, to the cities of Huambo and Kuito, both of which had seen heavy fighting throughout the years of conflict.

One year earlier I had traveled alone to Angola to photograph the ICRC work there. On this Woza trip we toured a prison where the POWs I had photographed the year before had been released. It was a unique experience to return to an empty prison that had been full a year ago. This was as close as the musicians could get to imagine the experiences a prisoner of war might have; taking them to an active prison would have been inappropriate. They got to feel, to a degree, what it was like to be a prisoner and what it was like to be released, the unique sense of freedom that comes when walking out the front door of a prison.

The physical destruction in Angola was unbelievable. For years the cities had been taken over by one armed force after another. A huge amount of ammunition and ordnance was used in these battles. Without heavy weapons, like in Chechnya and Somalia, the buildings were still standing while riddled with bullet holes and grenade blasts.

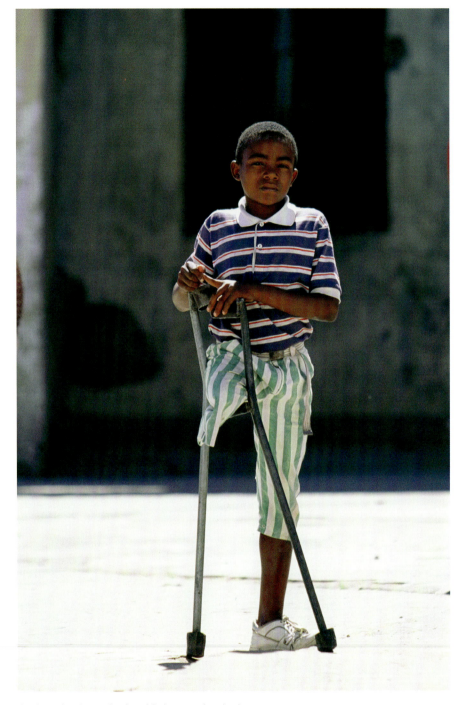

An Angolan boy who lost his leg to a land mine.

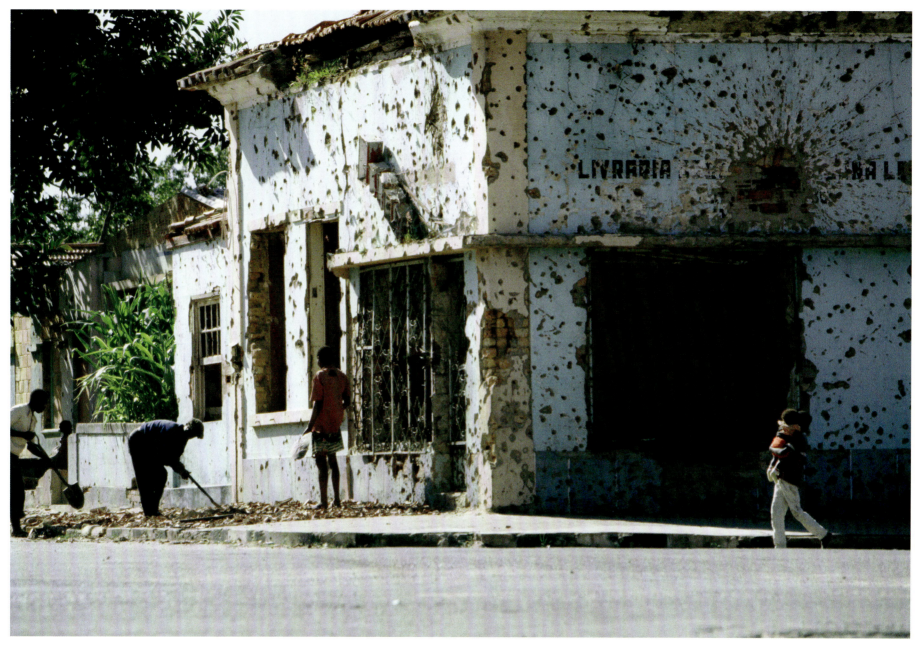

A street corner in Kuito, Angola, shows the degree of destruction that has occurred all over the small city.

Huambo prisoners in 1995, the room behind the lens is full of people.

Papa Wemba speaks with a former prisoner in 1996.

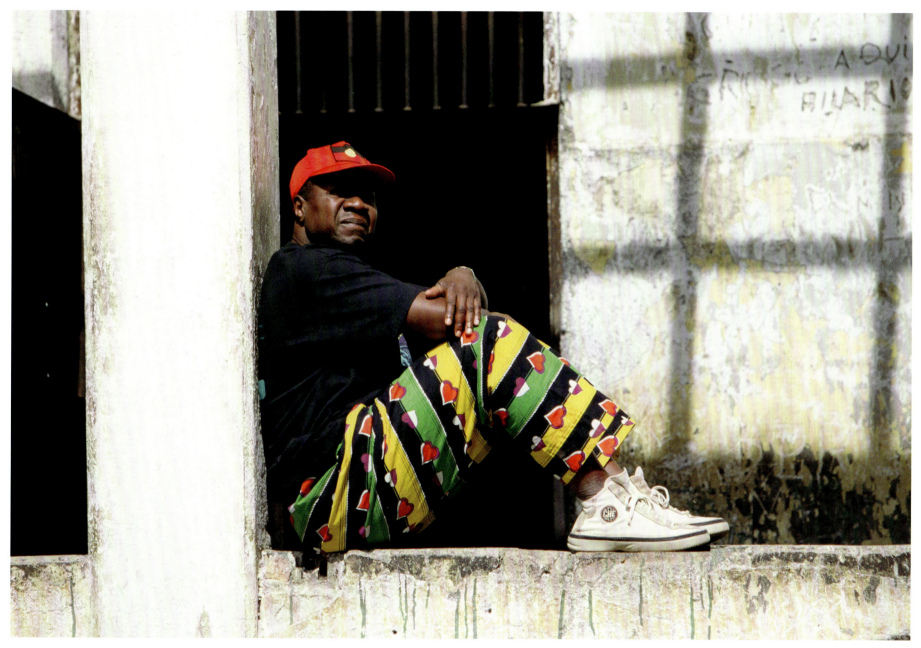

Papa Wemba sits outside a prison cell that a year earlier had held around fifty prisoners in Huambo, Angola.

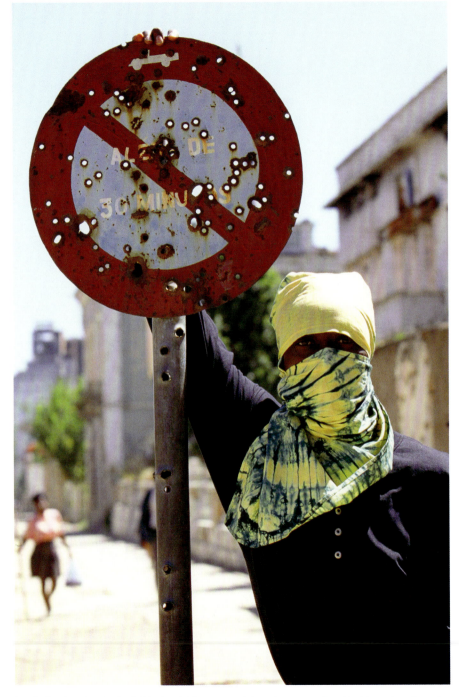

Lagbaja stands at a bullet hole–ridden no parking sign on a street in Huambo, Angola.

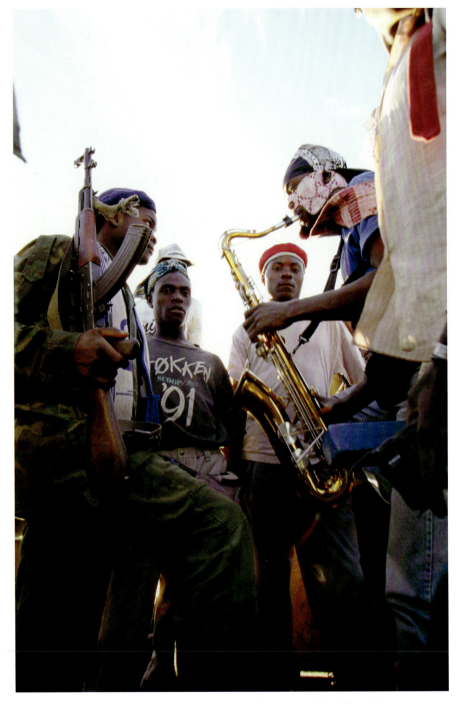

Lagbaja plays his sax to armed rebel fighters in the countryside of Angola.

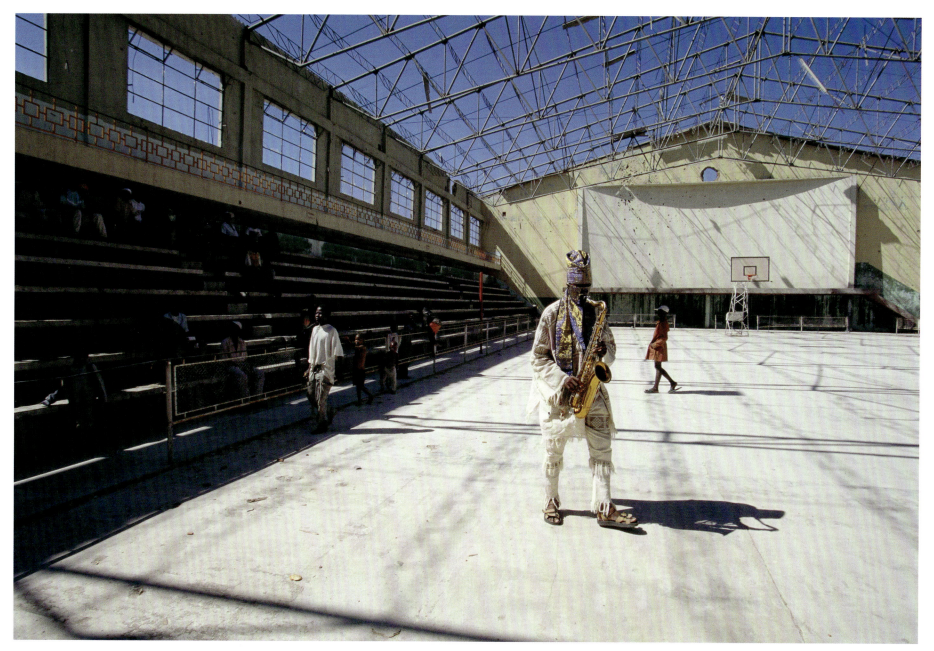

Lagbaja plays his saxophone in a destroyed sports stadium in Kuito, Angola, where children come in off the street and begin to fill the seats.

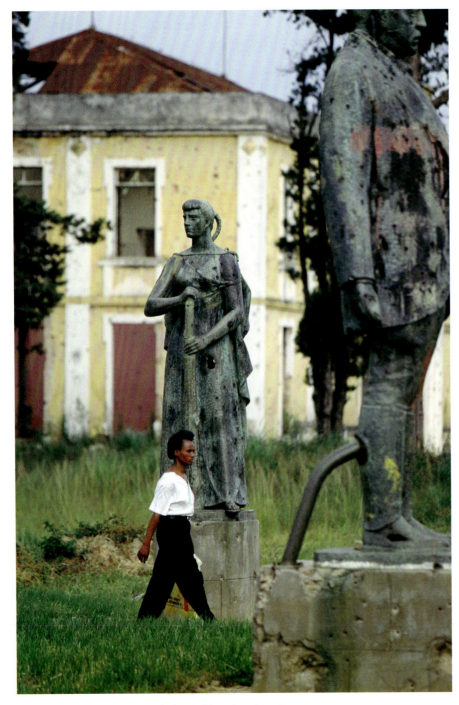

Even the statues have bullet holes in Huambo, Angola.

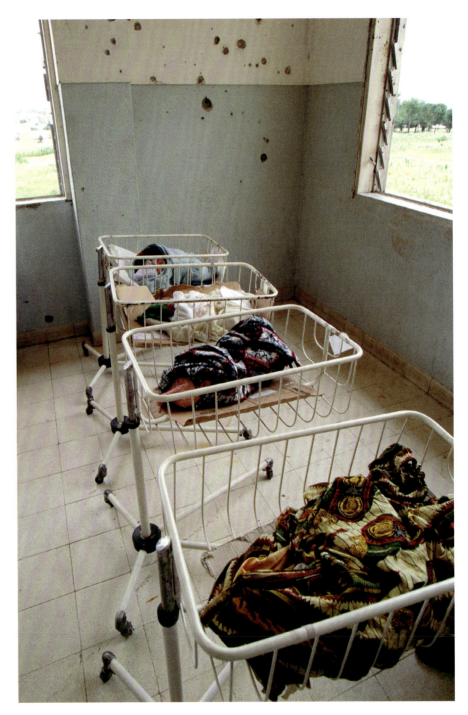

Newborn babies at the Huambo Hospital, Angola.

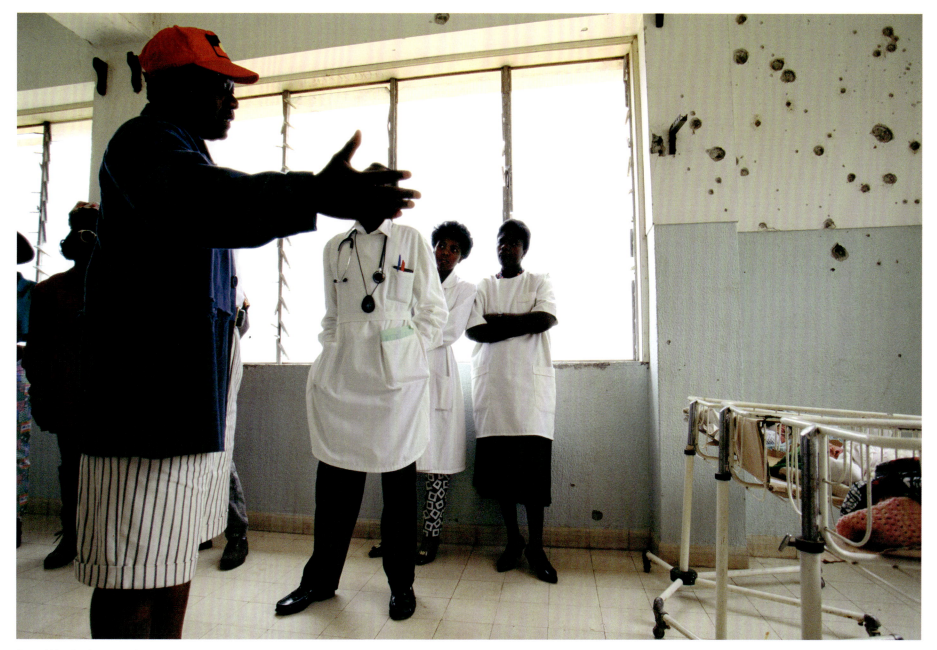

Papa Wemba laments the plight of newborn babies in a maternity room at Huambo Hospital, Angola, which has no glass in the windows and is full of bullet damage.

Papa Wemba sings at a destroyed theater building in Kuito, Angola.

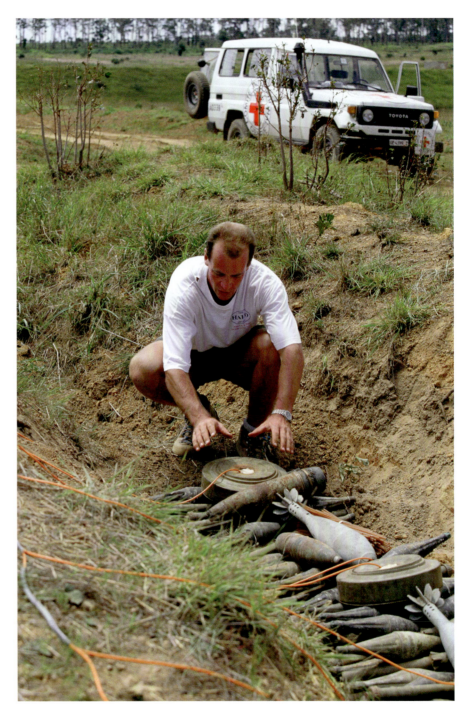

A team member of the Halo Trust wires unexploded ordnance with C4 explosive.

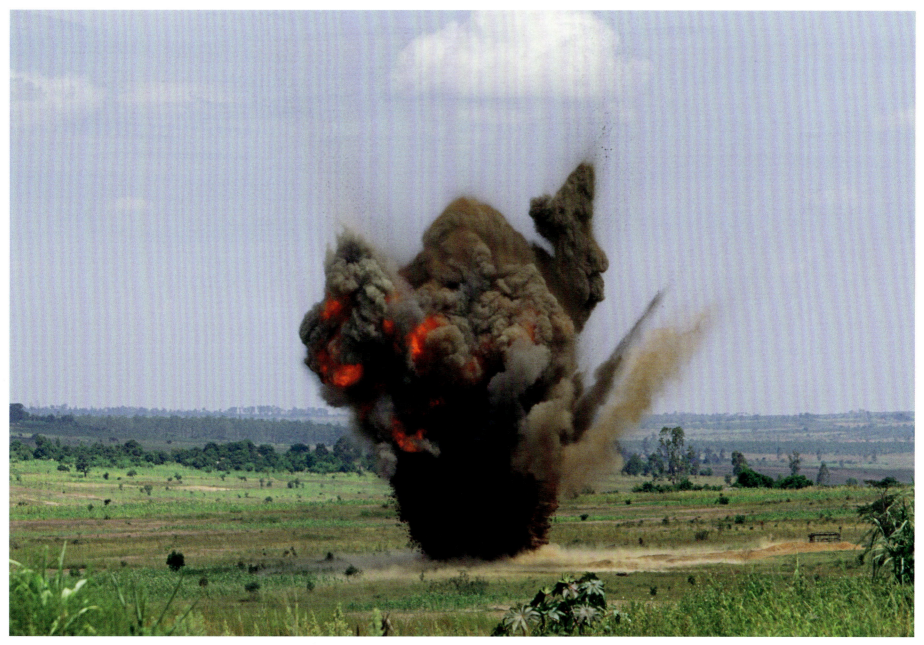

Remote detonation of unexploded ordnance outside Huambo, Angola.

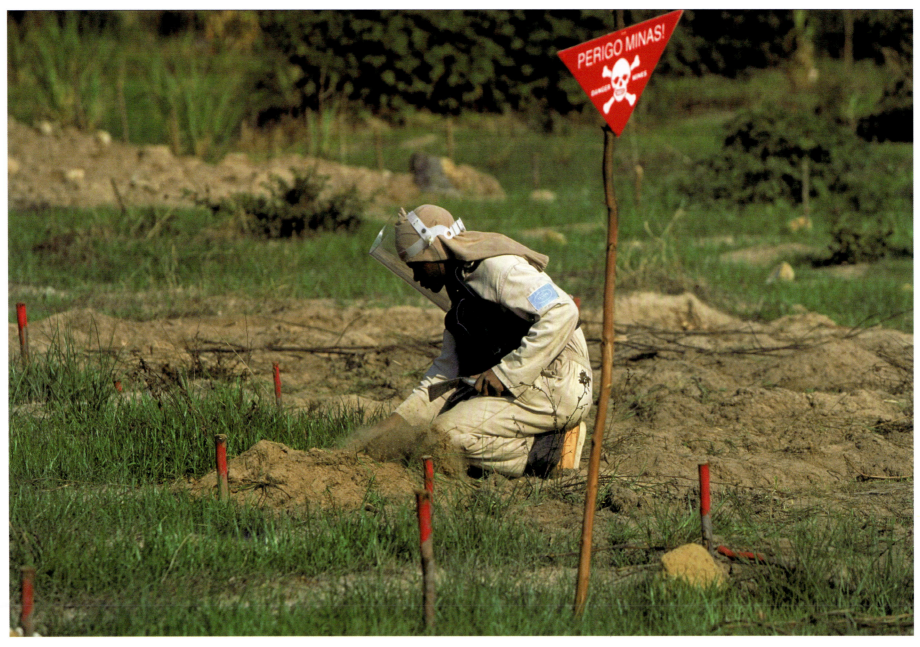

An Angolan de-miner working for the Halo Trust organization carefully exposes an antipersonnel mine outside Kuito, Angola.

An antipersonnel mine lies hidden in the grass outside Kuito, Angola.

Monrovia, Liberia, was the last stop for the Woza tour. The rapid exposure to conflict zones ended with the boy soldiers who had inspired the project years before. We met former boy soldiers living on the street in Monrovia. Hundreds slept in an urban shelter at night. Others had formed a band as a way to heal and simply looking for something to occupy their time. It was hard to see how their lives would get back on track. Some had been forced to kill their parents, forced to smoke crack cocaine and then asked to join the killing as fighters or die. Those who accepted, which were the ones to survive, lived a life of murder and depravity that most cannot even begin to imagine. I heard two boys describe how they used to bet whether a pregnant woman they encountered was carrying a boy or a girl. They would cut the woman open to see who had won the bet.

The stories I heard in Liberia haunted me. I had been swimming with sharks and these young boys seemed much scarier. Especially when they were fully armed. The look in their young eyes was a cold and ruthless gaze of those who have total control over the life and death of another human. Their faces were blank and arrogant at the same time. Boys just like these had been the inspiration for the musicians to gather. I hope that the time the Woza musicians spent with these young ex-soldiers will inspire change, for the boys, for the musicians, and for all of us.

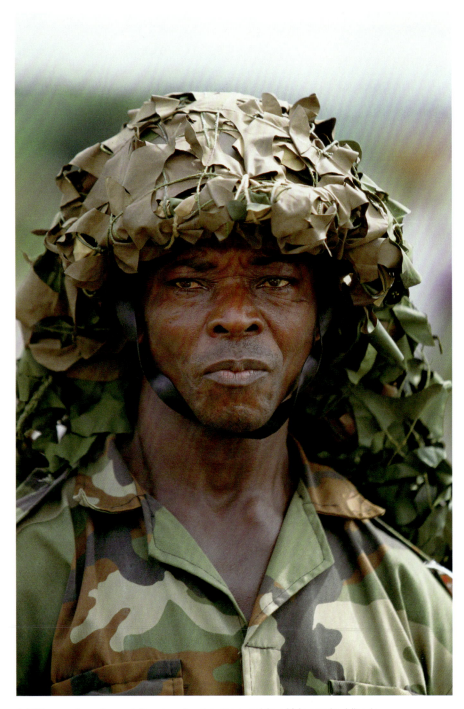

A UN peacekeeping soldier at a checkpoint outside of Monrovia, Liberia.

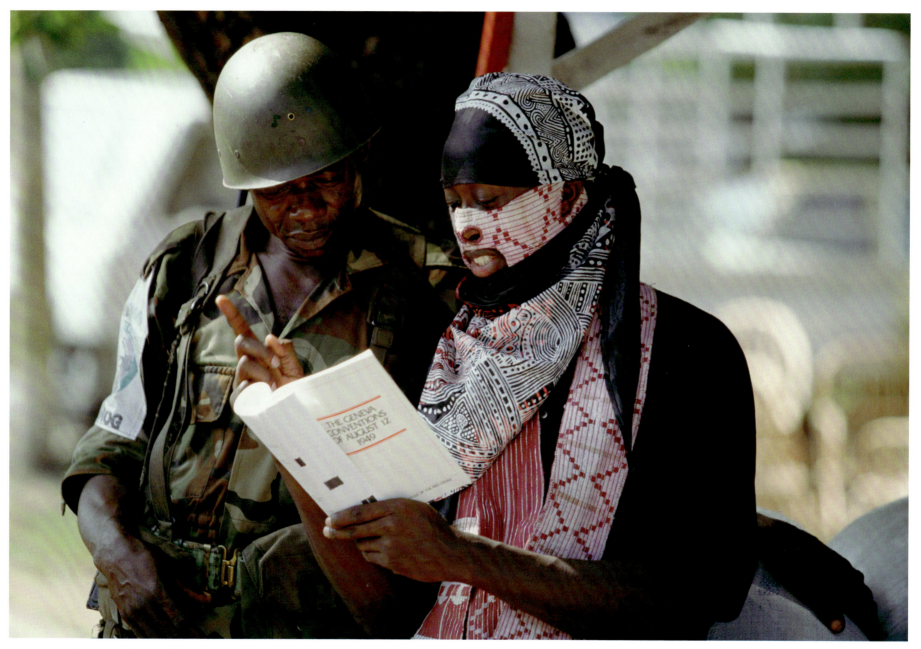

Lagbaja reads from the Geneva Conventions to a UN peacekeeping soldier at the main checkpoint in downtown Monrovia, Liberia.

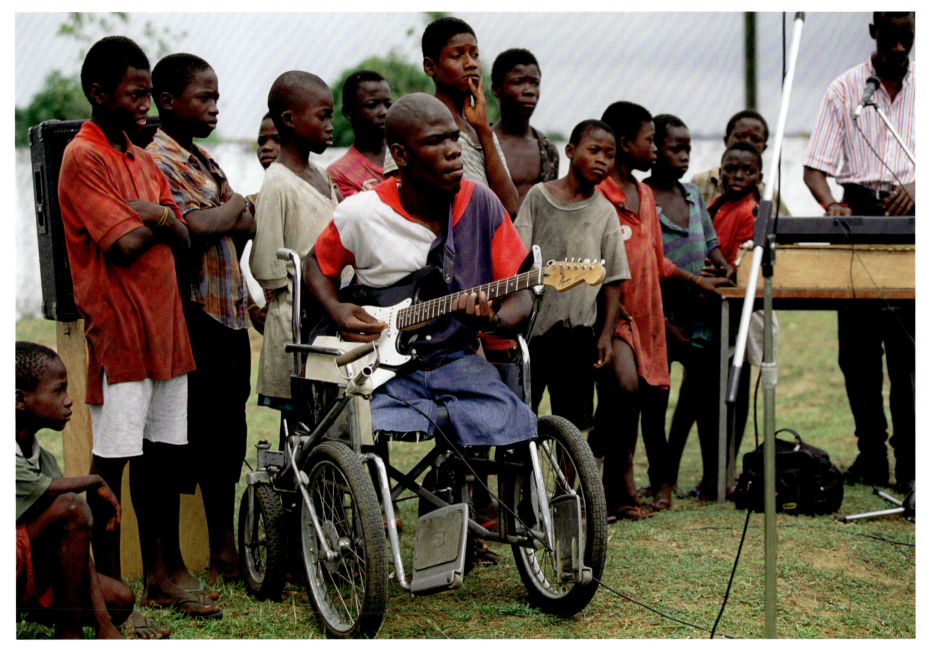

A band made up of former boy soldiers jams in Monrovia, Liberia, with the Woza musicians.

A former boy soldier talks with Papa Wemba and Youssou N'dour through an interpretor on the docks of Monrovia, Liberia.

The musicians gathered on Gorée Island off the coast of Senegal in West Africa in January of 1997. It had been a year since the whirlwind tour of African conflict zones. They met land mine victims and had seen how mines are cleared from the fields after a conflict. They visited villages where massacres occurred just days before. They saw and felt the pace of an active war surgery hospital. They talked, cried, sang and shared with people from many ethnic and tribal groups. They experienced Africa in a way that few have the chance to. As they gathered in Senegal there was a solemnness to the task at hand. The location enhanced the fusion of their musical styles and the sharing of their inspirations from the journey.

Gorée Island had been a jumping-off point for the slave trade on Africa's west coast. One doorway from a prison on the island led to the sea and was infamously called the Door of No Return. Through it slaves stepped onto a slave ship or jumped into the sea. The musicians were to learn from the museum curator that millions of slaves had stepped through that very door.

Youssou N'dour had arranged for the use of Gorée Island as an inspirational setting for the creativity of the Woza musicians. It proved a fitting environment and the music flowed. There would be a concert in Paris at the release of their album entitled *So Why?*, which was widely distributed. Along with the album came a book entitled *Woza Africa! Music Goes to War* containing a foreword written by Nelson Mandela, and a BBC television special *So Why?*, which was viewed by audiences around the world.

Jabu stands at the Door of No Return that led to slave ships. Millions of slaves are said to have stepped through this door to the Americas.

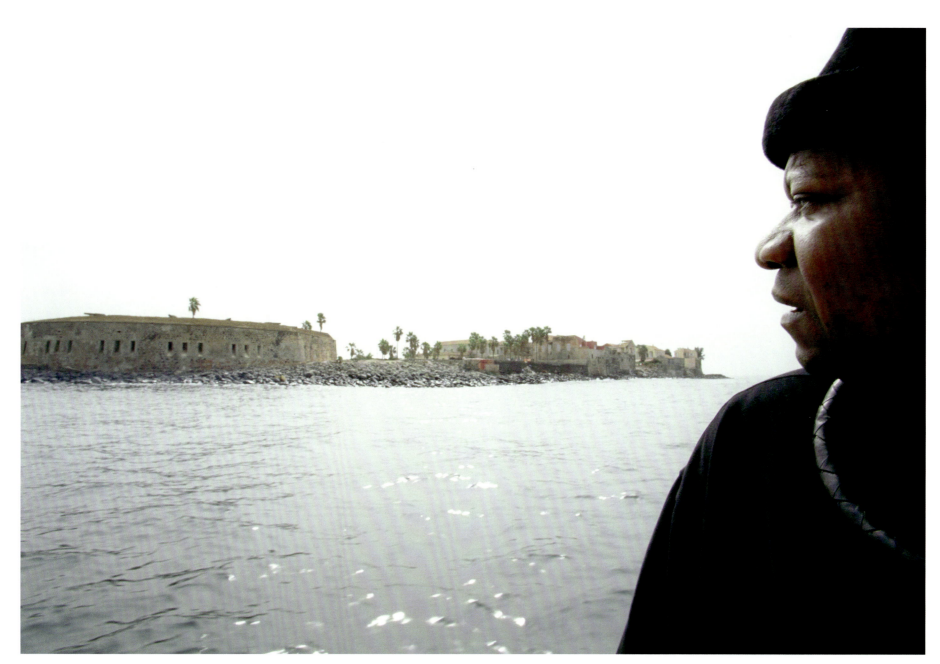

Papa Wemba looks out from a boat at the prison on Gorée Island as he arrives from Dakar, Senegal.

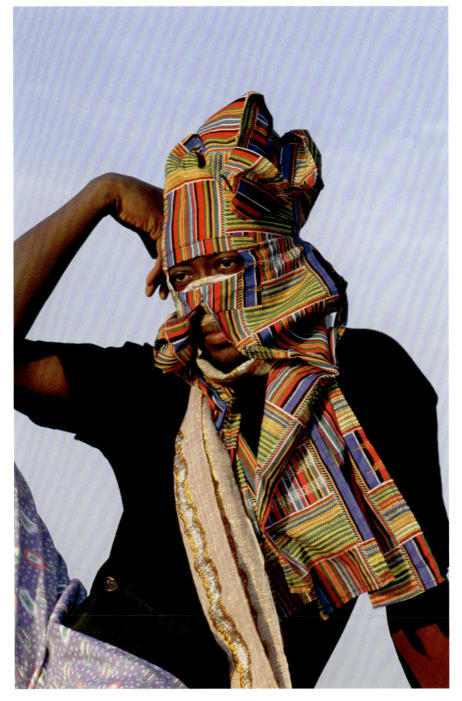

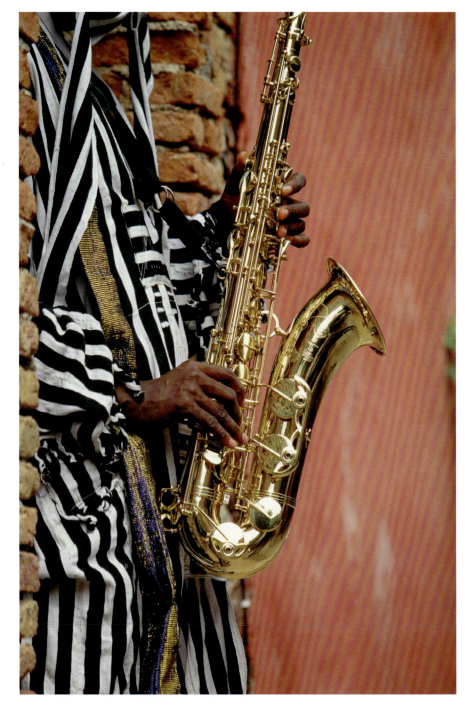

Lagbaja looks westward toward the Americas from Gorée Island.

Lagbaja plays his sax on Gorée Island, Senegal.

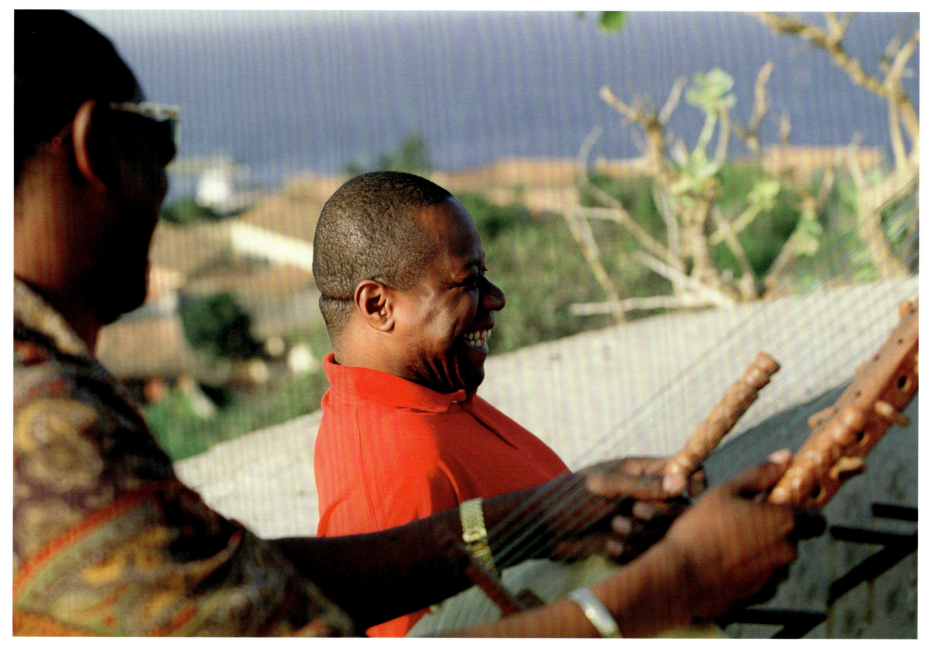

Jabu and Papa enjoying the jam session on Gorée Island.

Youssou N'dour plays a conga drum with the Woza group on Gorée Island.

Woza musicians jam together on what was once a military installation as the sun goes down on Gorée Island in Senegal.

War and Peace

Shamans pray as offerings are lit and smoke rises into the sky at a gathering of the tribes hosted by the World Bank in Huehuetanango, Guatemala.
Left: A rebel ELN fighter joins a discussion group about the Geneva Conventions in the countryside of Colombia.

The shaman blew on the conch shell. Its deep, oceanic call brought the participants to full attention. He stood atop an ancient sacred structure, built like a small pyramid that rose out of the jungle of northern Guatemala and greeted the sky. The morning fog thinned as the day began to warm. Shamans and leaders from the tribes of Guatemala gathered in Huehuetenango for the first time since the end of hostilities to make offerings for a ritual of peace and reconciliation. A World Bank team hosted the meeting as a way to move forward from the ravages of civil conflict. Although our objective was peace and reconciliation, the reverence and devotion of the ritual stirred my blood in a way akin to the intensity of war.

Across the world, two years earlier, a huge explosion and fireball rocked the armored personnel carrier as I photographed out of a bulletproof glass window. We were about two football fields away when it blew. Over thirty antitank mines, piles of rockets and other unexploded ordnance had been wired with charges of plastic explosive in a deep pit and destroyed. In Bosnia the leftover explosives waste of years of fighting littered the countryside. It would take quite some time to remove the land mines buried in the ground, the booby traps from buildings and to collect the rocket shells that never exploded. I've seen kids in hospitals with their hands blown off from playing with cluster bomblets left scattered around like toys.

What links these two experiences for me is that both were acts of clearing away the detritus of war: one energetic, one physical. Both awakened an intense clarity in me as I photographed them; that clarity is a strong drug and I've become addicted.

A shaman begins the ceremony by blowing a conch shell at a sacred site.

Unexploded ordnance is disposed of in a controlled blast in Bosnia.

In places of war, suffering and death, the beauty in everyday humanity was enhanced, accentuated in the mind's eye and heightened in the heart. I have fallen in love many times on photography missions. There were many beautiful and sensitive nurses. There were gorgeous women met in the corners of a war zone. There was the interpreter who completed sentences and thoughts for me. A woman I seemed to "know" without understanding her language or culture.

I met her in Nagorno-Karabakh, or was it Abkhazia . . . no, I distinctly remember the cold . . . ah yes, she was the gorgeous Russian woman with short cropped black hair, eyes like a deer and a spring in her step while she interpreted for the ICRC team in Chechnya. In her presence I was infused with energy. The lyrical way her voice spoke English, the way her heavy accent sounded otherworldly at the beginning but soon became like listening to a stream rushing over smooth boulders.

We spent days together in Chechnya moving around the dangerous landscape. We engaged with people for hours in conversations that were full of emotion. She translated my questions in a way that I could feel the truth behind the words. The conversations were about family members lost and messages from those who had been found. They were about battles being fought and bridges blown up, about suffering and loss. We talked with doctors, officials, soldiers, mothers and children. The adrenaline always flowed as we moved through the fear and compassion together, sharing experiences as though one being.

An ICRC interpreter in Chechnya.

Snow-covered hillsides and trees in Chechnya.

During my last days in Chechnya our closeness led to my stepping beyond the role of photographer. The entire ICRC team had left the delegation in Nazran for a meeting. We were the only ones remaining and had been told to do anything we wanted in Ingushetia but to stay out of Chechnya. We had worked closely together for weeks at this point and did not want to spend the day doing a touristic visit to the local market or sitting around awkwardly in unspoken love. So we collected a handful of Red Cross messages that needed to be delivered and warmed up the Land Cruiser. The first message was to a family living near Nasran, Ingushetia. It was from their son. The family received the letter with a touching and tear-filled response. We got back in the Land Cruiser and turned to the next message. It was to a family who lived close to the front line in Ingushetia and was from their son, a prisoner of war.

We looked at each other and without needing discussion made a silent agreement, and I drove off. We made our way to the address on the message. On arriving at the house we were greeted by the same man who had written the message. He had sent the letter to his mother from a prison on the Russian side and had subsequently been released. His face was badly bruised and carried a deeply pained expression as he invited us in. He explained over tea that he was an accountant, with nothing to do with the fighting, and one day men came to his house and had taken him forcefully away.

An ICRC delegate prepares to leave Nazran, Ingushetia, for a day of work in Chechnya.

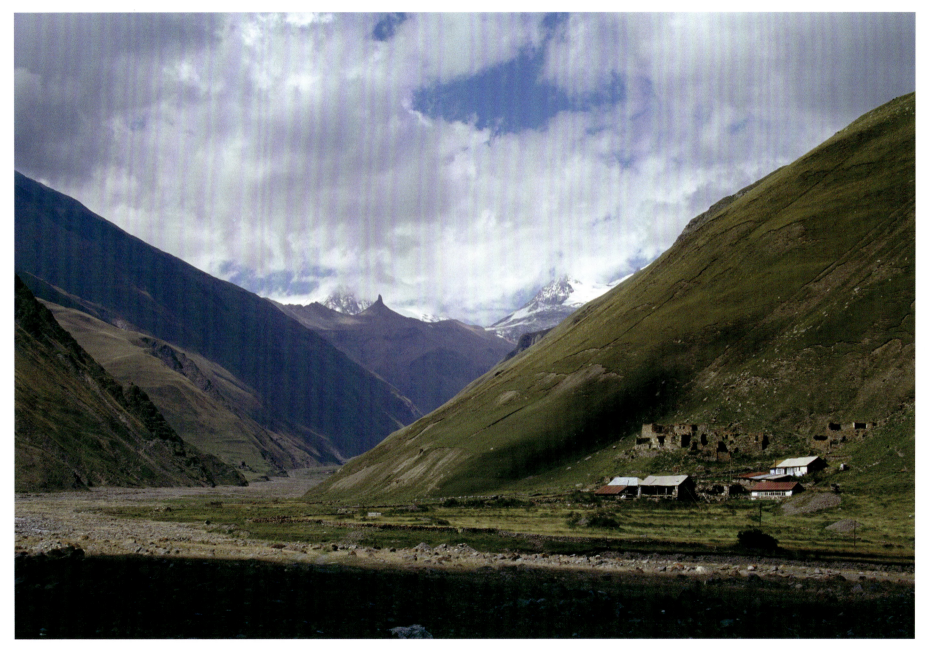

The Caucusus mountains as seen looking northward from the border of Georgia and Russia.

Driving back in the Land Cruiser I knew I had overstepped my bounds as a photographer and would get in trouble for having done so. I had met with and interviewed a prisoner who had been recently released. In a case like this there were specific procedures that must be followed. When we got back the interpreter looked at me deeply, smiled and said I must follow through; that everything would be OK. So I sat down with my journal and wrote what had occurred. I noted every detail and nuance that I could remember, along with the roll numbers of film from the day. I then rewrote my notes into a formal report on the delegation computer and printed it out in the early hours of the morning. The next day the interpreter and I went to the market and wandered through normal life instead of through a war zone. When the team returned that afternoon I submitted my report to the head of the delegation and was roundly scolded for stepping outside my role as a photographer. The next morning, as I prepared to leave Chechnya, the head of the delegation remarked on how thorough my report had been, which took away some of the sting.

The expanded capacity to feel and see the world more intensely in dangerous and rapidly changing situations is a potent drug. The world seems quite flat and dull when the high wears off on returning home. One way my body responded was by developing a rare tumor that generated large amounts of adrenaline whenever it wanted. I could be sitting quietly in the woods by a stream and all of a sudden feel like I was back in a war zone on full alert. This became debilitating and has taken years of work to heal. The psychological and inner work has been as important, or more so, than the physical treatments in my recovery.

An ICRC nurse interacts with a girl showing off her new dress in Angola.

A full trolley running in Sarajevo, 1996.

Here I was dressed in a business suit, headed for the Old Executive Office Building and had been in his hometown days before, a place wracked with starvation half a world away. He had to ask why I had been to Huddur. When I told him that I had been called to go to photograph the suffering and the relief operation under way through the Red Cross, he smiled broadly and asked if I could spare some time.

With a little over an hour before the meeting I said yes. He raced off through the city and soon pulled up to a nondescript building in the Adams Morgan area of D.C. Jumping out of the cab, he walked to the house, opened the door inviting me inside. His wife met us at the door, greeted me and asked me to take off my jacket and sit down at the table. She presented me with a plate heaped with the spaghetti meal I had become familiar with in Somalia. After making sure I finished a second plateful, Hassan said that we had to go. He whisked me to 17th and Pennsylvania, offering prayers for a good life as I left his cab. He refused to accept payment for the ride and drove off into his life as I walked back into mine. I was just in time for the meeting.

I fell in love with the Somali spirit, the people and their gracious hospitality. When I hear about Somalia or meet a Somali person I am compelled to engage and remember—the smells, the feelings, the rawness while witnessing starvation and chaos. I remember the dignity of the people, whose countries having fallen apart around them, did the best they could each day. When I am asked why I went to Somalia and the places that followed, I would like to reply from the feelings shared in this book. The call of this ephemeral radiance will always keep me seeking light.

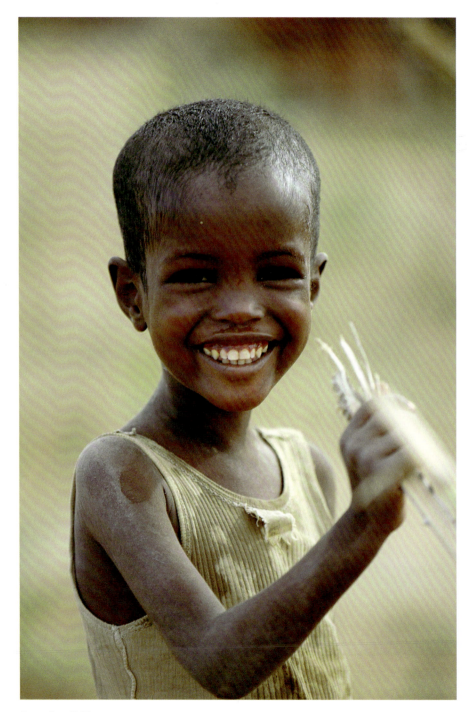

Somalia, 1992.

216

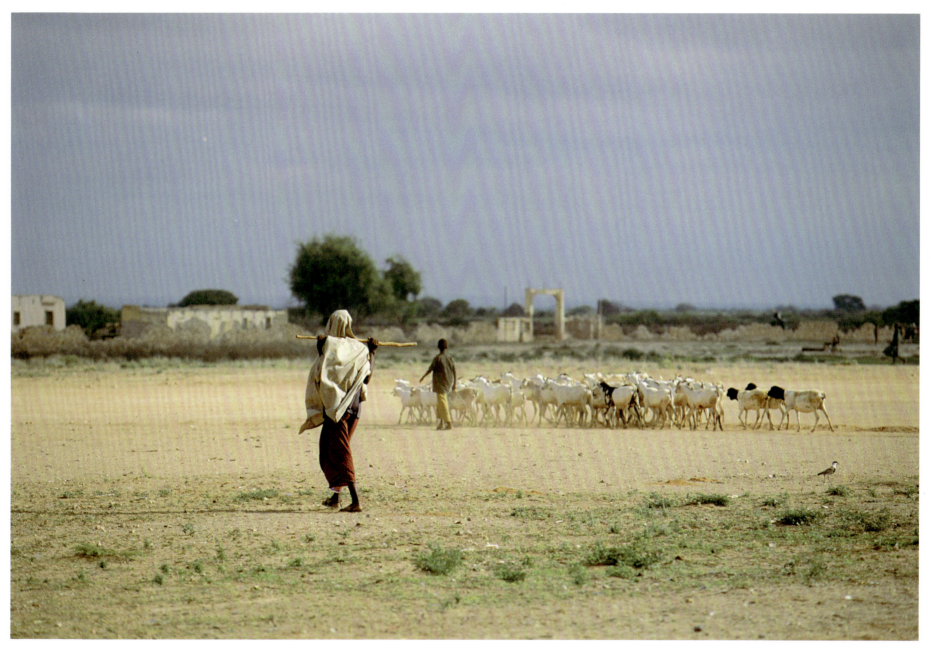

Herding goats across the runway in Huddur, Somalia.